P9-AFT-999

02550788

DATE DUE

Story and Space in Renaissance Art: The Rebirth of Continuous Narrative focuses on a puzzling but ubiquitous feature of Renaissance art: continuous narrative, in which several episodes, each including the same characters, are shown in a single space or setting. Continuous narratives have often been considered to be incompatible with the new system of representing space, one-point perspective, which has been traditionally understood to freeze time as it unifies pictorial space.

In this study, Lew Andrews reassesses the problem and offers a new interpretation of continuous narrative. Focusing on the writings of Leonardo and other artists and theorists, he demonstrates that the restrictions that one-point perspective supposedly imposes with respect to time are simply conventions, theoretical accretions that reflect the standards of later centuries; they are not inherent in the system itself and, moreover, have no bearing on the art of the Renaissance. By looking afresh at the visual narratives of the fifteenth and sixteenth centuries within the context of the visual and narrative theories of those times, this study shows that continuous narrative is a progressive feature of Renaissance art, inextricably linked to the expansion of space through one-point perspective.

Story and Space
in Renaissance Art

Story and Space
in Renaissance Art
The Rebirth of Continuous Narrative

Lew Andrews

University of Hawaii at Manoa

CAMBRIDGE
UNIVERSITY PRESS

Published by the Press Syndicate of the University of Cambridge
The Pitt Building, Trumpington Street, Cambridge CB2 1RP
40 West 20th Street, New York, NY 100114211, USA
10 Stamford Road, Oakleigh, Melbourne 3166, Australia

First published 1995

Printed in the United States of America

Library of Congress Cataloging-in-Publication Data
Andrews, Lew.
Story and space in Renaissance art: the rebirth of continuous
narrative / Lew Andrews.
p. cm .
Includes bibliographical references and index.
ISBN 0-521-47356-X
1.Narrative painting, Italian. 2. Narrative painting,
Renaissance – Italy. 3. Perspective. I. Title.
ND1452.182A5 1995
759.03 – dc20 94–46328
 CIP

A catalog record for this book is available from the British Library.

ISBN 0-521-47356-X hardback

To the memory of my parents

CONTENTS

ILLUSTRATIONS

PREFACE

THIS BOOK grew out of my doctoral dissertation, which I had begun in an attempt to describe and explain a specific type of Renaissance narrative – those pictures in which the same character appears more than once. I had long been fascinated by these images, above all by their somewhat surreal and shamelessly paradoxical character. I had initially assumed that they were simply freakish anomalies, as rare as they were odd. After more careful investigation, however, I realized that these curious and discursive narratives were extremely widespread and by no means as unusual as I had originally supposed. And that realization made their presence all the more puzzling, for the popularity of continuous narrative is hard to reconcile with other aspects of Renaissance art, most notably with perspective. There seemed to be a fundamental contradiction, a misunderstanding or misinterpretation of some kind, that warranted further exploration.

My earliest efforts were more descriptive than analytic, but with the patient prodding of my advisors, I increasingly turned my attention to the issues underlying this surprising development, seeking to understand why continuous narrative flourished in the age of one-point perspective, when by all accounts it was supposed to disappear. Before long, I was led to consider even broader questions concerning the perception of time and space and on their place in the visual arts both during the Renaissance and in general. And I would like to think that the final result sheds some light not only on the specific historical situation that was my point of departure but on these larger matters as well.

The present version of this book is quite different from the original; many sections have fallen away and others have been added. The main argument is now a good deal more focused, emphasizing fundamental concerns more than specific historical examples, but my purpose remains the same as before. I still wish to establish an accurate theoretical framework for these remarkable narratives, to place them in their

proper context and to explain why and how they were so readily accepted in the past and why it is that we look upon them today as flawed and eccentric.

In the first chapter, " 'By the Ocean of Time,' " I consider the prevailing views of the representation of time in the visual arts, with emphasis on Lessing's *Laocoön*. I then advance an alternate approach based on the art of memory and using a picture by Hans Memling as an example. The next chapter, "The Viewer and the Vanishing Point," focuses more specifically on the assumptions underlying one-point perspective and the implications of this type of perspective with respect to time and movement; Leonardo's opinions are given particular attention, along with those of Piero della Francesca.

In Chapter 3, "A Single Glance," I extend the conceptual framework by examining the writings on perception and cognition contained in Ghiberti's *Third Commentary*, in which duration is a more important consideration than either simultaneity or instantaneity. Then in the fourth chapter, "Simpler Completeness," I offer a new interpretation of Leonardo's well-known comparison between painting and poetry, which makes more allowances for temporal succession than might be supposed; Leonardo's brief but noteworthy remarks on continuous imagery itself are also considered at this juncture.

After that, the discussion turns in a slightly different direction, and in Chapter 5, "Position and Meaning in Continuous Narration," I explore the expressive possibilities of the continuous approach – its special advantages and potential – concentrating primarily on depictions of the Banquet of Herod painted in Italy and the North. Finally, in the last chapter, "Space and Narrative," I tackle the problem from a more chronological point of view, tracing the development of continuous narrative during the Renaissance period, and then its demise, emphasizing most of all the close connection between this mode of narration and the realistic depiction of space. Curiously, in the end, the most paradoxical aspects of continuous narrative – those very qualities that first lured me to this project – turn out on closer inspection to be nothing more than compelling illusions, as magical as they are convincing.

Having spent many years on this project (and having revised the

manuscript more than once), I have a large number of people to thank. It would take another book adequately to acknowledge all of them, but I would like to express my gratitude here to some of those most directly involved in this project in all its stages. First, special thanks to my primary advisors, David Rosand and Richard Brilliant, both of Columbia University, for their encouragement from the outset and good advice all along the way. I am fortunate to have had the benefit of their wisdom, knowledge, and guidance. I would also like to thank Martin Kemp, of the University of St. Andrews, who read a recent, longer version of the text, for his insightful comments and many helpful suggestions. So too am I grateful to James Beck, Maristella Lorch, and James Mirollo (all of Columbia University), members of my dissertation committee, for their insights and kind words.

Thanks also to Hubert Damisch, of the Ecole des Hautes Etudes en Sciences Sociales, who read portions of the manuscript, and whose comments proved instrumental. A number of other people also read parts of this study, among them Michael Koortbojian, Sarah Lawrence, Louise Rice, and Andrew Ross. I am in their debt for their many valuable criticisms and suggestions. I profited greatly as well from informal exchanges of ideas with colleagues and friends: Jane Long, Norberto Massi, Della Sperling, Michael Schwartz, and Peter Walker, among others. Their thoughts helped me to get over many hurdles and to crystallize my thinking on important issues. I am also grateful to my students at the University of Hawaii for their challenging questions and their patience.

My mother, the late Violet Andrews, and my father-in-law, the late Mervin Warfield, both read the dissertation in its original form. Their approval was especially gratifying.

Early in my work on this study, I received a Wittkower Fellowship from the Department of Art History and Archaeology, Columbia University. I am grateful for this assistance. I would also like to thank the staff of Avery Library, Columbia University, and especially William O'Malley and the late Bela Baron, for their help on numerous occasions, both while I was at work on my dissertation and in subsequent years. My thanks too to the staff of Hamilton Library at the University

of Hawaii. In addition, I am indebted to David Norton and Richard Shipp for their cooperation and technical wizardry.

Chapter 5, in slightly modified form, first appeared as an article in *Word and Image* (10 [1994]: 84–94); I am grateful to John Dixon Hunt and to Francis & Taylor for permission to reprint that material here. I would also like to thank the readers at Cambridge University Press for their insightful comments and useful suggestions. Beatrice Rehl, the fine arts editor at Cambridge, was extremely helpful, and I appreciate her staunch support; Camilla Palmer kept things moving smoothly during the production process; and Susan Greenberg did a remarkable job of copyediting. I would also like to acknowledge Liz Weisberg and Francesca Valerio at Art Resource in New York for their help in assembling the illustrations.

And most of all, now more than ever, thanks to my *anima gemella*, Laura Warfield, for absolutely everything.

Story and Space
in Renaissance Art

INTRODUCTION

the point may be compared to an instant of time, and the line may be
likened to the length of a certain quantity of time, and just as a line
begins and terminates in a point, so such a space of time begins and
terminates in an instant.

<div align="right">LEONARDO DA VINCI[1]</div>

Stephen closed his eyes to hear his boots crush crackling wrack and
shells. Your are walking through it howsomever. I am, a strid at a time.
A very short space of time through very short times of space. Five, six:
the *nacheinander*. Exactly: and that is the ineluctable modality of the
audible.

<div align="right">JAMES JOYCE[2]</div>

IN HIS *DE PICTURA* OF 1435, Leon Battista Alberti likens a painted
picture to an open window: A picture, in his view, should be made
to seem as if it were a pane of transparent glass through which we
look into an imaginary space extending into depth.[3] Moreover, Alberti
provides very specific instructions on how such an illusion might best
be achieved – the first written statement we have on one-point per-
spective. The system he describes has proven itself to be an effective
means of rendering three-dimensional space on a two-dimensional sur-
face: One-point perspective is often hailed as having revolutionized
the representation of the visual world, apparently creating a unified
and rational view of a homogenous space for the first time and setting
art on the course toward greater realism that it would follow for more
than four centuries.[4]

Among the artists first to use the method described by Alberti was
the sculptor Lorenzo Ghiberti. Ghiberti's *Isaac* relief (Fig. 1), part of
the *Porta del Paradiso*, the east doors of the Baptistery in Florence, is
virtually a textbook example of Alberti's technique – even if the work
is cast in bronze rather than painted. In the relatively shallow plane

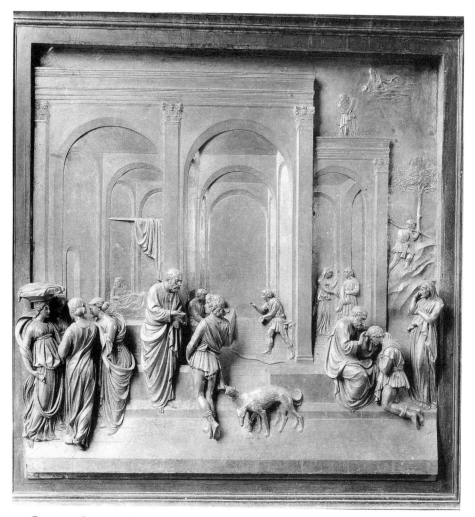

Figure 1. Lorenzo Ghiberti, *Story of Isaac*. Florence, Baptistery. Courtesy of Foto Marburg/Art Resource, NY.

of his relief Ghiberti created a convincing illusion of deep and continuous space, an ample and impressive setting for the Old Testament subject he depicts, which is indeed shown as if it were seen through a window.[5] But in the same panel we also find a rather curious form

of narration, now generally referred to as continuous (or polyscenic) narrative: A number of actions occurring at different moments but involving the same characters are presented together in a single unified space.[6] In the panel Ghiberti tells the story of how Jacob obtained the blessing of his father, Isaac, in seven distinct phases: Isaac appears twice in two separate episodes; Jacob and Esau, three times each; and Rebecca is shown in four different positions, scattered about in the imaginary space.[7]

We find a similar approach to pictorial narration in Masaccio's well-known *Tribute Money* (Fig. 2) in the Florentine church of Santa Maria del Carmine; Masaccio's fresco, another touchstone of quattrocento style, painted about 1427, includes three episodes in the same landscape setting, a setting often praised for its clarity and depth. St. Peter appears three times and the tax collector twice.[8] And, similarly, in Fra Filippo Lippi's depiction of the Banquet of Herod in the Cathedral of Prato (Fig. 3), a work of the early 1460s often noted for its striking treatment of space, we see the figure of Salome three different times and the head of the Baptist both on the left and on the right.[9]

To the modern viewer such pictures pose something of a paradox: The more developed the depiction of space is – the more a picture suggests a view through a window – the more puzzling the repetition of characters or the proliferation of events within that space seems. We generally assume that a convincing representation of space implies the simultaneity of that which it includes, as would be essentially the case in a photograph, for example, in which everything is shown in the same place at more or less the same moment. Consequently, it strikes us as odd and illogical when we see several successive episodes, with the same character or characters in each of them, in the accomplished evocations of space just mentioned. Very simply, to return once again to Alberti's analogy, when we glance through a window we do not expect to see the same figure in two (or more) places at once. Yet that is precisely the paradoxical situation we find in these, and indeed in many other, pictorial narratives of the quattrocento, the same century in which one-point perspective first came into use.

3

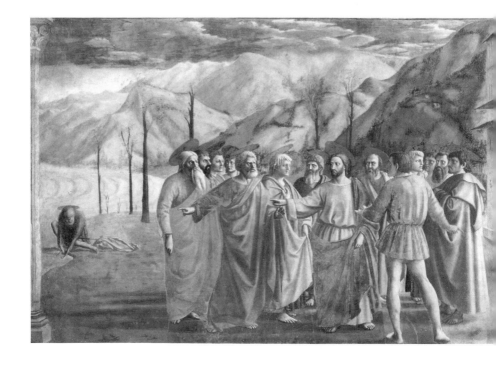

THE STANDARD VIEW

It is often suggested that quattrocento instances of continuous narra-
tive must be regarded as survivals of medieval practice (in turn, a
vestige from earlier centuries): Such pictures, it is generally assumed,
reflect an approach to pictorial narration incompatible with the spatial
innovations and representational logic of the quattrocento, a method
that was discarded as soon as this conflict became clear. Episodic,
discursive narratives in which numerous incidents are included within
a single picture made sense in the Middle Ages, when there was little
interest in representing the world realistically. But once a more accu-
rate view of nature was desired – starting, shall we say, at the end of
the thirteenth century or the very beginning of the fourteenth century
– this sequential sort of imagery was no longer feasible or acceptable:
By the fifteenth century it was merely a bad habit, a little difficult to
break.

4

Figure 2 (opposite page and left). Masaccio, *Tribute Money*. Florence, Santa Maria del Carmine. Courtesy of Scala/ Art Resource, NY.

One of the most emphatic statements of this position was put forward by Dagobert Frey, whose analysis remains the basis for the current valuation of the place of continuous narrative in the Renaissance. In the controversial *Gotik und Renaissance* (1929) Frey drew a sharp distinction between the artwork of the two periods with which he is concerned, between Gothic painting in particular (e.g., Giotto) and that of the Renaissance (e.g., Masaccio). A Gothic painting, Frey suggested, must be *read* rather than seen:

it rolls off, as it were, like a film before the observer, except that the successive pictorial impressions do not depend upon the mechanical movement of the film, but upon the intellectual movement of the viewer.[10]

Renaissance pictures, by contrast, are tailored for a simultaneous viewing. This condition is dictated by one-point linear perspective, which establishes a fixed viewpoint from which a picture must be seen: Pictures can no longer be viewed sequentially because the eye is no

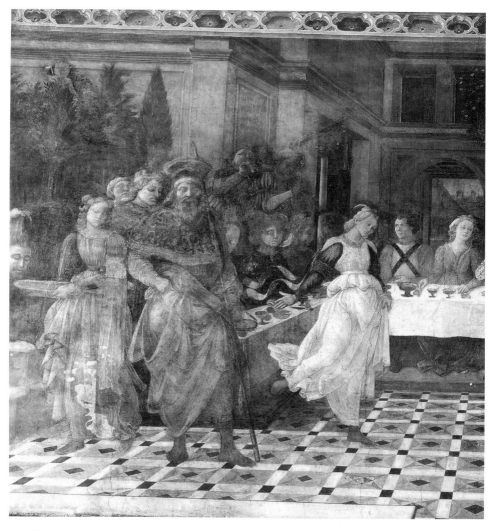

Figure 3 (opposite page and above). Filippo Lippi, *Banquet of Herod*. Prato, Duomo. Courtesy of Alinari/Art Resource, NY.

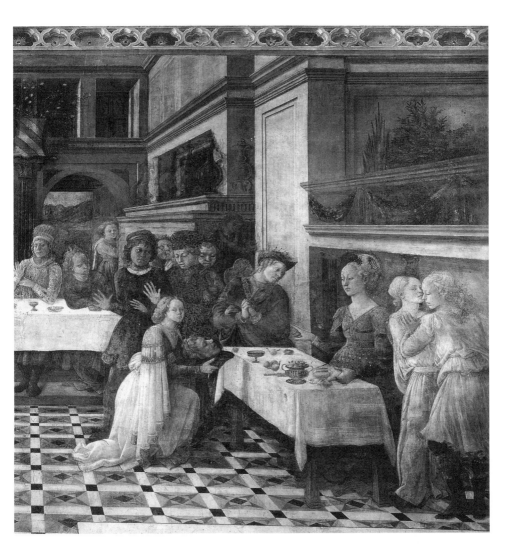

longer free to move across them. The eye instead remains stationary, and the picture is taken in at a single glance, simultaneously. This in turn requires that the depicted events, also stationary of course, be simultaneous as well. As a result, Frey went on to say,

the Renaissance conception had to give the death-blow to the "continuous representation" of the Middle Ages. Perspective and continuous representation

7

are irreconcilable in their very presuppositions. In spite of this, the medieval joy in storytelling is felt long afterwards.[11]

For Frey, then, the persistence of continuous narrative (which requires sequential viewing) in the quattrocento – in just those pictures, in fact, in which linear perspective breaks onto the scene – is clearly a hold-over from previous centuries. The same assumption underlies many other discussions of quattrocento art. It is echoed, for example, in a recent book on Alberti, in which the author argues that:

> The depiction of different narratives in one painting, or of several events of a narrative sequence, was gradually abandoned [in the quattrocento]; and as the plurality of dramatic moments disappeared from the picture, so did the plurality of its "spaces," the impossible coexistence of several independent views. The picture came to be unified as a single, visual image.[12]

The quattrocento, then, becomes a kind of transitional phase or epoch in which an outmoded medieval form of storytelling overlaps the emergence of Renaissance realism; the general trend is presumed to lead from widespread use of continuous narrative to its eventual elimination by the end of the century, as artists increasingly came to grips with a more realistic mode of representation. In other words, there was a basic contradiction between continuous narrative and realism that would take some time to understand and overcome.

PICTORIAL EVIDENCE

A close examination of the evidence would seem, however, to rule out Frey's assessment. Although in use since Antiquity, continuous narrative had not been equally popular in all periods. Indeed, the evidence suggests that continuous narrative was less common in the trecento than it was in the quattrocento; it was especially uncommon at the beginning of the trecento (as well as in the latter part of the duecento). By contrast, complex polyscenic narratives occur with great frequency throughout the quattrocento, in panels, frescoes, and reliefs.

We need only compare the quattrocento frescoes in the Sistine Chapel (1482) with Giotto's paintings in the Arena Chapel (ca. 1306)

to grasp the general development of narrative painting during the early Renaissance: The earlier frescoes are almost without exception monoscenic, including only one episode or moment, whereas the later narratives, taken individually, are infinitely more elaborate.[13] Giotto's version of the Baptism (Fig. 4), for example, is a unified interpretation: The characters and action all pertain to a single event, both compositionally and dramatically. Perugino's fresco of the same subject in the Sistine Chapel (Fig. 5), on the other hand, includes not only the Baptism proper but several additional incidents as well, all contained within a spatial setting that is deeper and more vast than the setting of the earlier picture.[14]

A similar development can be observed in narrative paintings of the life of St. Francis. In its canonical form the imagery of St. Francis is a

Figure 4. Giotto, *Baptism of Christ*. Padua, Arena Chapel. Courtesy of Alinari/Art Resource, NY.

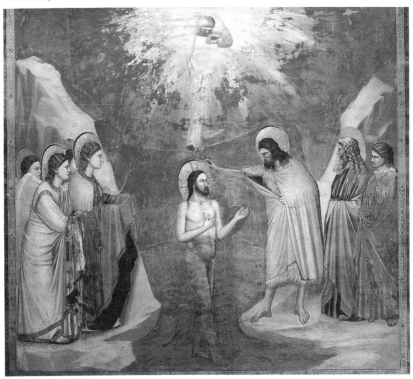

product of the duecento and the early trecento: Francis died in 1226 and was canonized in 1228; representations of his life began to appear almost immediately afterward.[15] The earliest depictions are largely monoscenic, focusing on a single moment or scene. This is most certainly true of the well-known fresco cycle in the upper church of San Francesco in Assisi (generally dated to the end of the thirteenth century or slightly later), which stands behind almost all subsequent representations of the life of the saint.[16] Giotto's frescoes in the Bardi Chapel in Santa Croce in Florence (early 1320s?), despite differences in style and format, are yet another instance of the same basic narrative approach.[17]

Toward the middle of the trecento we begin to see a shift: Continuous narrative is gradually introduced into Franciscan subjects. In Pistoia, for example, in a fresco cycle in the church of San Francesco (dated ca. 1340) several of the pictures include more than one incident, although most of them are monoscenic, relying heavily on the

Figure 5. Perugino, *Baptism of Christ*. Vatican City, Sistine Chapel. Courtesy of Scala/Art Resource, NY.

influential models at Assisi.[18] About a century later (1437–44), Sassetta too uses continuous narrative in several panels he paints for the Borgo San Sepolcro altarpiece (National Gallery, London). But for Sassetta, as for the painter of the Pistoiese frescoes, continuous narrative is the exception rather than the rule.[19]

This is no longer the case, however, in Benozzo Gozzoli's frescoes of the life of St. Francis in Montefalco (1452), where numerous episodes of the saint's life are presented in continuous form in spatially elaborate settings.[20] In several instances Gozzoli follows tradition, combining episodes that had already been joined together at Pistoia, or by Sassetta.[21] But in many other frescoes Gozzoli creates new continuous types: The *Death of the Knight of Celano*, the *Dream of Innocent III and the Approval of the Rule*, and the *Birth of St. Francis and the Homage of a Simpleton* all appear as continuous narratives for the first time at Montefalco – as far as we can tell from the surviving evidence.[22] The *Death of the Knight of Celano* (Fig. 6), for example, is described in three separate incidents: St. Francis predicts the knight's death, the knight confesses, and the knight expires in the arms of his loved ones. The same subject had been treated earlier, at Assisi (Fig. 7) and by Taddeo Gaddi in the *armadio* panel originally for the sacristy of Santa Croce in Florence and now in Munich. In both cases, the earlier versions are monoscenic.[23]

Continuous narrative, then, becomes prevalent in Franciscan imagery for the first time at the historical moment in which we might expect its gradual disappearance. Much the same thing occurs in illustrations for Dante's *Divine Comedy*. As is the case with Franciscan narratives, the earliest Dante pictures, which begin to appear in the trecento, are predominantly monoscenic. Only toward the end of the trecento, and with increasing frequency and complexity in the quattrocento (as in the work of Giovanni di Paolo and Botticelli), does continuous narrative become prevalent in illustrations of Dante's poem.[24] Numerous other examples – in subjects of all kinds – also attest to the fact that continuous narrative becomes a more vital part of quattrocento art after the introduction of linear perspective than it had been before. And it would retain that vitality, in a wide range of imagery and in a variety of contexts, throughout the century and even beyond.

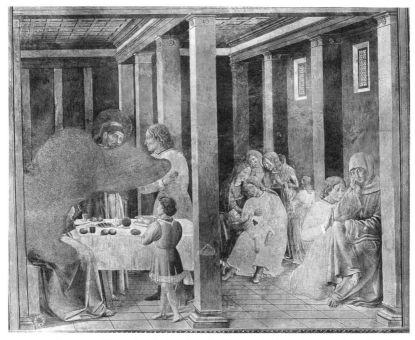

Figure 6. Benozzo Gozzoli, *The Death of the Knight of Celano*. Montefalco, San Francesco. Courtesy of Alinari/Art Resource, NY.

WRITTEN EVIDENCE

If the increasing popularity of continuous narrative contradicts modern expectations, it presented no such difficulty during the quattrocento. Indeed Renaissance commentators are curiously silent on the matter, and seem altogether undisturbed by imagery that would strike us now as anomalous or illogical. When, for example, Bartolomeo Fazio, writing in 1456, praises Gentile da Fabriano's famous Strozzi altarpiece (1423) depicting the Adoration of the Magi, he fails even to mention that the Journey of the Magi is also included in the same painting.[25] And he describes Ghiberti's Old Testament reliefs as copious and varied without further commenting on the artist's polyscenic approach.[26] Yet Fazio remarks that "No painter is accounted excellent who has not

Figure 7. Anonymous, *The Death of the Knight of Celano*. Assisi, San Francesco. Courtesy of Alinari/Art Resource, NY.

distinguished himself in representing the properties of his subjects as they exist in reality," a statement that seems to preclude acceptance of the continuous method.[27]

Alberti, too, ignores the issue. Of course, the approach to painting he outlines in *De pictura* is so empirical that the modern reader finds it difficult to imagine that Alberti approved of continuous narrative. Still, whereas Alberti decries the use of gold backgrounds as an archaic practice that must be discarded, he makes no such complaint about continuous narrative.[28] Similarly, Filarete's discussion of *storie* ("histories," i.e., narratives), based in large measure on Alberti, could be construed as a caution against the use of the continuous method: "When

you have a *storia* to make," he says, "think as much as possible how to harmonize everything you do" (quando tu hai a fare una storia, ingegnati d'accomodarla il più che tu puoi a quello per che tu la fai).[29] Yet the monument he singles out for praise in this respect, the model to be followed in composing a *storia*, is Trajan's column, perhaps the most ambitious continuous narrative ever made.[30] And Filarete himself relied on continuous narrative in his reliefs for the doors of St. Peter's in Rome (1433–45).[31]

Other writers, also artists, accept polyscenic narration with no embarrassment or apology. Ghiberti, discussing his own reliefs for the Baptistery in Florence, is utterly matter-of-fact about the presence of many scenes within each panel.[32] And Vasari, much later, is equally casual: He explains the discursive narratives of Ghiberti, Masaccio, and many other quattrocento artists without discomfort. Indeed he singles out Masaccio's *Tribute Money* for special praise and describes Ghiberti's last set of doors as "perfect in every way" (Ed in vero si può dire che questa opera abbia la sua perfezione in tutte le cose).[33] Vasari is no less accepting of the presence of more than one episode in the works of his own century, such as Raphael's *Liberation of St. Peter* in the Vatican Stanze or Michelangelo's depiction of the Temptation and Expulsion on the Sistine ceiling.[34]

Only Leonardo da Vinci comments specifically on the continuous method, advocating its use in certain cases, and he does so without hesitation.[35] If the continuous method had been looked upon as a lingering anomaly, or as a true violation of Renaissance notions of pictorial reality, we might expect a vociferous reaction, even diatribes or warnings, especially considering how frequently it was used. But nothing like that seems to have occurred. Evidently the audiences of the time were perfectly comfortable with such methods, were undisturbed by what we now find irrational, and continuous narrative flourished without complaint.

CURRENT THINKING

Given the prevalence and apparent acceptance of continuous narrative, we cannot, then, easily dismiss this method as an outmoded, medieval

habit, one that was somehow at odds with the main currents of Renaissance art: Continuous narrative was undoubtedly an integral, even a progressive feature of quattrocento practice, and it must be carefully reconsidered in that light. But an important question immediately arises: How is such an approach to be reconciled with the presuppositions of one-point perspective? As already indicated, one-point perspective apparently guarantees the simultaneous unity of that which is represented; an illusion of space is as timeless or instantaneous as it is convincing precisely because of the means that bring it about, or, more specifically, because of the restrictions presumably imposed on the movement of the viewer. Continuous narrative, in contrast, makes sense only if such notions are discarded. How then is this conflict to be resolved? Were the artists of the quattrocento in effect working at cross-purposes, forging new means of creating an illusion of space on the one hand, yet in a sense undermining that illusion on the other? Or have we misunderstood these artists' objectives, especially concerning the representation of time and space and the theoretical preconditions for one-point perspective?

In recent years, scholars have begun to study these issues. In the early 1970s, Leo Steinberg raised the possibility that a picture as unified as Leonardo's *Last Supper* can include more than one moment or incident. Although many complicated questions remain as to how we should read Leonardo's great painting, Steinberg effectively dislodged long-standing misconceptions concerning the interaction of narrative time and pictorial space.[36]

Ernst Gombrich also ponders the narrative methods of the Renaissance and other periods in his important essay *Means and Ends*.[37] He carefully demonstrates how in the complicated frescoes on the walls of the Sistine Chapel or in Bernardino Luini's *Crucifixion* in Lugano the adding on of episodes did not undermine their hard-won realism but served instead – given the specific requirements of the subjects and the sites – to preserve it. Gombrich's argument turns, in part, on Leonardo's important remarks on the continuous method, cited earlier, which (as we shall see) he places in their proper context.[38]

Similarly, John Pope-Hennessy speaks of the continuous method when he evaluates Ghiberti's Old Testament reliefs for the east doors

of the Florentine Baptistery.[39] The traditional dating of the individual panels is based, at least in part, on the assumption that Ghiberti gradually discarded continuous narrative as he worked, reducing the number of incidents he depicted in each panel and modernizing his approach.[40] Pope-Hennessy argues that on the contrary Ghiberti's more discursive reliefs (like the Isaac panel mentioned earlier) must be dated after rather than before the more unified monoscenic ones, not only because of their higher quality but also because of their greater narrative clarity. Although he takes the matter no further than Ghiberti's reliefs, Pope-Hennessy indirectly makes an extremely useful point: The continuous method and perspective space can be a viable, even a logical, combination.[41]

On a broader level, in several suggestive and insightful essays Sixten Ringbom explored conventions and devices in Renaissance narrative imagery (continuous and otherwise), setting the stage for further, more extended studies.[42] In the same context, the compendium Le figure del tempo should also be mentioned. This work includes valuable texts by Umberto Eco, Omar Calabrese, and Lucia Corrain: It is an intelligent and systematic guide to visual narratives from the trecento onwards and provides a useful framework for more detailed investigations.[43] Corrain's remarks introducing a series of commentaries on specific continuous examples are particularly relevant. Like Pope-Hennessy, Corrain recognizes that Renaissance space allowed for more extended narratives in which the added depth is exploited to good effect.[44] This, in essence, is one of the underlying assumptions of the present study as well.

More recently, Marilyn Lavin has made an extensive study of narrative cycles (most of them frescoes), concentrating her attention on their settings and the ordering of scenes.[45] Many of her examples are continuous narratives, a proper reading of which can be accomplished only by taking into account the overall organization of the cycles to which they belong, as she rightly suggests and clearly demonstrates. But Lavin does not consider the continuous method itself at any length, nor does she pursue the theoretical implications of its popularity – questions beyond the avowed scope of her undertaking.[46]

My concern here is with more general theoretical matters. My pur-

pose is not so much to trace a historical development or to analyze specific pictures or cycles. As the reader may have surmised, my aim is to explore the implications of the continuous method and, more particularly, the implications of its prevalence and vitality during the quattrocento and the cinquecento, when it seems especially out of place. Continuous narrative, it might be said, serves as a kind of wedge, a theoretical crowbar if you will, with which to pry loose for examination certain largely unquestioned assumptions that condition our attitude toward Renaissance art, blinding us to some of the period's most sophisticated imagery. (Such assumptions, it may be added, still limit the role of movement and narrative in many of the visual arts.)

ILLUSION OF THE SPIRIT

In basic terms it is my contention that one-point perspective need not curtail or eliminate the representation of passing time, that is, continuous narrative; one-point perspective can also lead in the opposite direction. The restrictions that it apparently imposes with respect to time are in fact not mandated by the system itself, and the limitations that we take for granted are later accretions, reflections of a stringent "photographic" aesthetic in which pictorial realism is understood in decidedly literal terms (as we shall see). In this later conception, the painted scene – the illusory world evoked by perspective – had to correspond with the viewer's reality in almost every respect. But that is not required by the system itself, as those who first used it clearly understood: No theoretical restraints were immediately or automatically imposed on the representation of time, or on continuous narration, even if we have come to think otherwise.[47]

During the Renaissance, the links between the viewer and that which is represented were less direct than would be the case in subsequent centuries. The imitation of nature – one of the avowed objectives of the art of the period – was carried only so far, and pictorial space was understood not so much as a literal extension of physical reality but instead as an indication or suggestion of such an extension – a suggestion that was never intended to fool anyone completely, no

matter how convincingly or effectively depth was portrayed. As Jacques Mesnil has written:

during the period of the development and the flowering of the art of the Renaissance, artists sought to produce not an illusion of the senses, but an illusion of the spirit. . . . and their works were creations of artistic imagination, not trompe-l'oeil.[48]

Renaissance perspective brought a new clarity and cohesion, even a new unity, to pictorial representation: Everything stands in some measurable relation to everything else (in the most orthodox examples, at any rate). But the system in itself does not, by definition, limit the duration of narrative action; on the contrary, one-point perspective provides spacious settings in which action can occur – over time, as if on a stage, making room for a variety of figures involved in different episodes or activities. Indeed, perspective space gives rise to many sorts of settings, small pockets of space or vast panoramas, all having a kind of temporal resonance, demanding, in effect, to be explored or inspected over time and almost inviting, by their very emptiness, the inclusion of additional figures and events. Ultimately, the deeper and more expansive it seems, the more readily that space can encompass an extended series of moments or scenes; in short, the more easily it can accommodate a continuous narrative.

CHAPTER ONE

"BY THE OCEAN OF TIME"

Thus music and narration are alike, in that they can only present them-
selves as a flowing, as a succession in time, as one thing after another;
and both differ from the plastic arts, which are complete in the present,
and unrelated to time save as all bodies are, whereas narration – like
music – even if it should try to be completely present in any given
moment, would need time to do it in.

THOMAS MANN[1]

In Lessing's *Laocoön*, on which we squandered study time when we were
young, much fuss is made about the difference between temporal and
spatial art. Yet looking into the matter more closely, we find all this is
but a scholastic delusion. For space, too, is a temporal concept.

PAUL KLEE[2]

THE HISTORY OF NARRATIVE ART has been described as "a series of
repeated attempts to smuggle the time factor into a medium which
by definition lacks the dimension of time."[3] Continuous narrative is
often discussed in similar terms, as an attempt to introduce passing
time into settings and situations where it does not belong. Such as-
sessments, it must be said, presuppose a rather restrictive view of the
visual arts, according to which, under ordinary conditions, pictures,
statues, and reliefs can depict only one place at one time – whatever
they describe must be either momentary or timeless. If necessary, pass-
ing time can be suggested in a series of separate images (this is where
the smuggling generally occurs), but not within a single work, by itself,
because the figures and objects are related in space only, not in time
(except, perhaps, in rare cases).

On the basis of these apparent limitations, a distinction is often
drawn between the visual arts and other art forms or media. As a result,
painting comes to be regarded, like sculpture, as a merely spatial art,
whereas poetry, or literature in general, which by nature lends itself

readily to the description of successive actions or events, becomes a temporal art. Poems and stories, then, should not dwell on the outward appearance of objects existing in space or on scenic views and physical beauty, which can be described more effectively by means of visual imagery. On the other hand, painting and sculpture should scrupulously avoid all forms of storytelling or any kind of sequential subject matter, leaving these to poetry and other time-bound media, which by definition are better equipped to handle such tasks.[4]

The classic statement of this formulation is, of course, Gotthold Ephraim Lessing's *Laocoön* (1766).[5] In this well-known study, Lessing argues that painting must renounce the time element altogether, because its forms and symbols can be combined in space only and, consequently, "progressive actions, by the very fact that they are progressive, cannot be considered to belong among its subjects."[6] According to Lessing, painting must therefore limit itself to the representation of "coexistent actions" (Handlungen neben einander) or of "mere bodies which by their position, permit us to conjecture an action."[7] For a painter to be concerned with temporal succession would be a serious misstep, tantamount to trespassing into forbidden, literary terrain:

It is an intrusion of the painter into the domain of the poet, which good taste can never sanction, when the painter combines in one and the same picture two points necessarily separate in time, as does Fra Mazzuoli when he introduces the rape of the Sabine women and the reconciliation effected by them between their husbands and relations, or as Titian does when he presents the entire history of the prodigal son, his dissolute life, his misery, and his repentance.[8]

In Lessing's view, good taste and simple logic demand complete unity: Two moments or episodes, that is, two points separate in time, cannot be included in the same picture. In this restricted context, time and movement – and most especially, continuous narrative – are clearly off-limits. But Lessing was not the first to impose such restrictions. Indeed, much the same sort of thinking is already evident in Lord Shaftesbury's book *Second Characters*, written some fifty years before *Laocoön*. Shaftesbury, like Lessing, also looks upon the represen-

tation of time with suspicion, and he too attacks continuous narrative, issuing one of the earliest categorical condemnations of the practice:

It is evident, that every master in painting, when he has made choice of the determinate date or point of time, according to which he would represent his history, is afterwards debarred the taking advantage from any other action than what is immediately present, and belonging to that single instant he describes. For if he passes the present only for a moment, he may as well pass it for many years. And by this reckoning he may with as good right repeat the same figure several times over, and in one and the same picture represent Hercules in his cradle, struggling with the serpents; and the same Hercules of full age, fighting with the Hydra, with Anteus, and with Cerberus: which would prove a mere confused heap, or knot of pieces, and not a single entire piece, or tablature, of the historical kind.[9]

For Shaftesbury continuous narrative is the ultimate and absurd consequence of an approach to painting in which the unity of time and place is not strictly observed: Painting, in his view, should involve the action of a single moment or instant only. And the logic of this position is apparently demonstrated, in more recent times, by photography's ability to arrest motion at the same time as it mechanically reproduces Albertian space, thereby excluding the possibility of continuous narrative in all but a few special cases.[10] Indeed, we tend to look back upon the aspirations of the fifteenth century in terms of what we understand to be the special characteristics of photography; the artists of the quattrocento are presumed to have been groping for what is finally achieved (more or less) in a photograph, not only with respect to descriptive realism, an accurate or realistic depiction of the natural world, but also with respect to time. We assume, in other words, that the goal of the Renaissance painter was to arrest movement with the precision we impute to the photographer, to create an instantaneous view of a piece of the world. Thus one critic, writing about Renaissance perspective (and echoing Frey), asserts:

This sort of pictorial space (really architectural in its conception) uses instantaneous time; thus the renaissance optical perspective in painting fuses

time with space by reducing time to a moment when the painted figures are associated in a unified action like that of the "regular" renaissance drama.[11]

The representation of time, then, is deemed inappropriate in paintings that comprise a unified and convincing illusion of space – in pictures more particularly constructed in accordance with the rules and conventions of Renaissance one-point perspective. A completely realistic depiction of space is, virtually by definition, the representation of a single instant.

THE UNITIES

The authority upon whom the entire approach that insists on temporal unity ultimately rests is Aristotle. Aristotle's pronouncements on drama (and by implication, on painting) as we find them in the *Poetics* had almost unassailable force during the seventeenth and eighteenth centuries, and today we still speak rather loosely but reverently of the Aristotelian unities, in particular, the unities of time and of place. Aristotle himself, however, in the *Poetics*, was less restrictive than his latter-day followers; in fact, he required only the unity of action, by which he meant that a plot – the ordering of incidents – must represent a simple action (a change of fortune, for example) with a beginning, a middle, and an end. The incidents or episodes by which that action is described must lead logically from one to the next, and extraneous events, events that do not advance the plot in any way, should be excluded. "A plot does not have unity," according to Aristotle, "simply because it deals with a single hero."[12] It must instead be driven by a strong unifying logic or premise.

Aristotle further advised that the amount of time *represented* in a proper plot for a tragedy should be limited to one revolution of the sun or slightly longer.[13] Similarly, the play itself should be of a reasonable duration, neither too short nor too long; but there need not be a direct correlation between the length of a performance and the amount of time represented in it. Interestingly, Aristotle explained the temporal constraints on drama in spatial terms: Beauty can be properly

apprehended only when the object in view is neither too small nor too large to be seen and appreciated all together. In the same way, a plot should be of such a length or size that all of it can be held in the memory without undue strain.[14]

Aristotle was not suggesting that all of the action in a play take place in one imaginary spot, no larger than a stage; nor was he recommending that the action be limited in duration to the amount of time necessary to perform it, that, in other words, fictive time coincide with actual time. Nevertheless, Aristotle's precepts were eventually understood to imply the specific and restrictive unities of time and place – that both the time and place in a drama (or in a painting) correspond exactly with the temporal and spatial reality of the audience. According to this more recent formulation (the same notions on which Lessing's argument depends), a play should depict only those events taking place within one limited span of time, which, ideally, would correspond to the duration of the performance (unity of time); similarly, a play's action should unfold within the confines of a single, unified place, or very simply, on the stage itself (unity of place). In both cases, unity – that which constitutes a single time or a single place – is defined solely in terms of the audience and therefore presupposes a strict connection between the imaginary world of the drama and the spatial and temporal reality of the spectators. The fictive time must correspond exactly with real time or else the drama becomes unconvincing; the same condition applies to space. But no such restrictions appear in Aristotle's *Poetics* and neither do the unities of time or of place.

CASTELVETRO

Intermingling the events on the stage with the reality in front of it, as well as the unities that follow from that literal interconnection, was first advanced by Ludovico Castelvetro in his commentaries on the *Poetics*, originally published in 1570 (*Poetica d'Aristotele vulgarizzata et sposta*).[15] Castelvetro interpreted Aristotle's suggestion that a play represent what transpires during the course of a single revolution of the

23

sun as an allusion to the events of twelve hours rather than of twenty-four. And twelve hours, he also reasoned, was the outside limit of an audience's physical endurance and attention:

But thus just as the exact place is the stage, so the exact amount of time is that in which the spectators can easily remain seated in the theater, which in my view cannot exceed one revolution of the sun, as Aristotle says, that is, twelve hours; this is because, due to bodily necessities such as eating, drinking, depositing wastes from the bowels and the bladder, sleeping and other needs, people cannot continue to stay in the theater beyond the aforementioned limit.[16]

Accordingly, it became conceivable to think of the duration of a play as coinciding with the amount of time represented in the play: A play describing the events of a twelve-hour span could be performed in twelve hours. And so the identity of acting time and fictive time is established in principle, even if it was little observed in practice. Similarly, the setting of the drama was defined in terms of the circumstances of the performance: The setting had to represent a unified place, as large or as small as the physical reality of the stage, which itself is an extension of the space occupied by the audience:

tragedy ought to have for [its] subject an action which happened in a very limited extent of place and in a very limited extent of time [spazio di tempo], that is, in that place and in that time, in which and for which the actors representing the action remained occupied in acting; and in no other place and in no other time.[17]

The imaginary world of the play and the real time and space of the audience are thus brought into harmony; they are the two sides of an equation, the time and space represented on the stage corresponding exactly with those existing in front of the stage. More specifically, the time taken up by the actions represented equals the time needed to perform those actions (and so also equals the amount of time demanded from the audience).[18]

The same principle – complete equality for both sides of the equation – can be transposed from drama to painting. This is especially true when a painting is conceived of as a window, as an opening onto an imaginary space (not unlike a stage) beyond or behind the picture

plane: If the *time* on either side of the equation (on either side of the picture plane, so to speak) were to be reduced to an instant, it would have to be correspondingly condensed on the other side. Thus if the fictive time of a work of art is diminished, then the viewing time must be as well. Conversely, if the viewing time is reduced, then the time that may pass within the imaginary space of the painting is also reduced. Moreover, the setting must shrink accordingly, for the spectator has to be able to take in the entire scene in an appropriate amount of time or from an appropriate position. Taken to its logical extreme, this kind of thinking can lead to absurd, paradoxical results. Stopping short of ridiculous extremes, however, we arrive back, in essence, at the sort of pictures envisioned by Lessing, at paintings in which a single moment of time is portrayed within a unified setting or from one single vantage point, or at what Shaftesbury characterized as "a single piece, comprehended in one view, and formed according to one single intelligence, meaning or design."[19] Such pictures represent what can be seen in a single glance; they define how much space can be seen at one time – one effectively indivisible space or place at an equally indivisible moment. And as we have seen, unified pictures of this kind can and should be comprehended in a correspondingly brief span of time – "in one view" – even if we choose to linger in front of the image, on our own time as it were, in contemplation, inspecting details, sneaking a behind-the-scenes glimpse of what, in effect, we were intended never to see.

IN MOTION

The unities and their implications were especially important topics of critical debate during the seventeenth and eighteenth centuries. But the restrictions on pictorial time that these "Aristotelian" principles presumably impose did not have any real force during the quattrocento, nor yet during the cinquecento as a whole. Instantaneous effects were not the goal of Renaissance artists. We commit a serious error if we look at quattrocento painting (or the art of many other centuries) with post-Lessing or post-Daguerre eyes, if we assume that time is

either irrelevant or fully arrested and that the goal of the quattrocento painter was, as it presumably is for the photographer, simply to stop time – to show an event as it would appear at a particular moment.[20]

Quattrocento artists were, on the contrary, more concerned with creating motion than arresting it. To be sure, the painted or sculpted figures created by these artists did not actually move: That was a given. The challenge was to make it appear – or at least to suggest the possibility – that they could move. Success in this regard was the basis for the praise heaped upon the outstanding works of the period – that they seemed alive – "che veramente," as Vasari said of the apostles in Masaccio's *Tribute Money*, "appariscono vivi" (they truly seem alive).[21]

Such comments cannot be entirely dismissed as rhetorical figures: These aesthetic judgments certainly owe a great deal to classical usage, but they also reveal one of the aims of Renaissance art. Remarks of this kind do not mean simply that figures should appear convincingly three-dimensional; rather, the figures must seem to be *alive*, seem to be in motion or capable of motion, both in space and in time, even if they are not.[22] So too must time seem to flow between one figure and another. When we look at quattrocento paintings, whether they represent one episode or several, we are looking at a process rather than a single moment or a collection of moments: One action follows the next, just as one event comes after another. Time is potentially present on every level – in the construction of individual figures, in the interactions between one figure and another, and in the orchestration of larger groups of figures and scenes – an altogether different ideal than the one set forth by Shaftesbury and Lessing.

ART AND MEMORY

To understand the implied successiveness, the sense of passing time built into quattrocento space (or potentially any pictorial space), we must think in very basic terms, indeed of time itself, or, more precisely, of the perception of time. We are not seeking theoretical definitions of time, nor, for that matter, of space; we are not exploring the sort of theological or cosmological issues that concerned Nicholas

of Cusa, for example, or Giordano Bruno. Our concern is with the subjective experience of time, and Frey's evaluation of continuous narrative, with which we began, bypasses important aspects of that experience.[23] In particular, Frey and like-minded critics sidestep the fundamental interdependence of time and space in the sensory world, in our everyday lives.

In the normal course of life time and space are experienced together, each virtually unknowable or inconceivable without the other. We might say that they are two different ways of experiencing or interpreting essentially the same situation or set of facts.[24] But whereas we readily acknowledge that space can be experienced only in terms of time and movement (that is, over time), the reverse is perhaps less apparent: Time is less easy to conceive of in spatial terms than the other way around. Nevertheless, it remains true that time cannot be experienced apart from space.

The notion of the flow of time is essentially a spatial one, and to make sense of any temporal sequence we must first understand its overall shape. Otherwise, that sequence becomes a random collection of happenings, each one disappearing to make way for the next and having no meaning except in itself. In other words, the different phases or elements of a given series, although occurring over time, must also be understood all together, in relation to each other, in order to be coherent.[25] Thus when we listen to a musical composition that unfolds over time, the individual notes of the musical sequence must assemble themselves into motifs, phrases, and themes in order to make sense. A group of notes establishes a local climax that in turn becomes a building block for a larger sequence with its own climax, and so on, culminating in the composition's final note, which is experienced as a resolution not because no other note follows, but because we remain aware of what has come before. Each note must take its place in a larger context, a context that is not only harmonic but also linear – in other words, spatial.[26]

The same analysis can be applied to dance movements, for example, or to language.[27] It also holds true for our perception of the visible world, which we do not see all at once but rather in a succession of images perceived over time. Nevertheless, as in the case of musical

27

notes, this succession of images is also experienced together, as a spatial whole. The temporal sequence of our fragmentary visual perceptions is integrated into spatial form as our visual world, and our sense of succession all but disappears unless our attention is drawn to it.[28]

The integration of successive elements – be they musical notes, words, or visual images – takes place in memory.[29] In basic terms, one of the tasks performed by memory is the assembling of individual moments or percepts, occurring or apprehended over time, into patterns, into "synchronously organized structures," in relation to which such percepts acquire meaning.[30] We rely on our memories to transform temporal stimuli into spatial form, and back again, when necessary or appropriate.[31]

This mental operation, this function of memory, was intuited long ago by such ancient rhetoricians as Cicero, Quintillian, and the anonymous author of the Ad Herennium. They made it the basis for a system of mnemonics whereby the items to be memorized (parts of a list or a poem, for example) are first given visual form and then assigned a position (locus) in an imaginary space, such as a room or a house divided into many rooms.[32] As Cicero explains:

persons desiring to train this faculty (of memory) must select places and form mental images of the things they wish to remember and store those images in the places, so that the order of the places will preserve the order of the things, and the images of the things will denote the things themselves.[33]

Arguments or poems committed to memory in this way are easily recalled by imagining oneself in the memory place, passing before each of the memory images in the desired, preestablished order.[34]

In a recent study of memory and medieval culture, Mary Carruthers has dubbed this venerable technique the "architectural mnemonic," which is an apt designation.[35] According to Carruthers, the architectural mnemonic declined in popularity after Cicero's time (first century B.C.) but was energetically revived starting in the thirteenth century.[36] And it was well known throughout the quattrocento, in Italy and elsewhere: The works of Cicero and Quintillian were widely circulated during this time, and mnemonic treatises incorporating the ancient techniques were common. The arts of memory (or artes memorativae, as

the architectural mnemonic was often called after the twelfth century) also lay at the heart of quattrocento religious life: They were embedded in public and private devotion, in preaching, in mystery plays (*sacre rappresentazioni*), and in the liturgy itself.[37]

THE GARDEN OF PRAYER

We have come rather a long way from painting and the question of continuous narrative, but the mnemonic techniques of the ancient writers have much to tell us about the temporal aspects of the visual arts.[38] Of special interest for our purposes is a text, the anonymous *Libro devoto e fruttouso a ciascun fedel christiano chiamato giardino de orationi*, known as the *Giardino de orationi* (Garden of Prayer), written in 1454 and widely available during the fifteenth and sixteenth centuries.[39] The *Giardino de orationi* is the religious counterpart of the ancient discussions of memory, a sort of handbook in which the faithful are instructed in how best to meditate upon and remember the story of the Passion:

The better to impress the story of the Passion on your mind, and to memorise each action of it more easily, it is helpful and necessary to fix the places and people in your mind: a city, for example, which will be the city of Jerusalem – taking for this purpose a city that is well known to you. In this city find the principal places in which all the episodes of the Passion would have taken place – for instance, a palace with the supper-room where Christ had the Last Supper with the Disciples, and the house of Anne, and that of Caiaphas, with the place where Jesus was taken in the night, and the room where He was brought before Caiaphas and mocked and beaten. Also the residence of Pilate where he spoke with the Jews, and in it the room where Jesus was bound to the column. Also the site of Mount Calvary, where he was put on the Cross; and other like places. . . . And then too you must shape in your mind some people, people well-known to you, to represent for you the people involved in the Passion – the person of Jesus Himself, of the Virgin, Saint Peter, Saint John the Evangelist, Saint Mary Magdalen, Anne, Caiaphas, Pilate, Judas and the others, every one of whom you will fashion in your mind.[40]

The faithful were thus advised to make a memory place of their own familiar surroundings, and in the manner set forth by Cicero and the

29

Figure 8 (opposite page and above). Hans Memling, *Scenes from the Passion*. Turin, Galleria Sabauda. Courtesy of Alinari/Art Resource, NY.

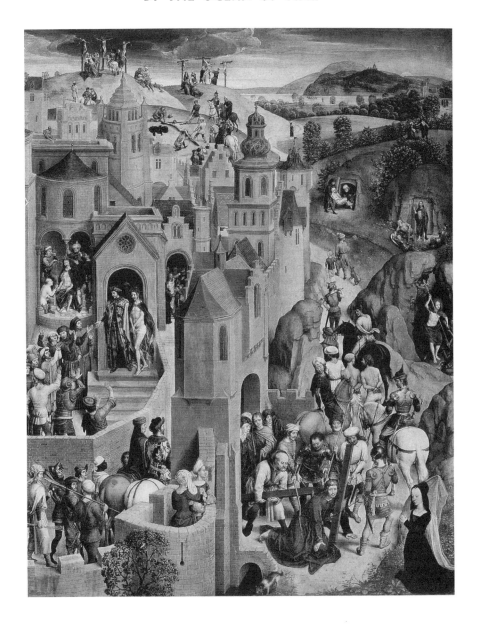

others to visualize the successive events to be remembered in various locations within that space, in short, to create a spatial representation of a temporal sequence.[41]

This spiritual exercise can be readily translated into paint, as indeed it was in many Renaissance pictures: Hans Memling's depiction in Turin of the Passion (Fig. 8), for example, is virtually an illustration of the passage just cited.[42] In Memling's panel, the events of the Passion are disposed in various locations that are distributed throughout the space of what appears to be a familiar town, representing Jerusalem. The picture, then, can be considered a depiction of a memory place; it is a pictorial realization of an imaginary setting, as recommended in the devotional handbook, including all the particulars, and one in which a succession of events – episodes of the Passion – are presented in spatial simultaneity, functioning in much the same way as does memory itself.

The handbook also tells us how to read the picture, which is analogous to the process of remembering (and here we are speaking of primary memory and immediate recall as opposed to long-term storage). The sequence of events is easily recovered by moving through the space of the painting, passing from one episode to the next in the manner described in the Giardino de orationi.[43]

When you have done all this, putting all your imagination into it, then go into your chamber. Alone and solitary, excluding every external thought from your mind, start thinking of the beginning of the Passion, starting with how Jesus entered Jerusalem on the ass. Moving slowly from episode to episode, meditate on each one, dwelling on each single stage and step of the story. And if at any point you feel a sensation of piety, stop: do not pass on as long as that sweet and devout sentiment lasts.[44]

Each event acquires its full meaning in the context of the whole sequence, the Passion, which reveals itself as we pass from one episode to the next. Just as time is experienced as space, space, in turn, can be experienced as time. Indeed, space and time are experienced together, integrated in our primary memories, as the ancient rhetoricians and their quattrocento successors were aware.

Quattrocento paintings and most especially continuous narratives

can be approached in the same way – they are aides mémoire as much as they are simple illusions, designed to facilitate the viewer's recall as well as to dazzle the eye. Their illusionistic brilliance spurs both imagination and memory, permitting the viewer to enter the painting's fictive world, to move through the picture's space as though traversing the imaginary rooms or houses of the ancient treatises or the familiar environments of the devotional handbook. Viewing or looking is presumed to be an active process, a kind of devotion.[45]

Continuous narratives, then, reproduce the operation of short-term memory, and unless they are understood in this manner, these pictures remain random collections of isolated events with no relation to one another, like so many statues in a sculpture garden, linked only by their being in the same place at the same time. But then we are back where we started. The analogy to memory, or, more specifically, to the mnemonic techniques of the ancients (the architectural mnemonic), provides a framework for understanding these pictures on their own terms. This approach offers a means by which the isolated components of a polyscenic picture can be related to each other in time; it is a way of assembling individual moments or events into sequences, which is to say, into narratives.[46]

CHAPTER TWO

THE VIEWER AND THE VANISHING POINT

Perspective can, therefore, only be quite right, by being calculated for one fixed position of the eye of the observer; nor will it ever appear *deceptively* right unless seen precisely from the point it is calculated for. Custom, however, enables us to feel the rightness of the work on using both our eyes, and to be satisfied with it, even when we stand at some distance from the point it is designed for.

JOHN RUSKIN[1]

The perspective representation corresponds exactly to the optical impression given by the object for a certain position of the eye in front of the plane of projection (picture).

When one views the picture on its own, but from a different centre, then one receives visual impressions which the object itself would not give. This will almost always be so, when one looks at a painted picture.

Now it seems to me to be the case that the spectator will easily *compensate* intuitively for this deformation, when the angle alpha which defines the boundary of the object is small, so that all the visual rays strike the plane almost perpendicularly. When, however alpha/2 is for instance equal to 45°, then the picture will appear deformed, if it is viewed from a distance which is greater than the distance of the projection centre from the picture. Then the intuitive compensation is likely to fail, so that the picture appears deformed. It is not easy to say which compromise solution the painter must choose in such a case.

It is probable that the use of a sufficiently restricted angle alpha in combination with central projection, is the only reasonable solution.

ALBERT EINSTEIN[2]

THE TRADITIONAL APPRAISAL OF CONTINUOUS NARRATIVE is built on a specific interpretation of Renaissance perspective. The innovations of Brunelleschi and Alberti are presumed to have led almost inevitably to the simultaneity of what is represented: "Simultaneous unity of content in painting," Frey maintains, "is scientifically attained in perspective."[3] As Frey presents the situation, the reason for this simultaneous unity is that by definition pictures constructed according to the rules of perspective embody an individual, particularized point of view. Such pictures represent what can be seen by one unmoving eye in a single glance from a particular point and must therefore be viewed from a single position and understood all at once, *in un' occhiata*, or instantaneously. The space is thoroughly unified, and the viewer is accordingly locked into place, automatically immobilized by the logic of the system.

Frey then takes the argument one step further: "Simultaneity in perceiving a picture also requires a synchronization of what is represented; by grasping the picture spatially as a unit we also assume the depicted events to be simultaneous."[4] In other words, we go back from the viewer to the picture itself: Because passing time is now no longer an issue in the viewing process, it must be squeezed out of the imaginary world within the picture as well, and devices or methods such as continuous narrative immediately become unacceptable, at odds with the principles and procedures by which pictures in perspective are constructed.

Frey's reasoning here is rather intricate and involuted, taking us from the picture to the viewer and back again. Linear perspective, by its very nature, creates a unified impression of space by relating all elements to a single point, namely, the vanishing point. This point in turn dictates the fixed position of the beholder (the viewpoint or station point), which is ordinarily presumed to be directly opposite and at a preordained distance from the central point of the construction. The viewer must not stray from that position if the illusion of space is to remain convincing; all movement in front of the picture is therefore arrested. Once that happens, when the viewer is barred from shifting position, all movement within the image is likewise eliminated, and the representation of the passage of time can no longer be permitted.[5]

This rather circular argument seems to turn almost entirely on the placement of the beholder, who is now, in the Renaissance, required to be stationary; continuous narrative is disallowed in Frey's analysis essentially because one-point perspective implies or demands an unmoving viewer. Unlike earlier forms of pictorial organization, which were relatively flexible (and which, accordingly, lent themselves to more episodic forms of narration), Renaissance perspective imposed certain more rigid conditions. As Giulio Carlo Argan, writing about Brunelleschi, put it: "One of these [postulates of perspective] is the reduction of narrative to drama, of temporal succession to the unity of place, of the evocation to the representation of an action."[6]

In the Renaissance itself, however, perspective was understood somewhat differently. To be sure, restrictions were placed on the viewer at the start; we hear about them right away when perspective is introduced. But these constraints were quickly relaxed, and a stationary viewer was rarely insisted upon over the course of the next one hundred years. Moreover, perspective procedure was seldom linked in any significant way to the realities of the actual setting. On the whole, there was a gradual loosening of the theoretical fetters, a shift toward greater leniency regarding the viewer, especially when these issues were addressed by practicing painters like Piero della Francesca and Leonardo. In Leonardo's case in particular, a moving viewer became a priority, and was given an emphasis that Frey, in dismissing continuous narrative, may have failed to consider.

DISCRETION

The importance of the correct viewpoint is clearly established in Brunelleschi's original demonstration of perspective, carried out in the 1420s (or perhaps somewhat earlier).[7] The earliest detailed account of this initial experiment is in Brunelleschi's biography, probably written by Antonio Manetti some fifty years later. Unfortunately, Manetti provides little specific information about Brunelleschi's perspective system – about the actual procedure – preferring to describe the outcome

rather than the underlying geometry. But Manetti leaves little doubt about what he considers the basic principle that Brunelleschi was seeking to underscore:

Since in such a painting it is necessary that the painter postulate beforehand a single point from which his painting must be viewed, taking into account the length and width of the sides as well as the distance, in order that no error would be made in looking at it (since any point outside of that single point would change the shapes to the eye), he made a hole in the painted panel at that point in the temple of San Giovanni which is directly opposite the eye of anyone stationed inside the central portal of Santa Maria del Fiore, for the purpose of painting it. The hole was as tiny as a lentil bean on the painted side and it widened conically like a woman's straw hat to about the circumference of a ducat, or a bit more, on the reverse side. He required that whoever wanted to look at it place his eye on the reverse side where the hole was large, and while bringing the hole up to his eye with one hand, to hold a flat mirror with the other hand in such a way that the painting would be reflected in it.[8]

Although Manetti tells us nothing about how the image was created, he is quite clear that the result must be viewed from a specific point: The beholder is required to look at a reflection of the painting through a peephole in the painted panel itself. This is necessary, Manetti explains, because "any point outside that point would change the shapes to the eye" (che in ognj luogho, che s'escie di quello, a mutare l'apparizioni dello occhio): The illusion of depth would start to disintegrate due to the distortions that arise from standing in the wrong position. Whatever form of perspective Brunelleschi employed, the success of the illusion depended on the correct viewpoint – and on the use of only one eye. Indeed, it would seem that the true purpose of Brunelleschi's mirror scheme was not only to demonstrate the effectiveness of his method but also to bring home that very principle, to underscore the importance of a stationary viewer using only one eye.[9]

In his other, presumably later panel, again according to Manetti, Brunelleschi turned his attention to the Palazzo della Signoria in Florence. Although we cannot be certain about the exact appearance of the resulting image, we do know that Brunelleschi's approach changed

along with his subject: He abandoned the rather complicated scheme dictating the viewpoint in the first demonstration and adopted a simpler arrangement that no longer involved a mirror or a peephole. The second panel was to be looked at directly, without any means of locking the beholder in place.[10]

By making this change, Brunelleschi eliminated, of course, the one guarantee that his panel would be seen from the exactly correct position and gave back to the viewer the freedom of movement that he had taken away in the first experiment. We might well wonder what led Brunelleschi to relax so crucial a requirement almost immediately after demonstrating its importance: Did it seem unnecessary to belabor the point once proven? Did the modification reflect a theoretical retrenchment? Or was there some simple, practical consideration?

Manetti anticipated these very questions and provided something of an answer: The problem, it seems, had been one of size and weight. The second panel, Manetti explained, was much larger than the first, too large and ungainly in fact to be held up together with a mirror. The panel was so big that the implied viewing distance was greater than the length of a normal arm, which would not have been strong enough in any case to manage the added burden: "No matter how far it extended," reasoned Manetti, "a man's arm is not sufficiently long or sufficiently strong to hold the mirror opposite the point with its distance" (perchel braccio dello huomo non e tanto lungo, che collo specchio in mano e lo potessi porre dirinpetto al punto con la sua distanza, ne anche tanto forzeuole, che la reggessi).[11]

Manetti's reasoning is plausible, but it really represents only half an answer; we still need to know why Brunelleschi chose to make a larger panel in the first place, if that meant eliminating such an important feature of the original demonstration. For this too Manetti had a response: The panel had to be large because Brunelleschi's second subject included more detail than the first, forcing him to work on a larger scale than before, which in turn led to the modification of the original arrangement.[12]

Again Manetti's explanation is couched in pragmatic terms, but he was not altogether unaware of the repercussions of the new approach. He recognized, at least, that Brunelleschi had now left it up to the

viewer to select the proper viewing position, as painters generally did. And he further realized that leaving such a determination to the viewer's discretion was no guarantee that the correct viewpoint would be selected, because, as Manetti chose to put it (perhaps indulging himself in a play on words), spectators are not always discreet – *discreto*, that is to say, discerning: "He left it up to the spectator's judgment, as is done in paintings by other artists, even though at times this is not discerning" (Lascollo nella discrezione di chi ghuarda, come interviene a tutte l'altrj dipintorj, benche chi guarda ogni volta non sia discreto).[13]

The underlying principle established in Brunelleschi's first demonstration presumably remained the same: An ideal viewpoint existed from which the illusion of depth could be seen to best advantage. But the viewer was granted new freedom of movement, and Brunelleschi's second experiment in perspective, his view of the Signoria, would be seen, for better or for worse, from more than one position. Even more importantly, it would be seen – and without undue harm – by viewers with both eyes open.[14]

EL MAIN

When describing the apparatus of Brunelleschi's initial demonstration, many years after the fact, and in particular, when explaining the importance of the peephole, Manetti obviously assumed that one-point perspective placed severe restrictions on the viewer's movements, virtually by definition; Manetti is in fact the only one who addresses the question directly until that point. Attitudes were changing by Manetti's time, however, and a new conception was emerging in which the viewer's mobility was accepted and affirmed. The change is already evident in Piero della Francesca's discussion of linear perspective, as we begin to see in Theorem XXX of the first book of *De prospectiva pingendi*, where Piero defends the new system against its detractors:

In order to take away the error of those who are not very adept at this science [perspective] and who say that many times in dividing the plane into dimin-

Figure 9. After Leonardo da Vinci, perspective diagram from MS Br.M. 62a (London, British Library). Redrawn by Richard Shipp.

ished squares the foreshortened side [of certain squares] is greater than the unforeshortened side . . . it is necessary to make a demonstration of the true distance and of the size of the visual angle.[15]

What this has to do with the viewer's movements is not immediately apparent, but underlying these remarks are important assumptions about the beholder's behavior. Piero is speaking here of a checker-board pavement, the sort of ground plane that appears so often in quattrocento painting, in which some of the foreshortened squares (those toward the lower corners of the picture) are shown with receding sides greater than their unforeshortened dimension, a perspectival oddity that would be of concern to Leonardo too.[16] Indeed, Leonardo would later provide an illustration of just such an extremely foreshortened square (Fig. 9), to which he gave the mysterious name *el main*: As Leonardo presented it, the left side of *el main* (*bf*), part of an orthogonal leading to a hypothetical vanishing point, is greater than the foreground (bottom) (*bg*) edge, which is not the case in the other foreshortened square in the same drawing (*dbac*).

Piero does not use the same term, but he has something similar in mind, and those to whom he addresses his demonstration seem to have regarded distortions like *el main* as unacceptable, even monstrous and abhorrent: It was generally expected that the foreshortened side (*lo scurto*) of any given square would be smaller than the unforeshortened side (*quello che non è scurto*), and it therefore must have seemed illogical for it ever to have been otherwise. Indeed, for the critics of perspective oddities of the sort that we have been discussing indicated a crucial flaw in the system itself: The very existence of these strange forms called into serious question the validity of the new, untrustworthy method.

In Theorem XXX, Piero responds to these objections and clears away certain misconceptions. For him, the presence of unusually distorted squares does not pose a serious threat to the system, nor does it reveal any weakness in it. As disturbing as they might be, such effects result instead from misguided choices and faulty procedure. As Piero painstakingly shows, it is only when perspective is used incorrectly that such anomalies appear. When all the rules are skillfully applied – and *De prospectiva pingendi* was, of course, intended as a guide in precisely that respect – problems of this sort need never arise.[17]

Piero goes on to demonstrate that this kind of deformation occurs only when the angle of view is too wide (or the distance used in the perspective construction too short). If the angle exceeds 90° (and the sight of one eye enters into the domain of the other eye, to use Piero's language), then unwanted distortion will result.[18] But if the angle is 90° or less (and the distance is half the width of the picture or more) then the foreshortened side of the square will not exceed the unforeshortened side, and foreshortened squares, even at the extreme edges of the construction, will not be objectionable, the critics will therefore be satisfied, and the matter can be put to rest.[19]

Piero never explicitly tells us why such forms were anathema in the first place, but, whatever other objections there may have been, one reason is clear, and here is where the movement of the viewer comes in: If these forms were considered objectionable it can only have been because they were to be seen from more than one position. From the classically correct position (through Brunelleschi's peephole, as it were) foreshortened squares, however drastic the foreshortening, appear entirely "normal"; only when the viewer moves away from that position and the squares in question are seen from other viewpoints does their oddness become apparent or disturbing. Had Piero and his contemporaries not wished to grant the viewer a certain latitude, had they not assumed some movement by the viewer, such aberrations would have been of very little consequence, and Piero would not have felt called upon to provide any sort of explanation. But a moving viewer must have already become something of a theoretical given, or an accepted precondition, even if Piero does not put the matter in quite

those terms. The restrictions established by Brunelleschi little more than half a century before have clearly lost some of their urgency and force.

Piero's discussion of these matters no doubt reflects his own experience as a painter, which was, of course, considerable. Indeed, many of his pictures, generally earlier in date than his theoretical endeavors, presuppose that the viewer will be granted a fair degree of latitude. Most of the frescoes in Arezzo – the *Finding and Testing of the True Cross*, for example, or, directly above it, the *Restoration of the Cross to Jerusalem* – are well above eye level; the ideal viewing position in these cases is from far above the height of a normal person and therefore physically impossible to attain, at least under ordinary conditions. And Piero was not the only painter to operate in this fashion: Leonardo, as has often been pointed out, did essentially the same thing in his depiction of the Last Supper in Milan, and many other artists did likewise.[20]

It would make little sense to suggest that Piero or any of these other artists were naively unaware of the implications of what they were doing; it is clear that they recognized the resilience of the system they employed – its inherent flexibility – and took it as a given that pictures in perspective remain legible and pleasing even when the viewer moves about more or less freely. Perhaps Manetti too would have been ready to concede this much, speaking as he did of the viewer's lack of discretion, but in Piero's theorem, such latitude gains new legitimacy, however indirectly. The movement of the viewer is now incorporated more completely into perspective theory, now embedded in the system itself – and this constitutes a significant change, a theoretical shift leading away from Brunelleschi and setting the stage for Leonardo's investigations in subsequent years.

LEONARDO

In his early notebooks, Leonardo defines and evaluates one-point (essentially Albertian) perspective very specifically in terms of the spectator: The correct placement of the viewer is one of his constant

preoccupations. In MS A., for example, which dates from the early 1490s, he notes:

If you want to represent an object near to you which is to have the effect of nature, it is impossible that your perspective should not look wrong, with every false relation and disagreement of proportion that can be imagined in a wretched work, unless the spectator, when he looks at it, has his eye at the very distance and height and direction where the eye or the point of sight was placed in doing this perspective. Hence it would be necessary to make a window, or rather a hole, of the size of your face through which you can look at the work; and if you do this, beyond all doubt your work, if it is correct as to light and shade, will have the effect of nature.[21]

And, on the following page of the manuscript, he adds: "A diminished object should be seen from the same distance, height, and direction as the point of sight of your eye, or else your knowledge will produce no good effect."[22]

In these passages Leonardo seems no more willing than Brunelleschi to grant the spectator any freedom of movement in front of the picture: The picture must be seen from a single, specified position. But in assigning such importance to the correct viewpoint, Leonardo is really referring to a special case: For the viewer to stand at the point, distance, and height indicated by a perspective construction is imperative only when the picture in question represents a wide-angle view (when the distance used in the construction is relatively short) – essentially the same situation Piero had instructed his readers to avoid.

One way around these difficulties according to Leonardo is to produce images representing an angle that is less wide, as if the images were being seen from a greater distance. Piero had advised this too in De prospectiva pingendi, a decade or so before. But Leonardo is more explicitly concerned with the position of the spectator than Piero had been. Leonardo's specific objective is to remove the most severe restrictions on the viewer, to give the viewer some leeway. When the distance used in the construction is sufficiently great, extreme distortions do not arise, and the most displeasing "disagreements of proportion," or "false relations," are eliminated; as a result, the beholder

is free to move about and inspect the image from a number of points, no longer compelled to look through a peephole.

Leonardo is not entirely clear as to the construction distance he considers most desirable. His recommendations vary somewhat from statement to statement, even in the same notebook (MS A.), and it is difficult to extract an underlying principle. At one point, after stressing the importance of the proper viewpoint, he advises: "Otherwise do not trouble yourself about it, unless indeed you make your view at least twenty times as far off as the greatest width or height of the objects represented, and this will satisfy any spectator placed anywhere opposite to the picture."[23] Elsewhere in the same notebook he recommends a distance "ten times the size of the objects"[24] or "at least twenty times as far off as the greatest height and width of your work."[25]

Many of these remarks have a distinctly negative, almost ironic flavor; at times, Leonardo sounds almost like one of the critics of perspective with whom Piero had had to contend. Nevertheless, Leonardo clearly understood that a stationary viewer was not always desirable or even important. What for Brunelleschi had been a necessity, and for Alberti and others may have been a theoretical ideal, is here, in Leonardo's notebooks of the 1490s, applicable only in certain cases; by the end of the quattrocento we find Leonardo considering ways of circumventing what earlier in the century had been presented as a basic condition.

SIMPLE AND COMPLEX PERSPECTIVE

A concern with the movement of the viewer is evident in Leonardo's later notebooks as well as in his earlier ones. Over the course of his life, his views on the matter seem to change, however. In several passages from MS E., for example, dating from 1513–14, when the artist was near the end of his career, he presents the problem in terms of two basic types of perspective, which are differentiated specifically by how much leeway they allow the viewer.[26] The first of these he calls "complex perspective" (prospettiva composta), a construction in which the distance is relatively great and the angle of view extremely wide. As

Leonardo explains it, complex perspective relies on what he refers to as "natural perspective" (*prospettiva naturale*), or the workings of natural vision (the optics or *perspectiva* of Alhazen, Bacon, and others), which is needed to compensate for the defects and aberrations associated with wide-angle views. The operation of natural perspective on the picture plane, the diminution or foreshortening of the painted surface itself, corrects the distortions resulting from the geometric construction — provided, of course, that the viewer remains in the proper position, at a fixed point: "But this said invention [complex perspective] requires the spectator to stand with his eye at a small hole and then, from that small hole, it will be very plain."[27]

Complex perspective in essence corresponds to the sorts of construction about which Piero and Leonardo himself had already expressed dissatisfaction. But Leonardo goes on to propose a distinct alternative, a different sort of construction which he calls "simple perspective" (*prospettiva semplice*). In simple constructions the angle of view is relatively narrow (and the distance correspondingly long), and as a result, the objects and shapes, including those at the edges of the picture, are shown "as the eye sees them diminished," or as close to their true form as possible, even when seen at very close range.[28] In this case the operation of natural perspective on the picture plane is no longer required to correct the distortions of the perspective construction, because everything is already represented and will appear to be *in propria forma*, and no further compensation is needed.[29]

Simple perspective does not necessarily require a construction distance as great as those suggested in MS A. — Leonardo makes no specific recommendations at this stage — but the distance must be great enough that the picture can be viewed from far away (at a distance equivalent to or greater than that used in the construction) or at close range, from side to side or up and down. The picture will appear to be correct no matter where — within reason, of course — the viewer happens to be standing.[30]

In Leonardo's earlier discussion, constructions in which the distances are relatively long are presented as a kind of compromise, or as the lesser of two evils — a concession of sorts to the limitations of Alberti's conception; there is a distinct note of frustration as Leonardo explains

how best to overcome what he seems to see as a flaw in the system. But in his later discussion, the same sort of approach, what he now calls simple perspective, is explained and described in an altogether more positive light, as a system complete within itself, in which a moving viewer is entirely consistent and compatible. The very issue of a moving viewer, moreover, receives more attention than before and has become a rather basic criterion: Simple perspective is preferable to all other types of construction precisely because of the freedom of movement it provides. As Leonardo says:

But since many (men's) eyes endeavor at the same time to see one and the same picture produced by this artifice, only one can see clearly the effect of this perspective and all others will see confusion. It is well, therefore, to avoid such complex perspective and hold to simple perspective which does not regard planes as foreshortened, but as much as possible in their proper form.[31]

In these last remarks Leonardo again makes explicit what had been only implicit in Piero's discussion: Pictures in perspective should be made in such a way as to accommodate a moving viewer or more than one viewer at the same time. Those forms of projection that do not permit such movement (even if correct in themselves) are to be rejected in favor of those that do. It is freedom of movement that is the primary objective at this point, and thus, by the end of his career, in the second decade of the cinquecento, Leonardo had arrived at a conception of perspective very different from that of Brunelleschi, a conception in which a moving viewer plays an entirely legitimate role and is no longer guilty of any indiscretion.

As we have already seen, and as Manetti had explained, in Brunelleschi's first demonstration the method of construction presumably established a fixed viewpoint that the mirror and peephole served to define: The point of view from which everything within the picture was represented established an equivalent position outside the image at which the observer was obliged to stand. But in Leonardo's system, at its most fully developed, this link no longer applies: The viewpoint incorporated into the image, and the viewer's station point on the other side of the picture plane, are considered separately, coinciding only in special cases, and as a result, the viewer is no longer locked

into position and considerable freedom of movement is now allowed, regardless of the precise placement of the vanishing point. One might indeed say that perspective theory has finally caught up with practical considerations, and the reality of a moving, shifting viewer is accorded a new and systematic legitimacy.

As soon as we acknowledge that a stationary viewer is not always required, or even expected, our judgment of continuous narrative, or any related means of expressing passing time, starts to change; the arguments of Frey and the others with which we began start to unravel. If movement of some kind is permitted, if the viewer need not be stationary – in other words, if there is no single or fixed position from which a picture with a single vanishing point should or must be viewed – then there is no reason to suppose that such pictures must be completely understood at a single glance, or instantaneously, as Frey had stipulated. And if a picture need not be understood all at once, it is equally unnecessary for that picture to represent a single moment or to include only that which occurs simultaneously: The action can shift through time as well as through space, as is so often the case in quattrocento paintings and reliefs whether they are continuous narratives in the strictest sense or not.

CHAPTER THREE

A SINGLE GLANCE

Nothing that is seen is seen at once in its entirety.

EUCLID[1]

When Apelles looked at a field he tried to paint it with colors on a panel. It was the whole field which showed itself in a single moment to Apelles and aroused this desire in him. This showing and rousing could be described as the "action." . . . The act of looking and painting done by Apelles is called "motion" because it proceeds in successive stages. First he looks at one flower then at the next and he paints it in the same way. It is the field which causes in Apelles' mind at one and the same moment both the perception of the field and the desire to paint it. But that Apelles looks at one blade of grass and paints it, and then another, at different and successive moments of time, is not an effect caused by the field, but by the soul of Apelles, whose nature it is to see and do different things one at a time and not simultaneously.

MARSILIO FICINO[2]

THE DISCUSSION OF PAINTING AND PERSPECTIVE in *De pictura* is founded on the notion of the visual pyramid, made up of hairlike rays, which Alberti likened to a bird cage or beehive ("cavea"); the pyramid's base comprises the object of vision, and its apex is at the eye.[3] The painted image, the picture plane itself, is then described as the intersection or cross section of this pyramid (the *intercisio*, or as Leonardo sometimes called it, the *taglio*), representing a view of the natural world that is interchangeable, one might say, with the original scene.[4] It would seem to follow that any picture or pictorial space conceived as an abrupt break, as a slice through a sheaf of light rays, can describe only a momentary, and, in effect, simultaneous, set of relationships (to the extent, at least, that the information in such a cross section is adequately rendered), whether the resulting depiction is to be seen all at once or not.[5]

If the configuration of light and color presented by the visual pyr-amid – the optic array – is assumed to be constantly changing, as in fact happens, then what is "captured" in the cross section can represent only one of these fleeting possibilities and hence only what can be seen in a given moment or instant; the flow of time is thus effectively halted, it would appear, virtually by definition. Indeed, Alberti would seem to have been describing just such transitory patterns as these, and the temporal restraints they imply, when he explained the function of the median rays, an essential component of the visual pyramid:

These rays do what they say the chameleon and other like beasts are wont to do when struck with fear, who assume the colours of nearby objects so as not to be easily discovered by hunters. These median rays behave likewise; for, from their contact with the surface to the vertex of the pyramid, they are so tinged with the varied colours and lights they find there, that at what-ever point they were broken, they would show the same light they had absorbed and the same colour.[6]

Leonardo perhaps had something similar in mind when he recom-mended painting on glass as a means of studying atmospheric per-spective. He instructs the painter to record the appearance of the same object, a tree in this instance, at various distances, on a series of glass plates, which can afterwards be used as standards of reference in ren-dering *la prospettiva de' colori* or *la prospettiva aerea*.[7] What Leonardo sug-gests sounds rather like the painted equivalent, on an enlarged scale, of lantern slides or of more recent kinds of transparencies. And pho-tographs, in turn, are the mechanical embodiment of the most restric-tive aspects of one-point perspective in the sense that they isolate and fix a momentary glance from the flux of forms and colors that con-stantly pass before the camera lens.

The implicit simultaneity of perspectival representation appears all the more imperative because the speed of light (the speed at which light travels between an illuminated object and the eye) had long been recognized as being extremely fast, as either infinitely fast in the strict-est sense or merely imperceptibly fast, depending upon which au-thority one accepted.[8] In either case, every piece of visual information reached the eye with incredible speed. No time lag, then, could be

ascribed to the nature of light itself, to its propagation or transmission, even if, throughout the fifteenth century, uncertainty persisted both as to the direction in which light traveled (either toward or away from the viewer) and as to whether light traveled at all, an object in that case being simply and immediately visible without any activity or movement in the intervening medium.[9] The latter view, especially, makes it difficult for one to suppose that a single glance could be anything but a momentary occurrence.

Yet the foregoing reasoning ignores an important distinction, which did not go unnoticed in the quattrocento, between the purely physical aspects of vision and more physiological or psychological considerations. The argument fails to differentiate between the conditions by which light is propagated and the nature of visual perception as such. However fast light was thought to travel, and in whatever direction, however directly visual stimuli were believed to present themselves to the eye, perception in its fullest sense, understood as an operation of the mind, was considered to be a relatively drawn-out process. Accordingly, the limits of an individual glance (that is, the amount of time encompassed by a single glance) must be extended to include a succession of mental calculations as well, a series of operations without which the raw data of sensory experience has little meaning. When vision is imagined as a protracted process instead of as a timeless or instantaneous set of relationships, the character of the visual pyramid by which that process is represented changes too, as does the significance of the *intercisio;* in such a conception, the flow of time remains a logical component of perception, an element inherent in even the most unified perspective renderings, despite what more recent developments have led us to expect.

CERTIFICATION

The disjunction between optical sensation and its psychological results and, ultimately, the links between them as well, emerge quite clearly in Ghiberti's *Third Commentary*. A source of much confusion, the *Third Commentary* is probably best described as an incomplete set of working

notes for a project that was itself left unfinished. It consists largely of passages copied, often inaccurately, from earlier well-known works on optics; the selections cover the anatomy of the eye and brain, the nature of light, the visual pyramid, and many other related topics, collected together without further explanation or interpolation.[10]

The apparently disorganized result has left scholars understandably bewildered regarding Ghiberti's overall purpose and very often puzzled over the meaning of specific passages or phrases. Nevertheless, Ghiberti's commentary is an important document for our purposes, indeed for any study of quattrocento perspective, as Mesnil recognized some years ago; beneath the confusing pastiche of disjointed notations rests a coherent optical and cognitive theory that can be reconstructed despite the garbled form in which it now appears.[11] More specifically, Ghiberti's text presents the theories of the well-known Arab authority on vision, Ibn-al-Haitham, or Alhazen as he was generally called (ca. 96–1038), whose views on optics held sway in the West until the time of Kepler's discoveries in the early seventeenth century.[12]

In many instances Ghiberti draws on Alhazen directly, relying on Italian translations already circulating in the fifteenth century of Alhazen's main work on the subject of optics, *De aspectibus*. In other cases Ghiberti selects from later authors, such as Bacon, Pecham, and Witelo, whose optical works were themselves based on Alhazen's theories, with only minor modifications.[13] Together these sources must be considered the most advanced, up-to-date discussions of optical science or *perspectiva* available in the quattrocento, with important observations on cognition and visual perception that warrant further investigation. The fundamental principles of one-point perspective, and, in particular, the implications of this type of perspective with regard to time and narrative, cannot be adequately understood if Alhazen's work and the studies that derived from it (including Ghiberti's) are not taken fully into account.[14]

According to Alhazen (and as reported by Ghiberti), vision occurs in two basic ways: either as immediate perception, *comprensione superficiale (per lo primo aspecto)*, or as more attentive and contemplative perception, *comprensione per lo risguardamento (per intuitione)*.[15] The former sort of vision is simply one's initial overall and relatively vague impression

of an object or field, as given by the visual pyramid. It begins with the passive experience of pure sensation; only the least complex features are distinguished, and then only tentatively – subject to a more prolonged and thorough inspection, which occurs in the second type or stage of visual perception. In perception of the latter sort, attentive and contemplative vision, the object or objects in view are seen more distinctly, and with greater certainty; a more detailed and complete mental image is gradually built up, over a perceptible amount of time, primarily by means of what is called "certification" (certificatione), which is the key to accurate perception and broadly comparable to saccadic eye movements (or related sorts of eye movements).[16]

Certification is accomplished by sweeping the main axis of the visual pyramid (the centric ray) over each and every point on the base of the visual pyramid, in succession: The axis moves about, therefore, like the needle on a dial, or a rifle seeking its target, while the base as a whole remains in place, at least in effect.[17] This operation is necessary because of the differing capabilities of the rays making up the visual pyramid, the strongest of the rays, of course, being the central one: Only what is seen along the centric ray (or along rays very close to it) is perceived with complete clarity, because that ray alone passes through the eye and into the optic nerve unrefracted. As a result, our initial view of any object or field is completely clear only at one point – where the centric ray strikes the base of the visual pyramid. A distinct or true view, then, requires that the centric ray pass over every part of the object or field; perception cannot be considered complete or certified until the entire object is inspected in this way, point by point, over time:

When the sense of sight [el viso] therefore, has perceived all of an object in view [cosa visa], it will find that the part opposite the middle [of the eye] is more manifest than all the other parts. And when it [el viso] needs to certify the form of the object, it will move around so that the middle is opposite each part of the object.[18]

The eye, in other words, rotates (in its socket), and in this way every aspect of the object or field in question (the base of the visual pyramid) is seen clearly, including minute details, most of which had

gone unnoticed initially; all of an object's visual properties or characteristics (*intentioni*) are thus determined and confirmed.[19] And as the central axis moves across every point on the base of the visual pyramid, the distinguishing faculty (*la virtù distinctiva*), which draws its power from the mind and has at least some role in even the most immediate judgments, evaluates and compares the visible characteristics (*intentioni*) of the object or objects in view, both in part and as a whole. Judgments thus are made concerning such properties as distance, shape, size, and texture.[20]

The same process is continued and repeated until a complete mental picture is assembled in the imagination, the repository of the common sense (*repositorio sensus communis*), a processing center in the brain.[21] A detailed overall impression is therefore built up piece by piece, an impression that is held in the mind as a kind of armature, or as the framework of a jigsaw puzzle, as more and more details are added in succession: Every separate observation – each piece of the puzzle – takes its place in an overall structure outside of which it has little or no significance.

The process Alhazen describes is familiar: It calls to mind the explanation of memory given in Chapter 1. The latter formulation is, of course, based on recent research and current theories, but it is clearly anticipated in Alhazen's observations. Like many of his modern counterparts, Alhazen regards perception as a successive operation, a process that occurs in stages: Vision in his view (a view shared by Ghiberti) depends as much on the functioning of the mind as it does upon pure sensation, that is, light and color per se; moreover, such perception requires a tangible or perceptible amount of time, no matter how rapidly the light is physically transmitted to the eye or how ideal the viewing conditions are. Such a conception does not lend itself very well to the creation of instantaneous images.

BEAUTY AND OTHER PROPERTIES

Elsewhere in the *Third Commentary* Ghiberti includes discussions (again drawn from Alhazen, for the most part) on how some specific prop-

erties or *intentioni* are perceived; many of these discussions are espe-
cially revealing as to the complexity of vision and the amount of time
it involves. Magnitude or size (*magnatudine*) is a good case in point. An
object's size, Ghiberti argues, cannot be determined by the visual angle
alone (Euclid's Eighth Theorem, the "Angle Axiom," notwithstanding);
distance too, the distance between the eye and the center of the ob-
ject, must be taken into account.[22] The distance, in turn, can only be
determined in relation to a series of intervening bodies or spaces, such
as the ground leading from the eye to the object under consideration,
and must be measured by a known standard, such as the height of a
person or the length of a foot.[23] Moreover, the exact position of the
object also must be ascertained, that is, whether the object is diamet-
rically opposed to the eye (perpendicular, if you will, to the centric
ray) or positioned obliquely (which could lead to errors in judgment
concerning size).[24]

Judgments thus must be made concerning a variety of factors before
the size of any given object, or the size of one object in relation to an-
other, can be accurately perceived in a process that requires the close
cooperation of the eye and the mind, as well as an adequate amount of
time. And the perception of other properties, of motion (*remotione*), for
example, likewise involves intellectual judgments as much as it does
raw or pure sensory data. Indeed, motion is perceived, according to Al-
hazen and Ghiberti, only when we recognize that an object has shifted
position in relation to other stationary objects or itself (assuming that
the viewer's position remains unchanged): Motion is considered to
have occurred when we perceive the moving object in a position or
place that can be distinguished from its former position. And such
changes of place, of course, imply the passage of time. "Let us say
then," Ghiberti writes, "that vision comprehends movement by per-
ceiving the moving visual object in two different positions, in two dif-
ferent moments between which is a perceptible amount of time."[25]

Time must also pass in order for us to understand that an object
has *not* in fact moved: "But rest is recognized only by observing the
visual object in the same place for a perceptible amount of time, only
when the object is in the same position at two different moments
between which there is a perceptible amount of time."[26] In other

words, even objects at rest can be perceived as such only over a long enough time to allow us to recognize that time has indeed passed; an immediate or instantaneous impression of the optic array is obviously not sufficient. And in this case especially, in the perception of rest, as well as in the perception of motion, a distinction arises between the reception of color and light per se and vision in a fuller sense, a distinction not altogether lost on Alberti, as we shall see.

The complexity of vision is all the more evident when it comes to the perception of still another *intentione*, namely, beauty (*pulchritudine*). Beauty, according to Alhazen (on whom Ghiberti continues to rely), depends most of all on the proportionality between an object's components, between its different aspects or parts, and the proportionality between those parts and the object as a whole (as between individual facial features, for example, and an entire face). To perceive such proportional relationships requires an intricate comparison of the relevant components in terms of their specific properties: shape, size, position, and the like. As Alhazen says: "And if one considers the beautiful properties, which are made up of individual properties joined together, one will find that the beauty which appears as a result of their conjunction would not appear if not for the proportionality of these conjunctions joined together among one another."[27]

Beauty, therefore, is perceived neither directly nor immediately, independent of other individual properties. Rather, its perfection arises from the proportional relations or consonances that are perceived between distinct characteristics (the perception of which may itself involve more than one operation).[28] Pure sensation, then, is only a starting point for a complicated process of comparison in which the *virtù distinctiva*, the distinguishing faculty, must sort out numerous bits of data and make a variety of judgments over a considerable amount of time. To be recognized as beautiful, an object first must be seen as a whole *per aspectus* (and recognized immediately or not as the case may be), and then every property it possesses must be analyzed individually and in detail. Only then is it possible to make the necessary comparisons by which it is determined that the relevant properties are harmonious, are truly beautiful or not.[29] Clearly, such an elaborate process can occur only over a perceptible amount of time.

Alhazen's emphasis on harmonious proportions as an important determinant of beauty was surely congenial to artists of the quattrocento, as Vescovini has suggested, and we will return to this question a little further on, in relation to Leonardo.[30] But for now it is important to stress the active sort of perception Alhazen's discussion presupposes, both in this case and in relation to the perception of size and movement; all of these examples indicate the intricacies of the process Alhazen describes. For Alhazen (and presumably for Ghiberti as well), visual perception demands the active participation of the mind; indeed, vision involves making judgments about a whole range of properties. Some of these properties, like beauty, are of considerable complexity themselves, and rest on the perception of equally complicated properties. In virtually every instance, for nearly every visual object or field, numerous factors must be evaluated in detail and in succession, individually and in combination, until a true, composite picture is created in the mind's eye, so to speak.[31] And even though light is transmitted to the eye very rapidly, if not instantaneously, visual perception in the true sense of the term takes somewhat longer, a perceptible amount of time in fact. The pattern of color and light given by the intersection of the visual pyramid – the optic array – is only the raw material for a more extended, contemplative kind of perception, comparable to gazing through a window.[32]

THE BARREL OF A GUN

Against the background of Alhazen's ideas on visual perception let us turn now to Alberti. Alberti too outlines a theory of vision in which the passage of time is taken for granted and that he likens to the act of painting (although not specifically with perspective). In the threefold process Alberti describes, we can perhaps hear echoes of Alhazen or the later perspectivists, despite the rhetorical language:

As painting aims to represent things seen, let us note how in fact things are seen. In the first place, when we look at a thing, we see it as an object which occupies a space. The painter will draw around this space, and he will call

this process of sketching the outline, appropriately, circumscription [*circum-scriptionem*]. Then, as we look, we discern how the several surfaces of the object seen are fitted together; the artist, when drawing these combinations of sur-faces in their correct relationship, will properly call this composition [*com-positionem*]. Finally, in looking we observe more clearly the colours of surfaces; the representation in painting of this aspect, since it receives all its variations from light, will aptly here be termed the reception of light [*receptio luminum*].[33]

A clear progression from the general to the particular is indicated here: Vision, like painting, takes place in successive stages, over time, beginning with an overall impression of an object as a whole, defined by means of an outline (*circumscription*), which is then followed by pro-gressively more detailed observations of the object's component parts, its coloring and other qualities (*composition and reception of light*).[34] In other words, for Alberti the passing of time during the course of visual perception yields increasingly detailed and certain – we could also say certified – results, as had been true as well, of course, for Alhazen and Ghiberti.

Leonardo, perhaps even more than Alberti, was familiar with the ideas of vision that stemmed from Alhazen and, more specifically, accepted the notion of certification.[35] One long passage from the *Codex Atlanticus*, for example, an early fragment (ca. 1479–80) with the head-ing "In What Way the Eye Sees Objects Placed in Front of It," and an accompanying diagram (Fig. 10) make little sense unless understood in terms of the certification of sight:

Supposing that the ball figured above [Fig. 10] is the ball of the eye and let the small portion of the ball which is cut off by the line *st* be the light and all the objects mirrored on the centre of the face of the said light, pass on at once and enter the pupils, passing through a crystalline humour, which does not interfere in the pupil with the things seen by means of the light. And the pupil having received the objects, by means of the light, immediately refers them and transmits them to the intellect by the line *ab*. And you must know that the pupil transmits nothing perfectly to the intellect or common sense, excepting when the objects presented to it by means of light reach it by the line *ab*; as, for instance, by the line *ca*. For although the lines *mn* and *fg* may be seen by the pupil they are not perfectly taken in, because they do not coincide with the line *ab*. And the proof is this: If the eye, shown above, wants to count the letters placed in front, the eye will be obliged to turn

Figure 10. After Leonardo da Vinci, diagram of the visual pyramid from *Codex Atlanticus* (Milan, Biblioteca Ambrosiana). Redrawn by Richard Shipp.

from letter to letter, because it cannot discern them unless they lie in the line *ab*; as the line *ac* does.[36]

In Leonardo's demonstration, *g*, *f*, *n*, and *m*, which are spread out along the base of the visual pyramid, are all transmitted to the eye and "received by the pupil" (*popilla*), but they are perceived less perfectly than *c* at the center; they cannot be discerned very clearly at all unless the centric line passes over them, certifying each individual point in turn. And that is exactly the sort of operation that Alhazen described and that requires a perceptible amount of time, as we have already seen.

On another sheet (undated) in the *Codex Atlanticus* we find a related passage built on similar optical principles. Leonardo again stresses the key role of the perpendicular axis, and he then essentially describes the certification of sight, this time using hunting imagery:

Now the objects which are over against the eyes act with the rays of their images after the manner of many archers who wish to shoot through the bore of a carbine, for the one among them who finds himself in a straight line with the direction of the bore of the carbine will be most likely to touch the bottom of this bore with his arrow; so the objects opposite to the eye will be more transferred to the sense when they are more in the line of the transfixing nerve.

That water which is in the light that surrounds the black centre of the eye serves the same purpose as the hounds in the chase, for these are used to start the quarry and then the hunters capture it. So also with this, because it is a humour that derives from the power of the imprensiva and sees many

58

things without seizing hold of them, but suddenly turns thither the central beam which proceeds along the line to the sense, and this seizes on the images and confines such as please it within the prison of the memory.[37]

Initially then, we see many things without seizing hold of them; vision thus begins with a vague general impression, which Leonardo likens to the beginning of a hunt, when the hounds "start the quarry." And afterwards follows a more detailed examination or investigation of the visual field, as the hounds close in on their prey; the central beam must be turned on each element in the field in succession in order to capture their essential features accurately and in detail, while the total picture presumably remains somehow in view, in the imagination or the common sense. The most pleasing or interesting images, once assembled and evaluated, are then passed on to the memory for long-term storage.[38] No matter how rapidly light is transmitted to the eye (an issue on which Leonardo offers no judgment), Leonardo clearly regards visual perception as a protracted, dynamic process, as it had been for Alberti and Ghiberti.

ACTIVITY

We should keep in mind that Leonardo never specifically invokes Alhazen's theories when explaining one-point perspective, nor does Alberti. Similarly, Ghiberti never links linear perspective to the optical theories he so assiduously transcribes (although that may indeed have been his true purpose).[39] But if the complexities of vision that Alhazen and his followers describe are embedded in the visual pyramid (as all three artist-writers would have agreed was the case), then the same dynamism must be inherent in the cross section or *taglio* as well, even if the *costruzione legittima* was generally explained in purely geometrical, and hence timeless, or static, terms.

Under the ground rules established by Alhazen, an abrupt slice through the visual pyramid, that is, a cross section that was either instantaneous or static, would lead to an altogether unsatisfactory result, as incomplete as it was rapid. Such a cross section would represent

only uncertified vision, vision *per aspectus*, an incomplete and vague impression, hazy everywhere but at the very center, much like a vignetted photograph. To be legible, the cross section, that is to say, the picture, must somehow also incorporate certified vision. Such vision cannot be reduced to a momentary pattern of color and light, to pure sensation, or to an optical array properly understood, as we have already seen; the passing of time – a perceptible amount of time – cannot therefore be excluded from such pictures, no matter how unified they may be in terms of space, even if they represent a view from a fixed position, a particular place, or a single glance.

In the context of Alhazen's theories we are given little reason to suppose that when explaining the underpinnings of perspective either Alberti or Leonardo was ever concerned with a precise, point-by-point transcription of the optical array at any one specific moment, that is, that the *taglio* should represent an exactly instantaneous or simultaneous configuration of color and light. Like Alberti, Leonardo recognized the distinction that we have already found in Ghiberti, and that derives from Alhazen, between pure sensation or the behavior of light in a strictly mechanical sense, and the broader concept of visual perception. Whereas perspective can be justified or explained in terms of pure sensation, the true concern of painting, as Alberti and Leonardo both describe it, is with visual perception, with perception understood as an extended process, or, to appropriate the terminology of noted psychologist J. J. Gibson, as an activity rather than an instantaneous event.[40]

SIMPLER COMPLETENESS

THOU still unravish'd bride of quietness,
 Thou foster-child of silence and slow time,
Sylvan historian, who canst thus express
 A flowery tale more sweetly than our rhyme:
What leaf-fring'd legend haunts about thy shape
 Of deities or mortals, or of both,
 In Tempe or the dales of Arcady?
What men or gods are these? What maidens loth?
 What mad pursuit? What struggles to escape?
 What pipes and timbrels? What wild ecstacy?

JOHN KEATS[1]

"I'm as sharp," said Quilp to him, at parting, "as sharp as a ferret, and as cunning as a weazel. You bring Trent to me; assure him that I'm his friend though I fear he a little distrusts me (I don't know why, I have not deserved it); and you've both made your fortunes – in perspective."

"That's the worst of it," returned Dick. "These fortunes in perspective look such a long way off."

CHARLES DICKENS[2]

IF SOME OF LEONARDO'S OBSERVATIONS signal an awareness or acceptance of the same fluid notion of vision and perspective that we find in the works of Alberti and Ghiberti (a view according to which temporal succession is inherent in the visual pyramid and its intersection), the argument Leonardo presents in his well-known *paragone*, a comparison between painting and other art forms, appears to lead in the opposite direction, toward a conception of painting in which passing time has no place. In these remarks, contained in the so-called *Treatise on Painting* (the *Trattato della pittura*), a collection of Leonardo's notes assembled after his death by his student Francesco Melzi, Leonardo argues for the superiority of painting over poetry as well as over

music and sculpture.[3] One of painting's principal advantages, it seems, is that pictures or painted figures and forms can be understood – taken in, as it were – all at once, in *uno medesimo tempo* or in *un' subito*. More than once Leonardo asserts how painting is to be preferred over poetry because of the harmonies that result when various parts of a figure or scene are perceived at the same time, whereas poetry, on the contrary, is less efficient and more tedious. In one such passage, for example, he states:

Painting presents its essence to you, through the visual power and the means by which the *imprensiva* receives natural objects, in an instant [*in un' subito*] and also in the same amount of time in which the harmonious proportionality of parts, which makes up the whole and pleases the senses, is composed. And poetry does the same but with a means less worthy than the eye; it carries the shape of the aforementioned objects to the *imprensiva* with greater confusion and more delay than does the eye.[4]

Painted figures or scenes, in other words, can be perceived very quickly, in a moment (*un' subito*), just as objects in nature can be, whereas poetry requires a greater amount of time to describe the same thing, which Leonardo regards as a decided disadvantage (for reasons that will be explained more fully a little further on). Statements of this kind certainly seem to be at odds with an unqualified acceptance of continuous narrative, or of a conception of painting in which the passing of time can be expressed within a single picture or frame. Indeed, Leonardo's remarks have sometimes been interpreted as paving the way for Lessing's celebrated distinction between the spatial art of painting and the temporal art of poetry, a dichotomy that dealt a theoretical deathblow to continuous narrative, as we have already seen.[5]

The momentary or instantaneous character of painting, as Leonardo seems to conceive of it, becomes even more evident when described in musical terms; in many instances Leonardo invokes music to explain the advantages of painting over poetry (although maintaining music's inferiority to painting). And once again a key point of comparison is time; the two arts can presumably be equated because in both cases harmonious relationships, be they between notes or between forms,

are perceived all at once, or simultaneously. In other words, visual harmonies can be likened to chords, the vertical or harmonic relations between musical tones sounded together (and lasting only briefly), the enjoyment of which depends on their conjunction, that is, on their simultaneity.[6] The fluidity and successiveness of Alhazen's optics would be hard to reconcile with such a conception.

A TIME

It is precisely the analogy between painting and music that allows us to reach a somewhat different – even opposite – conclusion. Although music often involves a number of voices acting together and so relies on simultaneous effects or harmonies, it is also quite obviously a temporal art. By drawing music into his argument, Leonardo ultimately brings out the successive character of painting rather than the instantaneous aspects of either art. For Leonardo, both painting and music can be considered in measured sections or units rather than indivisible instants. Musical harmonies, like music itself, reveal themselves over time, horizontally, so to speak, more than vertically, as our discussion of Ghiberti and Alhazen might lead us to expect.

The possibility of a more fluid, temporal conception begins to emerge in a passage drawn from the *paragone* in which Leonardo compares musical harmony to the outline or contour of a visual form:

Music is not to be called anything other than the sister of painting for it depends on hearing, a sense second only to vision, and creates harmony through the conjunction of its proportional parts during the same span of time [*nel medesimo tempo*], being constrained as it is to come about and die in one or more harmonic times [*tempi armonici*], times which surround the proportionality of their members so that the resulting harmony is not otherwise composed than as a line, defining the member, by which beauty is generated.[7]

On first reading, the statement is rather bewildering. Although Leonardo speaks of harmony (*armonia*) and harmonic or musical times (*tempi armonici*) it is difficult to know exactly which specific aspect of music he is referring to here; the word "time" in this context is espe-

63

cially unclear.[8] But some of the uncertainty can perhaps be resolved by looking at Renaissance musical practice. In the musical terminology of Leonardo's day, as we find it, for example, in the texts of Leonardo's contemporary at the court of Milan, the musician Franchino Gaffurio, a time, or *tempus*, had a specific technical meaning that is of considerable importance for our purposes. The term referred in fact to the duration of one kind of note in relation to another, or more specifically, to the subdivisions of a breve into smaller units: either two or three semibreves (*tempus imperfectus* or *tempus perfectus*), which can themselves be subdivided into minims, semiminims, and so on. Although there is no precise modern equivalent, a *tempus* is roughly comparable to a current-day measure, but without the regularity of accent that such a convention implies; barlines did not as yet exist.[9]

A *tempus*, in other words, is a unit of musical time of relatively brief but definite duration, which can include only one note, a relatively sustained breve (now generally transcribed as either a half note or a dotted half note), or numerous notes of values less than a breve. A single *time*, then, can conceivably contain as many as nine minims, for example, and as many harmonic changes, even if only fleeting ones. And succession is therefore implicit in even one such *time*, however brief; each of these musical units can include a succession of individual notes or "chords," as voices move along from one note to the next, from semibreve to semibreve or minim to minim.

Augusto Marinoni has shown that Leonardo also used a "tempo armonico" as a standard of measurement when he conducted scientific experiments of various kinds. For much of his life, in measuring such things as velocity, Leonardo used a "tempo armonico" as a unit of time roughly equivalent to 3.33 seconds; after 1508 he apparently modified his methods and standards, and, if Marinoni's calculations are correct, Leonardo's "tempo armonico" then became the equivalent of 1.2 seconds. In either case, Leonardo had in mind a span of time of specific and perceptible duration. It should also be noted that in the many passages cited by Marinoni the terms "tempo," "tempo armonico," and "tempo musicale" are used almost interchangeably.[10]

The meaning of Leonardo's remarks now becomes clearer. When he speaks of music as a series of *tempi armonici*, as coming to life and

dying away in one or more harmonic times, he is not speaking of *tempo* in the modern sense, nor yet of harmonic rhythms (i.e., the rate of harmonic change) as has also been proposed, but rather of a progression of metrical units or small sections, each of which can include numerous tones and harmonies. And when he speaks of the harmony that results when different notes or parts, in proportion one to another, are joined together in *uno medesimo tempo* (in the same time), Leonardo is similarly, in all likelihood, speaking of a span of time, of a musical continuum like a line in which the proportional relationships between distinct tones or combinations of tones (either consonances or dissonances) can make themselves felt. This is hardly surprising given the polyphonic context in which Leonardo's remarks must of course be understood and interpreted, a context in which vertical relations are subservient to the horizontal development of interwoven melodies.[11]

THE SPACE OF TIME

In the *paragone* itself, Leonardo provides few additional comments (beyond those in the passage we have been discussing) as to how proportional relationships between one note and another might be formed or how such harmonies might be perceived. But elsewhere, on a sheet in the *Codex Atlanticus*, he does describe the workings of these linear relationships in greater detail; he explains quite specifically how musical harmony can come about between two distinct notes, one sounded after the other:

Every impression is held for some time in the appropriate sensitive organ . . . like the tones in the ear, which if it did not hold the impressions of tones, would never perceive the gracefulness of a single voice; when the first tone jumps to the fifth, the two tones are heard as if in one time, and the true consonance that exists between the first and the fifth is therefore heard; and if the impression of the first did not remain in the ear for some space [of time], the fifth which immediately follows the first would seem isolated, and one tone [by itself] cannot create consonance.[12]

According to Leonardo, a musical line (or several lines together) can only have grace, indeed make sense at all, when successive notes are understood in relation to one another. Each note is held in the mind (in the short-term memory) long enough for this to happen; otherwise, the harmonious proportions between each indivisible unit would be lost (as we began to see in the discussion of memory and mnemonic systems in Chapter 1). In other words, two notes, one following on the heels of another, are heard both alone and together in the same span of time, *nel medesimo tempo*: They must blend together at least to the extent that the mathematical interval between them becomes evident. The two notes in effect become continuous, even if they in fact are not.

Leonardo likens this phenomenon, this sort of linear continuity, to the impression that moving objects make on the eye, to the way raindrops look, for example, as they descend from the clouds. A raindrop as it falls appears to be a line that represents, in effect, the movement of that drop of water from one place to another (as well as the amount of time needed for such movement to take place).[13] In the same way, musical notes, although not actually moving, extend themselves into a melody or line on the basis of which proportional relationships can be established between them (as we have already seen). Painting too operates in this fashion. Like a musical line, a graphic or geometric line must be regarded as a continuum – as a collection or succession of individual points representing the transit of a single point along a particular course in a given "space of time." As Leonardo himself suggests:

the point may be compared to an instant of time, and the line may be likened to the length of a certain quantity of time, and just as a line begins and terminates in a point, so such a space of time begins and terminates in an instant. And whereas a line is infinitely divisible, the divisibility of a space of time is of the same nature; and as the divisions of the line may bear a certain proportion to each other, so may the divisions of time.[14]

A simple line, then, virtually by definition is a representation of passing time, and it is on the basis of such a conception that Leonardo

can make his comparison between painting and music. Because the passing of time is apparently inherent in the contours of painted forms and figures (as it is in the imaginary lines formed by falling rain), these lines may be considered comparable to musical ones, or to music in general, which also develop over time. Just as individual notes (or chords) can be "added" together horizontally to create harmonious effects, painted lines define the forms "by which human beauty is generated." Visual beauty, like musical harmony, is revealed by means of proportional relationships (proportions such as might exist between one part of a face and another). Alhazen tells us that ratios of this kind can be perceived only over time. Leonardo, like Ghiberti, apparently agreed with him.[15]

CONTINUITY AND DISCONTINUITY

Turning back to the *paragone*, we can now distinguish more precisely between painting and music on the one hand, and poetry on the other. The distinction is not so much one between spatial arts and temporal arts, because time, after all, plays a role in all three cases. Instead, Leonardo sets poetry apart from painting and music on the basis of its relative inability to convey harmonious proportions, proportions, it is important to remember, on which beauty depends. As Leonardo explains:

But if poetry were to attempt the depiction of a perfect beauty by means of a detailed representation of every part which in painting comprises the aforementioned harmony, no other gracefulness would result than that which occurs in music when one is made to listen to each tone by itself in different times, from which no harmoniousness [*concento*] can come about, just as if one were to look at a face piece by piece, always covering over that which had just been shown, from which indications forgetfulness would prevent the composition of any proportionality of harmony, because the eye cannot embrace them all with its visual power in the same [span of] time [*à un medesimo tempo*]. A similar thing happens to the beauty of anything depicted by the

poet; because the parts are described separately in separate times memory cannot perceive any harmony in them.[16]

Leonardo's comparison here turns very specifically on the representation of beauty. In poetry the beauty of that which is described (as opposed to the beauty of the poem itself, to the harmonious relations between words and lines, which Leonardo conveniently ignores) is disclosed in discrete, discontinuous units; each piece of a given object or figure, as it might be described in words at least, is disconnected from all of the other pieces.[17] Leonardo likens the situation to looking at the individual parts of a face out of context, as if with blinders on: The adjoining features remain completely out of view, and no single one of them can be contemplated in relation to any of the others. As a result, the sort of harmonious proportions that might give rise to an impression of beauty can be neither conveyed nor experienced.[18]

The main reason for the relative discontinuity or disconnectedness of verbal descriptions as opposed to painted ones, of course, has to do with the amount of time required from the audience in each case (in other words, with the capacity of short-term memory). In Leonardo's view, a written description takes so long to unfold (whether read aloud or not) that the relationships between the various components of what is being described, and hence the harmonious proportions that might be between them, cease to be apparent. Each individual facial feature, to continue with Leonardo's example, must be considered in a separate, discontinuous span of time and therefore cannot be evaluated together with any other feature or with the face as a whole. For example, by the time the poet were to describe the mouth, the audience would have already forgotten what had been said of the nose or the brow.

In painting, on the other hand, the time required to inspect or to experience the same thing is much shorter. Each span of time is short enough so that the subdivisions or pieces of what is being represented can be juxtaposed or integrated in the mind with ease. The harmonious proportions that must exist if a figure or object is to be considered beautiful, therefore, can also be perceived quite readily, just as they can be in music. Taken to an extreme, the decided efficiency of

painting in this regard can lead to the sort of arguments put forward by Shaftesbury and Lessing, to the absolute elimination of passing time from the plastic arts. But, for Leonardo the immediacy or apparent speed with which painting conveys the beauty of a face or a figure is relative. The art of painting communicates beauty more swiftly than does poetry, but not necessarily simultaneously nor yet instantaneously. In painting as in nature (and in music as well), the recognition and enjoyment of beauty requires a perceptible amount of time.

CONTENT AND FORM

In the course of the *paragone*, Leonardo draws a distinction between *invenzione* and *misure*, "invention as regards the subject matter which he [the painter] has to represent and measure in the objects which he paints so that they should not be disproportioned."[19] Quite simply, Leonardo calls attention to the dichotomy between content and form.[20] The remarks on painting in the *paragone* with which we have been concerned thus far have been devoted to the latter, to primarily formal issues; Leonardo was largely interested in how quickly beauty is perceived – in painting as well as in poetry. But the content or subject matter, the events or actions represented in a work of art, must also be considered.

In only one passage does Leonardo compare painting and poetry in terms of their respective ability to tell a story:

And if you, oh poet, tell a story with your pen, the painter with his brush can tell it more easily, with simpler completeness, and so that it is less tedious to follow [. . . *di più facile sottisfazione et meno tediosa ad essere compresa*].[21]

And it comes as no surprise to find that even in regard to storytelling Leonardo believes painting to be more effective than poetry: Less effort and less time are needed to comprehend and appreciate a painted narrative than a written one. Nevertheless, at no point does Leonardo specify or intimate that the simple completeness of which he speaks is the result of a radical abridgment of the story; he does not suggest that painting limit itself, in contrast to poetry, to the representation

of a single moment in order to achieve the desired result. Moreover, Leonardo's observation could well apply to a continuous narrative.

As we know, Leonardo had once recommended the use of continuous narrative quite specifically. In a manuscript from the early 1490s he had raised the possibility of representing a number of incidents from the life of a saint within the same, unified picture:

and if you should say: In what way am I to represent the life of a saint divided into several pictures [molte storie] on one and the same wall, I answer that you must set out the foreground with its point of sight on a level with the eye of the spectators of the scene, and upon this plane represent the more important part of the story and then, diminishing by degrees the figures, and the buildings on various hills and open spaces, you can represent all the events of the history.[22]

As Gombrich has shown, Leonardo's comments here were intended as an antidote to a specific problem. They offer an alternative to the then standard form of fresco decoration in which the wall of a chapel, for example, or of any comparable painted surface, would be divided into individual scenes on different levels, each scene having its own vanishing point (or points) and its own horizon. In Leonardo's view such schemes were completely illogical, most of all because the ground plane and buildings in the higher frescoes would be above the sky in the lower ones; thus the illusion of space created in any one of these pictures would be contradicted or canceled by others on the same wall.[23]

Piero's Cycle of the True Cross in Arezzo and Lippi's frescoes for the cathedral of Prato are both indicative of the approach to which Leonardo objected; a later, more extreme example, combining many more scenes, would be the elaborate set of frescoes by Gaudenzio Ferrari on the tramezzo in the church of Santa Maria delle Grazie in Varallo (Fig. 11), painted in 1513.[24] Gaudenzio presents his extensive narrative, ranging from the Annunciation to the Resurrection, as a series of small monoscenic images in three tiers surrounding a larger central representation of the Crucifixion. The wall thus is broken up into numerous separate units, each evoking its own illusion of space, like so many boxes stacked together. Indeed, Leonardo had once lik-

ened just such an arrangement to a shop in which the wares are displayed in little rectangular cubbyholes ("casette fatte à quadretti").[25]

Leonardo clearly preferred a different approach. He insisted that there be nothing to contradict the illusion that one fictive space existed beyond the painted surface as a whole, that each wall, in other words, present a unified illusion of space. To preserve this illusion – to safeguard the integrity of the overall effect – Leonardo deemed it advisable that as many episodes as the subject required be included within the same picture; numerous incidents or moments would be depicted in a single space, with the main character, a saint in Leonardo's hypothetical example, presumably appearing more than once. In this way the wall would not need to be broken up into potentially contradictory scenes, and the spatial illusion would remain intact. A continuous narrative, in short, was preferable, as far as Leonardo was concerned, to a number of monoscenic representations grouped together on the same wall.[26]

LUINI'S FRESCO

As Gombrich has suggested, a fresco that seems to satisfy most of Leonardo's requirements is the Crucifixion in the church of Santa Maria degli Angeli in Lugano (Fig. 12), painted about 1530 by Bernardino Luini (one of Leonardo's followers). The wall surface in this example is roughly comparable to Gaudenzio's Varallo fresco; here too we are dealing with a *tramezzo* on which many incidents are represented and as before the main emphasis is on the Crucifixion. Otherwise, however, Luini's approach is fundamentally different: Instead of dividing the narrative into separate compartments as Gaudenzio had done, Luini presents all of the action within a single picture that takes up the entire wall. In the foreground is the Crucifixion proper, large and dominant as Leonardo had recommended, and behind the three crosses is the rest of the story, suitably diminished in scale (as Leonardo would have wished). To the left of the central cross are events leading up to the Crucifixion and to the right are events that follow it, culminating in the Resurrection. And despite the presence of nu-

Figure 11 (opposite page and left). Gaudenzio Ferrari, *Scenes from the Life of Christ*. Varallo, Santa Maria delle Grazie. Courtesy of Alinari/Art Resource, NY.

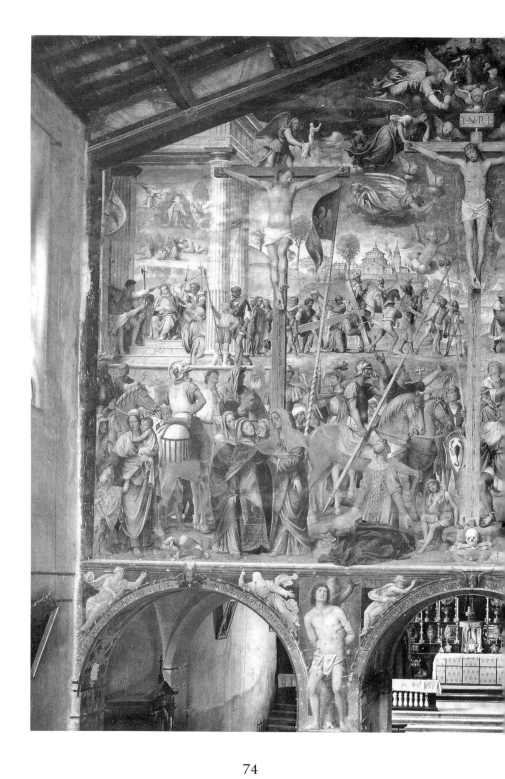

74

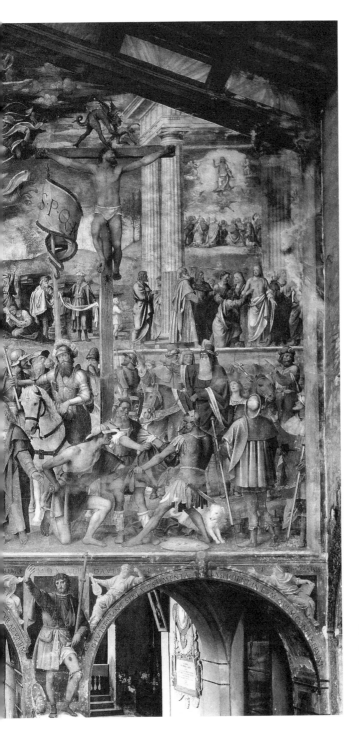

Figure 12 (opposite page and left). Bernardino Luini, *Crucifixion.* Lugano, Santa Maria degli Angeli. Courtesy of Alinari/Art Resource, NY.

merous individual scenes, nothing here immediately interferes with the impression that an imaginary space lies behind and beyond the surface of the wall; the same cannot be said of the fresco in Varallo.[27]

It is important to note that the space in Luini's fresco is represented as if it were seen from a single position. The space is organized, that is to say, around one central point, even if that point is above the height of an ordinary viewer (about halfway up the main cross). Leonardo, it seems, would have preferred this point to be lower; he advises that the *punto* be on a level with the eye of the spectator ("a l'ochio del riguardatore della storia"), a standard that he himself did not always uphold. Nevertheless, in describing his hypothetical continuous narrative, Leonardo envisioned a picture with a single vanishing point: The main scene is to be structured in relation to that one point and everything else diminished accordingly.

The kind of setting Leonardo had in mind was not as consolidated, perhaps, as the spaces in some of the pictures we have discussed. It was less unified, no doubt, than Lippi's *Banquet of Herod*, for example, or Leonardo's own *Last Supper*. Indeed, Leonardo speaks of buildings, of various hills, and of open places – a rather expansive scene not unlike that in Luini's fresco. We cannot be sure, however, whether he is describing one place in the strictest sense or several. In any case, the underlying unity of the space does not impose stringent limits on the amount of time that is presumed to pass: The life of a saint, as Leonardo suggests, can be readily accommodated.

In the *paragone*, as we have already seen, Leonardo stresses the brevity of viewing time: A painted narrative, he argues, is perceived in less time, and thus is less tedious, than a written account of the same set of events or actions would be. Here, in acknowledging the usefulness of the continuous method, Leonardo is concerned with a different issue, with the imaginary world that the painting evokes on the other side, as it were, of the painted surface. And in this illusory space, however unified or expansive it may be, time is permitted to flow in accordance with the demands of the subject, regardless of how quickly the spectator, standing in front of the picture, can follow the narrative and understand its meaning.

CHAPTER FIVE

POSITION AND MEANING IN CONTINUOUS NARRATION

As for disposition, it is necessary that the artist move from section to section following the course of time in the narrative he has undertaken to paint, and do so with such propriety that the spectators judge that this affair could not have taken place in any other way than the one he depicted. He should not place later in time what ought to come earlier, nor earlier what should come later, but lay things out in a most ordered fashion, according to the way in which they succeeded one another.

LUDOVICO DOLCE[1]

It is true that Giulio Romano, having to represent the same story [Apollo and Daphne], did not unify it but divided it instead, and included two separate actions in the same picture. In the foreground he represented Daphne fleeing, pursued by Apollo; in the background he represented Daphne again, who is transformed into leafy branches, in the arms of her avid lover. Giulio was very learned and he was guided in this by the painters of Antiquity who sometimes did the same thing, dividing their subjects into various scenes in the same story, as in the examples which have come down to us in the descriptions of Philostratus, and more recently in the Psyche by Raphael. These wise masters were careful, however, when adding scenes, to keep the main one in first place, with the largest-sized figures, while making the rest diminish in the distance in such a way that they would only accent the subject, but not determine it.

GIOVANNI PIETRO BELLORI[2]

RECENT DISCUSSIONS OF LITERARY NARRATIVES often draw a distinction between the order of occurrence (story-time order) and the order of telling (discourse-time order), that is, a distinction between the standard or chronological order of events, and the way

those events are actually presented, which can be altogether different.[3] The same basic sequence can be presented starting at the end or in the middle, or as a series of flashbacks, to name only some of the countless possibilities. By altering the sequence of events these incidents acquire new meanings, both in relation to each other and when set against their original order.[4]

A number of critics have gone on to assert that this fundamental distinction is an essential condition of narrative itself, no matter what story is involved and no matter which medium. For a narrative to be considered as such, many would argue, it must be structured in this two-tiered way, having what has sometimes been called a "double-time ordering."[5] This conception would seem to be especially applicable to continuous narratives, in which, unlike in other kinds of visual imagery, the passage of time is made explicit, and more than one moment or episode is presented.

Important questions, however, immediately arise: On what basis do we distinguish one sequence from another, or one order from the next? Is it really possible when analyzing pictures and reliefs in which more than one scene is shown to speak of an ordering of events that is distinct from the story itself, especially given that the narrative action is seen and not told? For this to be the case there must be established conventions for viewing images – a reading order that is standard and fixed. It must be so standard that any variation can be immediately understood or recognized as such, at least within a particular culture or a specific historical period. In other words, there must be some reliable counterpart to the order determined by reading a book in the customary way, word by word and line by line, from the first page to the last, over time. Only then can we judge whether an image deviates from the normal sequence of events or speak of double-time ordering in a meaningful way.[6]

Such a standard has proven elusive. Although some preference for reading images from left to right and from top to bottom has been noted in Western imagery, perhaps following linguistic conventions, the viewing process is neither invariable nor inevitable, and the exceptions are so numerous, especially among the continuous narratives of the Renaissance, as to call the rule itself into question.[7] Numerous

examples read right to left, rather than the other way around, or in a combination of directions that defies easy categorization. Moreover, these arrangements are often the result of an interconnected set of iconographic or formal considerations arising from a larger overall context, from the chapel or the cycle as a whole, in which left-to-right norms are frequently overridden or ignored.[8] Without a trustworthy measure, we cannot easily determine whether the chronological facts of the story have been rearranged or not, and under such circumstances it is extremely difficult effectively to disentangle the order of occurrence from the order of telling or presentation.

SURFACE AND DEPTH

If double-time ordering as a critical construct is not altogether applicable to narrative imagery – however useful it may be in other contexts – continuous narrative can nevertheless be discussed in ways that go beyond the basic chain of events; the story itself can still be distinguished from the manner of presentation, or from the discourse. To do so, however, we must approach the problem from a different direction, in a more specifically visual way: We must first of all take the pictorial space more fully and directly into consideration and then, instead of distinguishing one temporal progression from another, think more in terms of an interplay or exchange between two and three dimensions, between the two-dimensional design and the illusion it creates.

Although in a great number of Renaissance narratives the action unfolds laterally across the length of the picture, either left to right or the other way around, in numerous pictures the setting and space are exploited more fully: The story unfolds not only from side to side but also in and out of depth, sometimes following a fairly circuitous path through the picture. The figures seem to move from one position to the next, from place to place, as if they were on a stage, and the order of occurrence cannot be understood apart from the space or setting in which it takes place.

Other aspects of the narrative, however, become apparent only

when the image is considered in more formal terms, as a series of two-dimensional relationships. Episodes greatly separated from one another in space, and remote in time, come together on the surface of the image: They coexist in the picture plane and establish formal connections that become an important means of enriching the narrative. Indeed, such juxtapositions often disclose what the action itself, or the ordering of events, does not.[9]

To be sure, we are speaking here of two aspects of the same experience, of complementary perceptions that are not easily separable: The picture plane generally remains in view even as we are drawn into the illusion of depth, and we must constantly balance our awareness of the former with our impression of the latter. Nevertheless, a distinction between spatial effects and surface relationships provides a useful way of understanding continuous narration; it enables us to discern a broad range of meanings, literal or otherwise, as we see when we turn to Masaccio's *Tribute Money* (Fig. 2), an early example of Renaissance space and a powerful visual narrative.

Masaccio's fresco introduces us to a pattern that is surprisingly common in quattrocento narrative painting. Instead of starting at one side or the other, the action here begins at the center, in the middle ground, with the encounter between the tax collector and Christ and his Apostles. It continues at the left, further back in space, as Peter, following Christ's instructions, obtains the needed money from the mouth of a fish. The story then concludes at the right, as Peter hands the money over to the tax collector, who, while Peter was busy at the left, had moved from the center to the right. We may speak of several things going on at once: One character moves one way while another heads in a different direction; the figures crisscross through the image, as the narrative flows from the center toward the left, into the distance, and then back across, to the final scene on the right in the foreground.[10]

This carefully orchestrated – almost contrapuntal – set of movements is conceivable only if we imagine the figures moving through space, with room to shift about in various directions, from one position in depth to another. If the space is disregarded or undermined in some

way, the progression makes little sense, especially because Peter's path from the left to the far right is blocked by the opening scene in the center. Indeed, the organization of Masaccio's picture is sometimes described as disjointed or atemporal.[11] But when it is understood in three dimensions, nothing stands in the way of a smooth transition from one episode to the next: Peter's movements are readily explained, and he can easily be pictured passing either in front of or behind the central group as he delivers the money he obtained at the far left to the tax collector at the far right.

There is little doubt that the initial scene, Christ's exchange with Peter, is the most important one, and this emphasis comes across more strongly in two dimensions than in three. Not only does the vanishing point of the perspective construction fall within this group (a two-dimensional issue as much as a spatial concern), but Christ and the figures surrounding him take up most of the center of the picture, an important position. In addition, because they are fairly close to us, these figures are also relatively large and prominent.[12] In these ways, in two-dimensional terms, the group of figures surrounding Christ clearly dominates the field, especially in relation to the scene at the left. The focus is on Christ's relationship to Peter, and Masaccio's *Tribute Money* thus becomes an image of ecclesiastical authority as well as the story of a specific miracle. Although the narrative concerns St. Peter (as does the cycle to which it belongs), the central character – both literally and figuratively – remains Christ. And rather than illustrate Peter's peregrinations in prosaic fashion or dramatize the miraculous discovery of the needed money in the mouth of a fish, Masaccio emphasizes the agency of Christ. He shows how Christ's authority is passed on to Peter, in much the same way as it is depicted in the scene of the Giving of the Keys or in comparable scenes.[13]

In effect, then, the deepening of space for which the *Tribute Money* is justly praised made it possible for the artist to accomplish two potentially antithetical goals. On the one hand, it enabled Masaccio to expand the narrative, to distribute additional scenes around the setting, linking them and separating them, and thereby to enliven the subject. Beyond that, however, it also allowed Masaccio to centralize the initial

scene, to make the narrative fold back on itself without jeopardizing the temporal flow or logic, and it enabled him, in turn, to clarify and strengthen the underlying meaning.

THE HEAD OF THE BAPTIST

The expressive or dramatic potential of the continuous method – how space, surface, and narrative can be coordinated and controlled – becomes especially evident if we turn to several versions, differing interpretations, of the Banquet of Herod or the Martyrdom of John the Baptist. This theme was represented many times in the quattrocento. One of the most ingenious examples is the predella panel by Benozzo Gozzoli (Fig. 13) now in Washington, D.C., in which the story is told in three separate moments. The organization itself, the position of each episode in relation to the rest, seems clearly to reveal the significance of what transpires.[14]

In Gozzoli's depiction, the action begins at the right, where Salome appears before Herod and his guests at the banquet in his honor. An imperious Salome strides forward, as if to request the head of the Baptist while yet dancing; her pose alludes to the dance without necessarily representing it. At the same time, Herod looks on, clearly shocked and dismayed, and the rest of the banqueters seem equally unhappy. The next scene takes place within a separate chamber, a closetlike prison that is absorbed into the overall scene, casting its shadow across the floor and even onto the banquet table. There we see the Baptist kneeling in prayer as his executioner, following Herod's orders and responding to Salome's request, prepares to bring down the sword. Salome appears again in the concluding scene, shown in the background, in an extension of the main hall, where she presents her bloody prize to Herodias.[15]

The narrative thus follows a path across the surface of the picture from right to left and then back toward the right and into depth; as a result, the final scene, a little to the left of center, appears to be framed by the first two, almost encircled by the curving figure of

Salome in the foreground and the executioner raising the sword over his head. This arrangement effectively heightens the importance of the final scene, and, more than that, it places Herodias at the very core of the composition, drawing a circle around her role in the drama and making her seem all the more in command, all the more the mastermind we know her to have been.

The importance of Herodias is further emphasized by the connection between the last scene and the first, linked together by the two incarnations of Salome, both facing in the same direction. The Salome in the foreground almost seems to emanate from the back, urged on by the same Herodias with whom the story concludes. In this way, Gozzoli reinforces the impression that Salome, requesting the head of the Baptist at the right, is acting on the instructions of Herodias, having just returned from the same small chamber where she will deliver the head at the end. Of course, in three-dimensional terms no such connection exists: The events follow one another in a reasonably straightforward manner. But when these same scenes are considered in two-dimensional terms, as forms coexisting on the picture plane, different, more interesting, meanings emerge, and Herodias, although tucked away in a back room, exerts greater control over the situation.

LIPPI'S INTERPRETATION

Filippo Lippi, in his version of the Banquet of Herod in Prato (Fig. 3), including roughly the same sequence of events as Gozzoli had, gives the story a somewhat different focus.[16] Indeed, Lippi's interpretation is a singularly tragic one. It begins near the center, where Salome dances rather languidly before the assembled guests; although she is somewhat to the left of the vanishing point, we are immediately drawn toward her by the perspective construction, which pulls us through the break in the barrier running across the foreground.[17] Salome herself is less than exuberant and far more pensive than energetic: She remains as wistful as her audience, seeming almost to be in a kind of trance. Her head inclines to the right, vaguely toward us, and her

right hand gestures in the opposite direction, as if she were making a request, while at the same time directing our attention to the following scene, the Baptist's martyrdom at the left.

In Gozzoli's panel Salome is absent when the Baptist is beheaded,

Figure 13 (opposite page and left). Benozzo Gozzoli, *Banquet of Herod.* Washington, D.C., National Gallery of Art. Courtesy of the National Gallery of Art (Samuel H. Kress Collection).

but Lippi chooses to include her: As the image turns the corner we see Salome again, still within the precincts of the palace (but outside of the banquet hall), receiving the head of the Baptist from the executioner, whose arm extends across the turn in the wall. Salome

85

reaches back to take the head but averts her gaze, turning toward the right: Her movements reveal her distaste for what is happening and, at the same time, alert us to the concluding scene across the hall, all the way to the right.

Finally, on the right side, Salome, shown a third time, delivers the Baptist's head to her mother, who is seated with Herod.[18] We have to imagine the head being carried across the front of the room, as the guests at the back table seem almost to respond, following the movement of the head as Salome carries it to her mother. As it reaches the small table at the far right, where Herod and Herodias are seated, the tension seems to increase: Attendants and guests (as well as Herod himself) react with horror, grimacing and raising their hands as if to ward off the horrible sight. Salome kneels – as she does in Gozzoli's version – while Herodias imperiously acknowledges her arrival.[19]

In terms of order, the narrative recalls Masaccio's *Tribute Money*, starting the viewer off near the center and proceeding first to the left and then all the way across to the right, and as in Masaccio's picture, the main character appears three times. She participates in the drama at every turn, her gestures and movements in all three incarnations leading the beholder from one part of the image to the next, along a rather complicated path. In this way, as we have already seen, Lippi's Salome acquires an importance she had not enjoyed before, bearing more of the responsibility for what has occurred than she does in Gozzoli's version.

Gozzoli's Salome remains a pawn in her mother's evil game: She follows Herodias' instructions and dutifully, without batting an eye, delivers up the head. Lippi's Salome, on the other hand, is more complex: She is implicated more fully in the crime, yet she is also more deeply moved, repelled by the results of her actions and unable to look at the bloody head. In Lippi's portrayal we have the making of a true tragic figure, who, to an extent greater than in Gozzoli's characterization or, for that matter, than in even earlier versions such as Masolino's or Giotto's, looks forward to the enigmatic antiheroine of recent art and literature.[20]

In Lippi's interpretation, a new emphasis is also placed on the dance itself, which seems to play a pivotal role here, apparently generating

the rest of the action. Each subsequent scene is presented in relation to the initial depiction of the dancing girl – almost as the direct result of her movements – while the character of the dance, sinuous and wistful, suggestive and smooth, is colored by the episodes (and the other Salomes) that surround it. The graceful dancer is bracketed by scenes of gloom and horror, and in this way, Lippi's picture almost becomes an object lesson on the fleeting pleasures of life, in which a joyous entertainment can very quickly become something else, something tragic. The Baptist, meanwhile, is almost lost in the shuffle.

Lucrezia Tornabuoni, in her extended dramatic poem on the life of the Baptist (*Vita di Sancto Giovanni Baptista*), possibly written with Lippi's fresco in mind, speaks of Salome's dance as the reason for the Baptist's martyrdom ("Che so fu questo [the dance] la cagion che Giovanni fé morire"). She goes on to observe how quickly the festivities are transformed into sadness. How brief, she laments, are joy and celebration, and her comments seem to echo the tone of Lippi's picture. Perhaps Tornabuoni, understanding the implications of the narrative order and style, had divined something of the painter's intentions.[21]

NORTHERN VARIATIONS

Other quattrocento painters tell the story of the Banquet of Herod somewhat differently. Rogier van der Weyden, for example, in his panel now in Berlin (Fig. 14), begins with the beheading of the Baptist – with the martyrdom itself – which takes up much of the foreground; the subsequent events are shown much smaller in the background. As a result, the saint's martyrdom predominates, and although the elegant Salome figures quite prominently in the initial scene, and appears again in the banquet hall, her role remains secondary to that of the Baptist himself – or at least of his head. Indeed, the head of the Baptist appears three times altogether: first in the foreground, being placed on the charger, and then twice more, as it is presented at the banquet (directly above the first head) and as it is carried off toward the right by a servant. In a rather grisly way, it is the head itself that becomes the main character.[22]

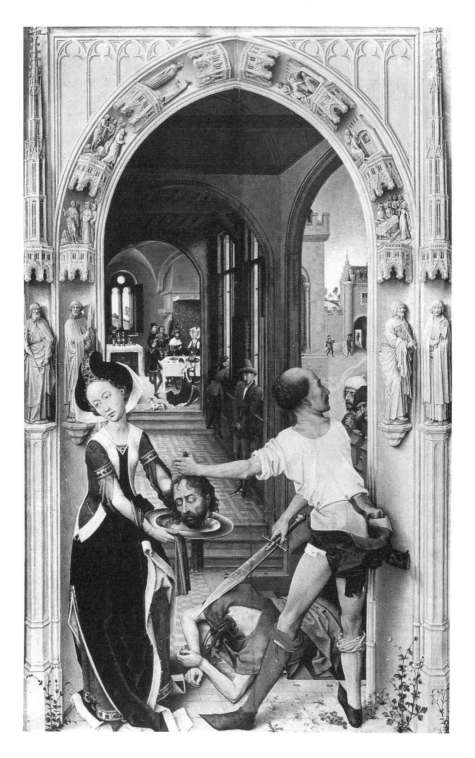

The earlier parts of the story, and in particular, Salome's dance, are included in Rogier's version as well, although this is not immediately apparent: These episodes are shown in the form of sculpture, as images within the image, carved on the archway framing the main scene overhead. These secondary scenes are thus removed to a different level of reality, are transposed to the realm of art and become more remote in time from the main action, at least in effect: If it is possible to speak of flashbacks in visual narratives, then these little vignettes should perhaps be considered in those terms, either as a series of flashbacks or as one extended flashback. They explain the execution by depicting the chain of events that led up to it, starting in the present and returning to the present. Only then are we fully prepared to consider the conclusion of the story, its aftermath, and turn our attention toward the scenes in the background, to the banquet hall and beyond.[23]

In Hans Memling's version of the demise of the Baptist, part of the *St. John Altarpiece* in Bruges (Fig. 15), the martyrdom itself is again shown in the immediate foreground. The arrangement is much the same as in Rogier's (on which it is based), although Salome stands to the right instead of to the left. But the delivery of the head is no longer included, being replaced by Salome's dance, a prior moment. In other words, what transpires in the banquet hall precedes the scene in the foreground rather than follows it, and as a result, the Baptist's execution becomes the culmination of the events shown in back (and in the adjacent main panel) and not the opening of the drama. Salome's role is now also quite different: She presides over the execution and delivers the head, but her role as performer or temptress is largely played down.[24]

When Quentin Metsys came to represent the same events, in the *Deposition Altarpiece* in Antwerp (Fig. 16), he may well have had in mind both Rogier's version and Memling's, but he made some significant changes, reversing the terms of the narrative and thereby radically altering its meaning. The martyrdom stressed by Rogier and Memling

Figure 14 (opposite page). Rogier van der Weyden, *Martyrdom of the Baptist*. Berlin, Gemäldegalerie. Courtesy of Foto Marburg/Art Resource, NY.

89

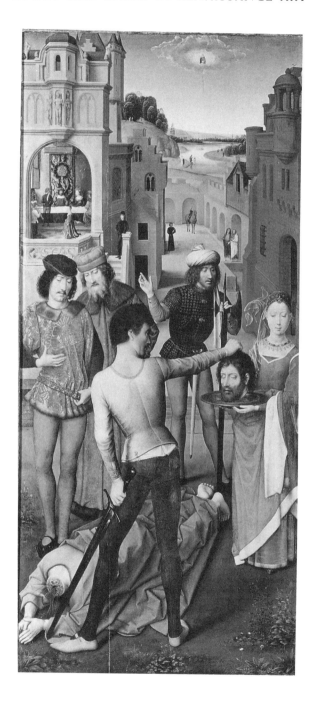

is now placed in the background, hidden away under an arch, whereas the subsequent scene, when Salome presents the head of the Baptist to Herod and Herodias, is moved to the foreground, dominating the image.[25] In two-dimensional terms, the beheading is sandwiched between the depiction of Herodias and the figure of Salome in the foreground, almost as if it were the subject of their thoughts and belying their expressions of surprise: The Baptist's head is almost literally enmeshed in the scheme, quite obviously the target of a treacherous plot. In this way, the depiction becomes as much a drama of human cruelty, intrigue, and deceit as it is an image of martyrdom, saintliness, and piety, and it nicely complements the depiction of John the Evangelist being boiled in oil shown on the other wing of the altarpiece, where the emphasis again is on the sadism of the participants more than anything else.[26]

Although all of these images are comparable in certain respects, including a similar sequence of events and even many of the same details, the meaning and impact are rather different in each case. Of course, such changes involve a variety of factors – from the facial expressions of the participants to the character of a line – but they also depend, in no small measure, on the narrative organization itself, on the ordering of episodes, and the basic structure of the picture. By shifting events from one position to another, relegating some to the background and placing others in the foreground, at the left, or to the right, the artist controls the shape of the discourse, exploiting the illusion of space to achieve the desired result.

LEONARDO

Renaissance authors provide little guidance in the matter of choreographing continuous narratives; their silence is somewhat puzzling, but there is virtually no discussion of the issue in the texts of the fifteenth

Figure 15 (opposite page). Hans Memling, *Martyrdom of the Baptist*. Bruges, Hospital of St. John. Courtesy of Giraudon/Art Resource, NY.

and sixteenth centuries. Alberti, of course, in his treatise on painting, *De pictura*, comments at some length on the creation of *historiae* (*storie* or *istorie*), of visual narratives – on their subject matter and composition, on characterization and movement (among many other questions). But his remarks are not specifically aimed at continuous imagery (however applicable they might be), and he does not address the questions of order and direction at all, either with respect to individual pictures or in relation to series and cycles.[27]

Of all the authors of our period, it is again Leonardo who is really the most helpful: Almost inadvertently, and without addressing the issue directly or at length, he nevertheless describes, on a reasonably practical level, one possible way of organizing a continuous narrative. At one point in his notebooks, as we have seen, he speaks of rendering the lives of saints in continuous fashion, advocating the inclusion of a series of incidents in the same unified picture. In so doing, Leonardo advises, the most important scene should be placed in the foreground, and the rest of the action should be placed further back, according to the demands of the subject and the limits of the setting: ". . . and upon this plane [the foreground] represent the more important part of the story," he says, "and then, diminishing by degrees the figures, and the buildings on various hills and open spaces, you can represent all the events of the history. . . ."[28]

There is a great deal that these remarks do not tell us: Leonardo does not say whether the story should begin in the foreground or end there, and he does not comment on whether the image should be read from left to right or in some other way. But we do learn that in Leonardo's estimation narrative scenes placed in the foreground are accorded special importance. Figures and episodes set further back in space are considered secondary, leading up to the main scene or away from it, moving from the past or into the future, qualifying or modifying what, by virtue of its position in the foreground, is both prom-

Figure 16 (opposite page). Quentin Metsys, *Banquet of Herod.* Antwerp, Koninklijk Museum voor Schone Kunsten. Courtesy of the Koninklijk Museum voor Schone Kunsten.

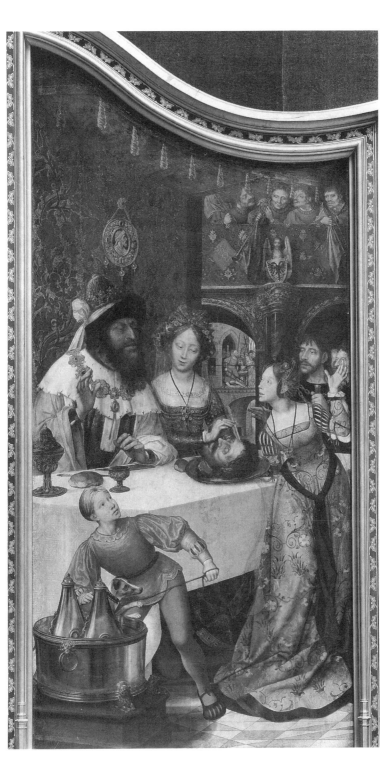

inent and significant. And thus we have at least one working principle, one basic guideline that might have proven useful in the construction of continuous narratives. As we have already seen, a number of Leonardo's contemporaries must have been thinking in similar terms.[29]

After the quattrocento, the focus in depictions of sacred themes and mythological subjects came to be on individual scenes – on miracles and martyrdoms, on isolated actions, or even, in many instances, on individual figures or heads. Admittedly, these more concentrated versions often have a greater dramatic intensity than the less unified pictures with which we have been dealing. But some of the expressive possibilities are lost: There are fewer ways to qualify the main event, to amplify the narrative or to add information.

SPACE AND NARRATIVE

I shall merely make use of a remark made by Mengs concerning Raphael's drapery. "In his paintings," he says, "there is a reason for every fold, whether it be because of its own weight or because of the movement of the limbs. Sometimes we can tell from them how they were before, and Raphael even tried to attach significance to this. We can see from the folds whether an arm or leg was in a backward or a forward position prior to its movement; whether the limb had moved or is moving from contraction to extension, or whether it had been extended and is now contracted." It is indisputable that in this case the artist is combining two different moments into one.

<div align="right">GOTTHOLD EPHRAIM LESSING[1]</div>

You have certainly read in Ovid how Daphne was transformed into a bay-tree and Procne into a swallow. This charming writer shows us the body of the one taking on its covering of leaves and bark and the members of the other clothing themselves in feathers, so that in each of them one still sees the woman which will cease to be and the tree or bird which she will become. You remember, too, how in Dante's *Inferno* a serpent, coiling itself about the body of one of the damned, changes into man as the man becomes reptile. The great poet describes this scene so ingeniously that in each of these two beings one follows the struggle between two natures which progressively invade and supplant each other.

It is, in short, a metamorphosis of this kind that the painter or the sculptor effects in giving movement to his personages. He represents the transition from one pose to another – he indicates how insensibly the first glides into the second. In his work we still see a part of what was and we discover a part of what is to be.

<div align="right">AUGUSTE RODIN[2]</div>

THE INNOVATIONS OF BRUNELLESCHI AND ALBERTI can be seen as the culmination of a gradual and often unsteady development, starting with Giotto (to mark a somewhat arbitrary but not inappropriate beginning), in which the representation of space and depth became increasingly accomplished, not only more convincing but often more vast as well. And as the pictorial space is in effect expanded, the representation of time, that is, the time embedded in the imaginary scene, is potentially extended along with it (depending, of course, on what is specifically depicted). That continuous narratives, which depend on the implicit temporality of pictorial space, should have flourished in the wake of this kind of spatial expansion is thus hardly surprising. Nor is it surprising that, in the earliest phases of this development, at the start of the trecento when the representation of space was both more tentative and less systematic and when painted spaces tended to be relatively shallow or restricted, polyscenic narratives were much less common than they would be later.[3]

There is little question that Giotto's pictures (those in the Arena Chapel, for example) represent a decisive break with the imagery of previous centuries, having a greater and more palpable sense of depth than before; it should also be noted, however, that the space in these images is far from expansive – indeed it remains fairly shallow – as we can see in the fresco of *Joachim's Dream* (Fig. 17), from the uppermost tier of the Arena Chapel. In this and other depictions from the same cycle, there is little room to manuever, and it would be hard to imagine that a setting such as this could accommodate the complex continuous narratives of the sort created in the quattrocento. Not unexpectedly, the great majority of Giotto's paintings, in the Arena Chapel and elsewhere, are monoscenic. They include, for the most part, only one episode or moment, represented in economical, concentrated terms (as we have already seen). The same holds true for Duccio, and for many of his contemporaries, Sienese or otherwise. Exceptions are remarkably scarce; it is almost as if the experimental, hesitant nature of the space in these works, as revolutionary as they certainly were, somehow thwarted any urge to expand the narrative beyond a single scene or moment.

In the work of younger masters – Taddeo Gaddi, for example, or

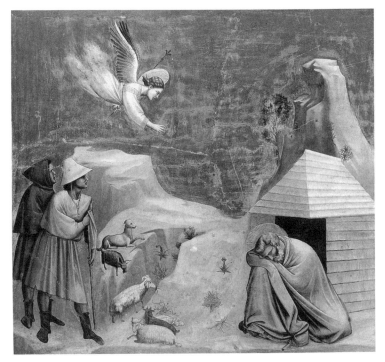

Figure 17. Giotto, *Joachim's Dream*. Padua, Arena Chapel. Courtesy of Alinari/Art Resource, NY.

Maso di Banco – the situation begins to change. Their spatial constructions, although far from systematic, are more ambitious and often more expansive or extensive. At the same time, we start to see more instances of continuous narrative. Many of the narratives are fairly rudimentary; rarely are more than two episodes included within a single picture, and these remain the exception rather than the rule. It would be fair to say, however, that artists were slowly awakening to the dramatic potential of this form of narration as an increasing command over space made it more viable to do so. If we compare, for example, Taddeo Gaddi's fresco of the *Expulsion of Joachim from the Temple and Joachim's Dream* (Baroncelli Chapel, Santa Croce, Florence) (Fig. 18), which includes two separate scenes in an expanding landscape, with Giotto's more reductive, monoscenic versions of these scenes, the

change is readily apparent; Maso di Banco's depiction of St. Sylvester and the Dragon in the same church (Bardi di Vernio Chapel) represents an approach comparable to Gaddi's.[4]

The evolution of pictorial space over the course of the trecento was anything but smooth and orderly, and the starts and stops, jumps and reversals, have yet to be fully charted.[5] But toward the end of the trecento we find a growing predilection for continuous narrative in pictures where the space has become more panoramic and inclusive than before. Agnolo Gaddi's depiction of *Chosroes' Blasphemy* and its aftermath (Fig. 19), for example, part of the True Cross cycle in the choir of Santa Croce, is a more expansive narrative in terms of both time and space than the nearby fresco by his father, Taddeo, that was just mentioned, the *Expulsion of Joachim from the Temple and Joachim's Dream*, on which it is partly based. Generally speaking, Agnolo's narratives, in Santa Croce and elsewhere, are more ambitious than Taddeo's had been, involving more figures and in some cases more episodes, in settings of considerable complexity and depth. And during the same period, Agnolo's contemporaries or near contemporaries, Spinello Aretino and Antonio Veneziano, produced numerous visual narratives that were equally elaborate, in the Camposanto in Pisa and other locations.[6]

From pictures such as these it is only a short step in terms of pictorial space and narrative time to the quattrocento imagery that was our point of departure. Pictorial space, already fairly deep and wide, becomes even more convincing with the advent of one-point perspective. Moreover, as we have already seen, visual narratives become even more elaborate and widespread – the rule, perhaps, and no longer the exception – and, in any event, a popular and effective means of telling stories in visual terms.

These developments are closely entwined. Clearly, the illusionism of Renaissance art answered a strongly felt need, a concern with bringing the stories of the time, sacred or otherwise, to life, and making them as plausible and as compelling as possible. To some degree, we can even regard the growth of realism in the fourteenth and fifteenth centuries as a direct result of such concerns and objectives; doubtless an interest in lively and engaging narratives called forth a more ef-

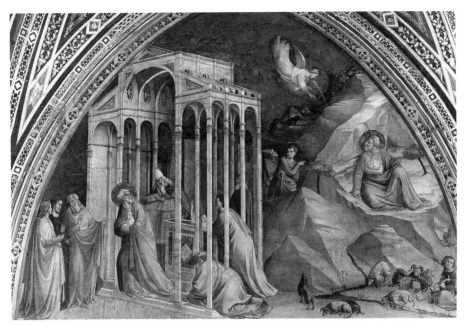

Figure 18. Taddeo Gaddi, *Expulsion of Joachim from the Temple and Joachim's Dream*. Florence, Santa Croce. Courtesy of Alinari/Art Resource, NY.

Figure 19. Agnolo Gaddi, *Chosroes' Blasphemy*. Florence, Santa Croce. Courtesy of Alinari/Art Resource, NY.

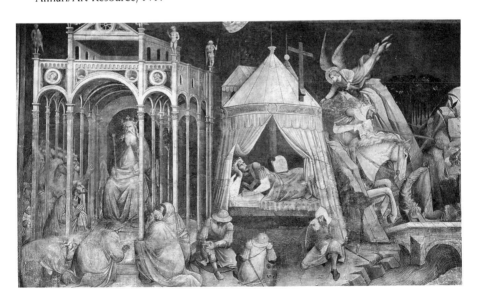

fective and convincing depiction of the visual world and three-dimensional space, and achievements with respect to pictorial space in turn fostered a more extended, elaborate, and episodic form of narration.[7]

There is no need to identify precisely a single driving force or impulse – to sort out the chickens and the eggs – for almost certainly continuous narrative and pictorial space developed hand in hand, nourishing each other in ways no longer possible to reconstruct exactly. Nevertheless, it is clear that, contrary to what has often been asserted, the invention of one-point perspective did not deal a deathblow to continuous narrative; instead, it gave it an added impetus, facilitating the extension and enrichment of numerous stories in frescoes, panels, and reliefs for over a century. Indeed, the methods for creating an illusion of space that emerged in the quattrocento, together with the renewed and growing interest in polyscenic narration, brought a special clarity to narrative imagery, which we now, conditioned by Lessing's strictures, generally fail to appreciate.

THE GOLDEN AGE

By the middle of the quattrocento, continuous narrative had become quite common: Fra Angelico, Fra Filippo Lippi, and Piero della Francesca all created memorable examples, and they were by no means alone. But it is the last third of the fifteenth century and the first years of the sixteenth century that was the real heyday of this sort of imagery: During these years, continuous narratives appear with great frequency, and we find some of the most involved and inventive *istorie* of the entire Renaissance period. Because of the richness and range of the narrative images produced at this time, over the course of only three or four decades, it is not unreasonable – later notions of pictorial unity notwithstanding – to regard this period as a kind of golden age, as an underrated but glorious epoch during which the continuous method was used with increasing freedom and to great advantage.

Toward the end of the 1460s (not long after Lippi had completed his frescoes in Prato, and Piero had finished the True Cross cycle in

Arezzo), Benozzo Gozzoli began work on his elaborate pictures on the walls of the Camposanto in Pisa, a project that occupied him for almost two decades and one that was much celebrated in its day. These Old Testament scenes surpassed in their complexity (in the sheer number of episodes within each fresco, if that is any measure) the nearby late-trecento frescoes by Antonio Veneziano and Spinello Aretino, for example, as well as Angelico's frescoes in the chapel of Nicholas V, in the making of which Gozzoli had a hand. The Camposanto narratives were the most ambitious *istorie* of Gozzoli's entire career, and they are more extensive and intricate, much greater in scope and more crowded with incident, than his works from the 1450s and 1460s at Montefalco and San Gimignano.[8]

Gozzoli's imagery set the stage for the grand series of frescoes along the walls of the Sistine Chapel by Perugino, Ghirlandaio, and others, including, of course, Botticelli (who was responsible for three of the scenes). Although history has not been kind to these pictures, which have been overshadowed by Michelangelo's ceiling, they are nevertheless wonderfully daring and entangled. In nearly all of them the continuous method is used in new and sophisticated ways, with unprecedented energy and ingenuity. Like Gozzoli's pictures in Pisa, these frescoes are clear indications of the great vitality of such imagery, of this episodic sort of narrative, in the latter part of the fifteenth century.[9]

Of all of the artists involved in this extensive and elaborate project, Botticelli seems to have been especially partial to the continuous approach. No doubt he developed a taste for it while assisting Filippo Lippi on his magnificent frescoes in the cathedral of Prato (where the continuous method is much in evidence). Building on his experiences in Prato and then in Rome, Botticelli went on to create the extraordinary narrative images included among his illustrations for Dante's *Divine Comedy* (ca. 1490s).[10] And Botticelli's fascination with this sort of narrative is again apparent after the turn of the century, in panels devoted to the stories of Lucretia and Virginia, two subjects from Roman history; in both cases the artist joins together numerous incidents within unified, classical settings. From the same period comes the well-known set of panels depicting the Life and Miracles of St.

Zenobius. These panels, which probably once decorated the oratory of a confraternity dedicated to this saint, are all continuous narratives.[11]

By the beginning of the cinquecento, continuous narrative was already an ubiquitous feature of Renaissance art, having found its way into images of all sorts. Not only was it used in ambitious narrative cycles on the inside and outside of churches and oratories, in paintings and reliefs devoted to the lives of important sacred figures, but the continuous method was also employed, with surprising frequency, for works with secular or literary themes, in pictures intended for private or domestic settings.[12] Indeed, the continuous approach made itself felt in a wide array of media and formats, becoming part of the very fabric of daily life in Florence as well as elsewhere in Italy and Europe.

ANCIENT STORIES

A development comparable to that which occurred in the Renaissance can be observed in ancient times as well, in the art of Greece and Rome. In Antiquity too interest in pictorial illusionism seems to have grown hand in hand with the use of continuous narrative, broadly speaking at least. In the classical period, when optical realism and perspective emerged as significant concerns, mythological subjects were rendered with remarkable conciseness, and the unity of space and time was generally observed. In subsequent centuries, however, as the command of pictorial space increased, continuous narratives began to appear, first in Hellenistic art and then becoming especially prevalent in Roman times in a wide range of subjects and media.

In his study of Roman art and the Vienna Genesis, Franz Wickhoff was among the first to speak of a link between illusionistic concerns and continuous narrative. In Wickhoff's view, the flowering of the continuous method in ancient art was largely the result of the emergence of what he called the "illusionist" style, a distinctly Latin or Roman brand of pictorial realism that reached a kind of climax in monuments such as Trajan's column or in the Odyssey landscapes (which Wickhoff regarded as a characteristically Roman work, com-

parable to Pompeian frescoes in the fourth style).[13] Indeed, for Wick-
hoff the connection between these two developments – between
continuous narration and spatial realism – is a very direct one, as he
states in rather poetic terms:

An incessantly active imagination had allied itself to the realistic tendencies
of this Western art, and out of the materials that deceptive illusionism offered
had created a new kind of narrative, the *continuous*. This was the bright, wav-
ing flower that grew on the strong root of realism.[14]

Much more recently, J. J. Pollitt also calls attention to the link
between illusionism and continuous narration, which he traces back
to the Hellenistic period. The building blocks of Pollitt's argument,
the specific monuments and basic chronology, are of course different
from Wickhoff's; the Telephos frieze (from the altar of Zeus at Per-
gamon) now plays a crucial role, and the Odyssey landscapes (once
more a key piece in the puzzle) are considered to be Hellenistic, rather
than Roman, works.[15] But Pollitt's primary contention and the under-
lying assumption of his analysis is much the same as before. For Pollitt,
as it had been for Wickhoff, the emergence of the continuous style is
closely related to the development of spatial realism.

Leaving aside questions of whether the key steps in this evolution
were Hellenistic or Roman and which medium or format was most
influential, the fact remains that for many centuries space and narrative
seem to have expanded together. Admittedly, the rendering of space
in even the most accomplished of these early examples is not alto-
gether systematic nor fully rational in a modern mathematical sense:
Not surprisingly, the space in these works has at times been described
as magical and supernatural or even as abstract. Nevertheless, we find
a remarkable marriage of continuous narrative and pictorial illusion:
They arose together in ancient times, developing in tandem. This
would again be the case in the Renaissance, when this earlier evolution
was, in effect, recapitulated.[16]

Perhaps it would be fair to say that the artists of the quattrocento,
in creating their special brand of narrative imagery, received consid-
erable guidance from these ancient prototypes (from those, at least,
that remained in view); it is certainly conceivable that monuments such

as Trajan's column or the many ancient sarcophagi that survived into the Renaissance period were of interest not only for their subjects and styles but also for their modes of narration. Filarete's comments on Trajan's column (cited in the Introduction), as well as his artistic response to Roman relief sculpture, are especially relevant in this context.[17] If nothing else, that the continuous method was obviously sanctioned by ancient practice undoubtedly contributed to its renewed vitality in the fifteenth century, when so many aspects of the classical world were being energetically revived. Indeed, the widespread appeal of continuous narration over the course of the quattrocento is perhaps best understood as an integral part of the Humanist culture of the period – not as an aberration or a leftover, but as intrinsic to the Renaissance spirit, in even the most literal sense of the term.

CONSOLIDATION

In the sixteenth century artists continued to make use of continuous narrative, although with somewhat less frequency than before. Michelangelo, for example, employed the continuous method in several of the scenes he painted on the Sistine ceiling, the best known of them being the *Temptation and Expulsion*, in which with great ingenuity he unites two separate episodes. Raphael too combined several scenes in his fresco of the *Liberation of St. Peter*, which won the praise of Vasari, as we have seen.[18] Pontormo, Rosso, and Salviati, to name just three of the sixteenth-century masters who came of age slightly later, all made use of continuous narrative as well, at least on occasion. And Luini's *Crucifixion* in Lugano has already been mentioned.[19] Numerous other instances, in Italy and elsewhere in Europe, throughout the century, can also be cited, and one can even point to seventeenth-century examples, admittedly rather rare, such as Velásquez's depiction of the Meeting of Anthony Abbot and Paul the Hermit (Madrid, Prado), which involves five episodes in the same picture.[20]

By the seventeenth century, however, a more exacting kind of realism had taken hold, in which such methods no longer had a logical place: Pictorial space had in effect congealed, had become unyielding

and unchanging, and had acquired a unity and simultaneity that it had never before possessed. As John Szarkowski expressed it in a recent work on the history of photography:

gradually the concept of composition, in which the narrative elements were arranged within a framework constructed according to architectural principles was replaced by a new concept, in which the picture consisted of a single part: the undivided, indivisible visual field.[21]

Ultimately, the indivisibility of the visual field was a necessary pre-condition – and this is Szarkowski's basic point – for the invention of photography centuries later, creating the possibility that a given view of space, as it appears in a single instant, can be captured and fixed. Only when this concept is firmly in place does it become reasonable to imagine that an illusion of space – as seen, for example, in a camera obscura – can be preserved by mechanical or chemical means. In any event, pictorial space gradually lost its temporal resonance; the flow of time was, in effect, slowly squeezed out of the picture and ulti-mately vanished from the visual arts.

A detailed analysis of this transformation remains to be written, but it would be misleading to look upon the hardening of pictorial space as the inevitable result of the invention of one-point perspective, as is sometimes asserted. It would be more accurate, perhaps, to view such a change as a reflection of a growing taste, or need, for visual realism, as an appetite for illusionistic effects, of which Brunelleschi's system was only one relatively early manifestation. In pursuit of such realism, and in order to surpass the achievements of the quattrocento in that respect, it became necessary to close the gap between the image and the viewer, to establish a close correspondence, more exact than be-fore, between that which was represented and the viewer's own reality. In other words, it was important that the imaginary world within the picture and the real one outside of it match as precisely as possible, in terms of scale, of space, and of time. If the picture was to be per-ceived with relative speed, all at once, in a single glance, then the time passing within it had to be reduced accordingly. The image thus became a literal extension of the visual world, as revealed in an instant and perceived instantaneously.

CHIAROSCURO

Caravaggio's *Crucifixion of St. Peter* (Cerasi Chapel, Santa Maria del Popolo, Rome) (Fig. 20) is a good example of the sort of change we have been discussing. As he does in many of his pictures, Caravaggio here brings us in very close to the action, which seems to belong as much to our world as to the picture itself. We are presented with an especially immediate view of the proceedings, as Peter and the Cross are pushed and pulled into position. There is perhaps a faint suggestion of movement and succession still to be found in this image, for the diagonals that form the structural underpinnings of the image imply a kind of progression from horizontal to vertical, tracing the movement of the cross as if on a graph. All the same, there is a strong sense of arrested motion, a feeling that we are seeing only a momentary view of the action and the space.[22]

The dynamism of the composition and the apparent energy with which Peter's tormentors apply themselves to their task make the interruption in the flow of time appear all the more abrupt and instantaneous. And, as if to reinforce the impression of instantaneity even further, what little space there is has been thrown into shadow. In this way, any implication of passing time that the space might still contain is largely eliminated or suppressed, and as a result, there is almost no sense of ongoing movement or succession. Instead, we are given a momentary, albeit riveting, glimpse of Peter's travails, a little block of space and time frozen together.

In Michelangelo's earlier version of the same subject (one of the frescoes in the Pauline Chapel in the Vatican) (Fig. 21), which undoubtedly served as Caravaggio's point of departure, time seems to pass more slowly. As in Caravaggio's picture, the inverted cross is shown as it is being hoisted into position, and here too Peter twists to look out toward the viewer. But the feeling of instantaneity is less pronounced: There is a lingering sense of succession, of progression and flow, action and reaction, as if the drama were unfolding gradually, by stages, over time – something that we do not experience, or do not experience to the same degree, looking at Caravaggio's painting. One basic moment is represented in both images, but in Michelan-

Figure 20. Caravaggio, *Crucifixion of St. Peter*. Rome, Santa Maria del Popolo. Courtesy of Scala/Art Resource, NY.

gelo's earlier one that moment is somehow extended; in Caravaggio's version, it passes in a flash.[23]

Not surprisingly, Filippino Lippi's interpretation of Peter's *Martyrdom* (Fig. 22), which takes us back to the latter part of the quattrocento, involves an even greater span of time than Michelangelo's, incorporating several episodes into one setting.[24] The action proceeds in and out of depth, from the right to the left, culminating in the crucifixion scene, with the cross already lifted into position with the help of a

pulley; Peter appears three times, moving from place to place over an extended period of time. In the expansive space described in Lippi's fresco, time flows with considerable freedom, despite the presence of several stone walls. As a result, there is a pronounced gap or disparity between the imaginary world of the picture and the reality of the viewer on the other side of the picture plane: The time passing within the image (including three basic episodes) cannot be equated with the demands on the viewer – with viewing time – in any literal way.

The disparity persists in Michelangelo's fresco, even if it is less extreme and therefore not as apparent. The narrative has, of course, been reduced to a single encounter, and the space has contracted to some degree, but the time within the picture still passes more slowly than the real time outside it: The figures seem almost to move in slow motion, and the setting, spare and remote, nevertheless has a kind of temporal resonance, which widens the gap still further. In Caravaggio's version, however, the two sides of the equation (to return to the analogy used in Chapter 1 when discussing Castelvetro) begin to coincide more closely. The time and space of the picture, quite limited in comparison to those of earlier examples, nearly equal the brief and delimited presence of its audience: Imagination and experience are brought into balance. Thus Caravaggio achieves the sort of dramatic unity espoused by Castelvetro, now transposed into pictorial terms. Such an approach precludes the possibility of continuous narration in any meaningful sense and heralds the explicit theoretical sanctions against it that are soon to follow.

PREGNANT MOMENTS

Later in the seventeenth century, in critical analyses of narrative imagery, the continuous method started to come under attack; by that time there was a growing sentiment that a picture or relief must represent one moment only, at least ideally. Nevertheless, even in this more restricted context, important questions concerning the representation of time remained. Although the exacting demands of verisimilitude no longer allowed the use of continuous narrative or comparable

Figure 21. Michelangelo Buonarotti, *Crucifixion of St. Peter*. Vatican City, Vatican Palace. Courtesy of Scala/Art Resource, NY.

devices, painting was still in many respects a literary art with the expressed aim of recounting stories. As a result, the passage of time still had to be indicated somehow, even if it could not be explicitly shown or developed.

A variety of solutions and criteria, granting either more or less license, were proposed, but in most discussions in the seventeenth and eighteenth centuries the common denominator was a kind of compromise. The idea was that when depicting a single instant the artist should hint at earlier and later moments, before and after the main scene, without actually showing them explicitly or at least without seeming to violate prevailing standards of pictorial unity and verisimilitude to any great extent. Thus, in a discussion of Nicolas Poussin's *Fall of Manna* (Paris, Louvre), held at the French Royal Academy

109

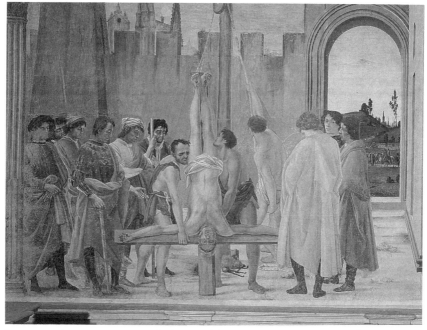

Figure 22 (opposite page and above). Filippino Lippi, *Martyrdom of St. Peter.* Florence, Santa Maria del Carmine. Courtesy of Scala/Art Resource, NY.

in 1667 (and recorded by André Félibien), it is allowed that although, strictly speaking, the painter can show only a single moment, it is nevertheless sometimes necessary to include prior incidents as well, so that the main action can be better understood.[25] Similarly, when describing a depiction of Apollo and Daphne by Carlo Maratti (Brussels, Musée Royale des Beaux-Arts), Giovanni Pietro Bellori speaks of how the image is enriched with references to earlier and later parts of the story, although the unity of the picture, in terms of time as well as space, is fully preserved.[26] The passage of time is admitted, even in pictures such as these that purport to represent a single event; time is introduced indirectly, almost surreptitiously, into pictures where within the critical framework of the period it no longer has any rightful place.

Shaftesbury, when tackling the same issue, is somewhat stricter. As we have seen, he is especially insistent that in choosing the correct

moment to represent, the present (i.e., the moment in question) not
be bypassed, even to the slightest degree.[27] But for all his insistence
on unity, Shaftesbury too favors those moments that hint at what
immediately precedes or follows them. And so in deciding how best
to represent the Judgment of Hercules, for example, he selects that
in-between moment when Hercules, torn between virtue and vice (per-
sonified by Minerva and Venus, respectively), turns toward the figure
of Minerva, signaling his virtuous choice. In other words, Shaftesbury
recommends a moment in which in addition to what actually is rep-
resented there is also an indication of Hercules' predicament, of a
preexisting condition that pertains to the past as well as some adum-
bration of the final outcome, still in the future.[28]

Even Lessing, presumably the most vociferous advocate of temporal
unity, and the least forgiving, was willing to concede that the main
action must almost always be extended to some degree and include
traces of slightly earlier or later instants or positions. Lessing makes a

point of saying that because only one moment can actually be depicted, that moment should be as suggestive, as pregnant with information concerning the entire course of events, as possible:

Painting can use only a single moment of action in its coexisting compositions and must therefore choose the one which is most suggestive and from which the preceding and succeeding actions are most easily comprehensible.[29]

Here again, as before in Shaftesbury or in Bellori, it is still desirable that a narrative image indicate past and future action, while yet obeying the limits of unity and realism. Nevertheless, the context has suddenly changed, because the very aims, essentially literary in character, that make such "pregnant moments" a useful solution are now, in Lessing's *Laocoön*, called seriously into question: The fact that individual images cannot include more than a single moment, however suggestive or extended it might be, limits their effectiveness as a means of telling stories and ultimately renders the visual arts altogether unsuitable for timebound purposes more properly handled by poetry, drama, and the like.

There is a bit of historical irony here perhaps: One could almost say that narrative art has been hoisted with its own petard in that the principles of verisimilitude, the needs of illusionism, once intended to enhance painting's ability to tell stories, to create visual narratives that are convincing and compelling, become in theoretical terms the primary reason why painting is deemed inappropriate for such purposes. The laws of perspective, which once expanded the temporal possibilities in visual imagery as they deepened pictorial space, now, in *Laocoön* and comparable texts, apparently require that painting and sculpture be thought of as spatial arts only, as at their best when concerned solely with objects coexisting in space and more effective for conveying the beauty of bodily forms than for telling stories or depicting movement. In this context, continuous narrative is, of course, clearly unthinkable and the representation of passing time in the visual arts no longer an important issue.

AFTERWORD

and I look upon a Picture with no less Pleasure (I mean a good one, for ill Painting is a disgrace to the wall) than I read a good History. They both indeed are Pictures, only the Historian paints with Words, and the Painter with his Pencil. All other Qualifications are common to them both, and they both require the greatest Genius and Application.

<div align="right">

LEON BATTISTA ALBERTI[1]

</div>

> Think, when we talk of horses, that you see them
> Printing their proud hoofs i' th' receiving earth;
> For 'tis your thoughts that now must deck our kings,
> Carry them here and there, jumping o'er times,
> Turning th' accomplishment of many years
> Into an hourglass . . .

<div align="right">

WILLIAM SHAKESPEARE[2]

</div>

ONE-POINT PERSPECTIVE CONSTRUCTIONS have been described as representations of infinite space, of space that extends uniformly to an infinite extent; Renaissance perspective has also been characterized as the graphic embodiment of a new anti-Aristotelian view of the universe in which the cosmos is conceived of as infinite instead of as finite, ordered, and enclosed.[3] But this is of little relevance in the present context. Our principal concern has been not the system's advanced mathematical implications, but that which the perspective grid actually depicts, in the most prosaic sense. The same underlying geometry can be used to represent vast, almost infinitely vast, and expansive spaces or made to evoke confining or limited surroundings. In the latter case especially – Leonardo's *Last Supper* is the most obvious example – the space is decidedly finite, representing what must be considered a unified place or setting. This becomes even more the

case in pictures such as those by Caravaggio, where the chiaroscuro unifies the scene even as it obscures much of the space.

Ultimately it is this aspect of perspective space, its essential finiteness, that leads to the undoing of the continuous method and to the type of assertions made by Lessing, and afterwards by Frey, concerning a painting's capacity to represent time. For indeed, in the most restricted and consolidated spaces – we must again refer to Leonardo and Caravaggio – the sense of passing time is generally reduced, often to a considerable degree. The extent of what is shown resembles more closely that which the artist might have seen in a single glance: one space, in other words, at more or less one time, or in what could conceivably be one moment (even if that is not always the case). The apparent unity of that which is represented in turn misleads us into thinking that the entire image can be seen with equivalent speed, all at once, in a single rapid glance.

MEMORY SPANS

Modern discussions of pictorial time still presuppose a theoretical link between imaginary time and audience time, even when they seek to expand time's place in the visual arts.[4] If we start with the viewer, with how long it actually takes to look at or to "read" pictures (and pictures, like the real world, can only be perceived over measurable spans of time, as we have already seen), it also becomes possible to speak of an impression of passing time that is generated by the image itself. Even in this case, however, a strict connection is maintained between what is represented and the time required to recognize or appreciate that representation: Audience time and imaginary time are allowed to expand, but only in tandem, and the dependence of the latter on the former is preserved.

Thus, in his often-cited essay "Time in the Plastic Arts," Etienne Souriau argues that viewing a painting can be likened to inspecting a Gothic cathedral, clearly a successive process.[5] And turning to the opposite side of the equation, the world within the picture, he goes on to suggest that "the time of the work [i.e., the fictive time intrinsic

to the work] radiates, so to speak, around the prerogative moment represented."[6] As Souriau sees it, this is because the subject of the picture and the symbols it includes (the tomb and its inscription in Poussin's *Et in Arcadio Ego*, for example) often add a kind of resonance to what is actually depicted – representing time essentially by implication.

Souriau then brings the time intrinsic to a work of art back into synchronization with the time needed to view it, concluding that there is "a more or less central moment of coincidence and of harmony between this time of contemplation [i.e., the extended viewing process] and the time itself of the work."[7] The balance between the two sides of the equation is maintained. And although his purpose was to suggest ways in which time makes its presence felt in the visual arts, challenging the traditional view of Lessing and the rest, Souriau provides only a variation of Lessing's basic position; the fictive moment from which time presumably radiates is really but an extended version of Lessing's pregnant moment.[8]

Similarly, Ernst Gombrich, in his discussion of the representation of movement, maintains a delicate balance between real time and fictive time. Gombrich's starting point is the viewer's experience, that is, the viewing of the picture or the "reading" of it. Reading a picture for Gombrich very definitely occurs over time; as a function of an "effort after meaning," the time involved in this process is measured in "memory spans," or the spans of time in which relatively instantaneous and fragmentary perceptions are assembled into meaningful units.[9] That the reading or viewing occurs in prolonged time spans rather than in instants gives rise to an impression of movement in the work under inspection (although Gombrich begs the question as to whether passing time is truly represented or merely implied). A sense of movement becomes conceivable because the viewing of pictures, like visual perception more generally, takes longer than is generally supposed. But a picture apparently can include only an amount of time equivalent to one memory span and no more, the same length of time required to grasp the picture's meaning. And the link then between the viewer's time and the imaginary time of the work remains in force, even if the time passing on either side of the picture frame – if the situation can

be described in such terms – is extended beyond what Shaftesbury or Lessing would have accepted.[10]

INTO AN HOURGLASS

Souriau and Gombrich, in their discussions of time and movement in the visual arts, are quite right to emphasize the extent and duration of this process (even if they describe it in different ways); viewing time is often rather slow, as experimental studies of the matter have amply demonstrated.[11] Indeed, pictures, like any object of vision, must be inspected piece by piece, the various pieces being integrated in our short-term memories. Our initial impression of a picture is one of only indistinct shapes and colors: The nuance and detail, the expressions and subtleties, do not reveal themselves immediately. And we must explore even the most limited spaces gradually, changing focus, moving in and out, examining textures, settings, and individual figures – integrating successive fragmentary observations into a composite view, a total understanding that we sometimes confuse with our initial perception.

Ghiberti, in transcribing Alhazen's views on perception and beauty, surely understood the complexity of this process as well as its duration. Not surprisingly, Alberti, too, clearly recognized the prolonged and unhurried character of aesthetic delectation. In *De re aedificatoria*, for example, in the passage cited in this chapter as an epigraph, Alberti compares looking at a painting to reading a good story (*bonam historiam*).[12] And in *De pictura*, he wrote:

A "historia" you can justifiably praise and admire will be one that reveals itself to be so charming and attractive as to hold the eye of the learned and unlearned spectator for a long while with a certain sense of pleasure and emotion.[13]

Alberti evidently had in mind a process more than a momentary response. In addition, the ground rules of one-point perspective, as they were promulgated and practiced in the quattrocento – Alberti's own *De pictura* being one of the key documents in this regard – in no

way proscribe this protracted sort of viewing process. Ultimately, however, the amount of time a viewer actually spends in front of a painting or relief, no matter how brief or how long it may be, has little or no bearing on the imaginary time presented within the given artwork, even if we have come to think differently. As we have already seen, long spans of time, elaborate stories, and complex chains of events encompassing days or even years are often represented in pictures the appreciation of which requires a relatively small amount of time: "[T]h' accomplishment of many years," in Shakespeare's words, is turned "[i]nto an hourglass."

Although reading pictures takes longer than is generally supposed, it is not a determinant of narrative time, and, conversely, the time passing within a picture need not be measured in terms of the viewer's movements in front of that picture (unless, of course, we accept Castelvetro's unities). Only later, long after the quattrocento, was the link forged between the viewer and that which is represented, and both sides of the pictorial equation brought into balance. And as the imaginary world of the picture is made to coincide, in the most literal sense, with the spectator's reality, time and continuous narrative are driven from the field.

PERCEPTION AND IMAGINATION

It has been argued here that pictures, like the visual world itself, can be experienced piece by piece, as a succession in both space and time, and that this is especially true when it comes to continuous narratives. We imagine ourselves within the picture space, moving throughout it over time as if it were the real world, following, even participating in, the sequence of events described. But reading pictorial narratives in this manner does not preclude a continuing awareness of an image in its totality. When several moments or episodes are included in the same work, they all remain in view, even as we concentrate our attention on first one and then another.

Ghiberti's Isaac panel (Fig. 1), for example, records a traditional narrative that unfolds in space and time: We willingly pass from one

moment to the next as if they were taking place before our eyes. Yet Ghiberti's relief remains a gilded surface of limited depth, with several Isaacs, several Rebeccas, and numerous Jacobs and Esaus. If we wish, we can look at each figure or moment in succession, temporarily disregarding the others, focusing on one Jacob or one Esau, and then on the next, and so on. But at the same time we see all of them together: all of the episodes, all of the figures. Neither one of these potentially contradictory impressions resolves entirely into the other; we oscillate between them, experiencing the part and the whole, separately and together. Mediating these apparently disparate possibilities is, as we have seen, the function of human memory.

It is this complex, synthetic form of looking that makes continuous narrative in particular a powerful expressive means. Because we see the separate events of which such narratives are composed both in sequence and together, at essentially the same time, these events modify each other in ways that are not possible, or less possible, in a series of completely separate scenes. Continuous narrative can be a way of emphasizing one action or event over others or of inflecting the meaning of one particular moment by its size or position in relation to another.[14] In Masaccio's *Tribute Money* (Fig. 2), the emphasis is on Christ's authority, or the transfer of that authority, more than it is on Peter himself or on the miracle of the fish. So too, in Lippi's *Banquet of Herod* (Fig. 3), does Salome's dance become especially macabre because of the two later, and very grisly, moments that bracket it.

The complex interplay between the reality of the painted surface and the imaginary world it describes is not, of course, unique to continuous or to any other kind of polyscenic narrative; it is also inherent in Renaissance perspective (or in any attempt to create the illusion of three-dimensional space on a two-dimensional surface). All such images demand a certain degree of deliberate self-deception, the willing suspension of disbelief (as Coleridge would describe it); they require us to balance the impression of a two-dimensional design with the illusion it creates, to coordinate perception, recognition, and imagination. We accept the suggestion of depth without being entirely deceived, without ceasing to appreciate its two-dimensional character and the formal or iconographic relationships it implies.[15]

Yet our willing participation, even complicity, in the creation of pictorial space does not undermine its plausibility as an analog of real space: We can experience the illusion of space fully, even if we are implicated in the deception. Without our full cooperation – when imagination and memory play no role – such representations remain inanimate or meaningless patterns that we admire passively, abstract designs or transcriptions in which time and continuous narrative certainly have no place. But once we accept the spatial illusion that one-point perspective can create – if, that is, we allow ourselves to break through the picture surface and enter the world beyond – we must at the same time recognize the implications of this act of imagination. To the extent that we are willing to imagine a painted (or sculpted) surface as real space, we must be prepared to experience that space in all its dimensions, including, of course, time; surface is transformed into space, and simultaneity dissolves into succession. Thus the apparently paradoxical nature of continuous narrative is in the end simply a function of the paradoxical nature of pictorial representation in general. On its own terms, within the imaginary world beyond the picture plane, continuous narrative is really no paradox at all.

DEFINITIONS

THE DESIGNATION "CONTINUOUS NARRATIVE" generally refers to various methods of combining individual scenes, moments, or actions into a unified context of some kind, usually indicated by a frame or by other, similar means. The term has often been used rather loosely, but attempts have been made to arrive at more precise formulations, mostly in relation to ancient or Early Christian art. Kurt Weitzmann, for example, in his study of ancient manuscript illustration, *Illustrations in Roll and Codex*, proffers a tripartite schema that both describes the evolution of narrative art and distinguishes between different kinds of pictorial narration.[1] Weitzmann speaks first of all of the "simultaneous method" characteristic of the art of the archaic period in Greece, whereby "within the limits of a single scene several actions take place at the same time, that is, simultaneously" (without the repetition of any of the actors in the scene).[2] Although more than one moment is included, the figures are so oriented as to form a single compositional unit, blurring the boundaries between individual actions or episodes.

The simultaneous method quickly gives way, under the sway of classical rationalism (and a new interest in narration per se), to the "monoscenic method," a method based on the principle of the unity of time and place: The secondary moments are stripped away, and only one action is represented in any given composition. All the elements in the scene are thus keyed to one moment and one moment only (the approach with which we are the most familiar and the one that we take largely for granted).[3]

The monoscenic approach evolves, in conjunction with the development of the illustrated text, into the "cyclical method," generally associated with Hellenistic or Roman art. In narratives of this type, a series of individual scenes are shown together in the same painting, the actors being repeated as appropriate. The repetition of figures, forming each group into a distinct compositional unit, signals that more than one moment is represented. This is a departure from the

simultaneous method in which more than one moment is shown but characters are not repeated. Also unlike the simultaneous method, the space for each unit or moment is to be regarded as separate from the rest, whether or not any division is marked, so that the unity of time and place is presumably preserved: Each episode is shown in its own setting or place, even if several such places are included in the same picture.[4]

For these same categories, Franz Wickhoff, in his seminal study of the Vienna Genesis, had used the terms "complementary" (*completirend*), "isolating" (*distinguirend*), and "continuous" (*continuierend*).[5] For the last category – the continuous method – Wickhoff added the precondition that the scenes be presented in a friezelike arrangement and connected by a common landscape background. Accordingly, his continuous method is really a special case of Weitzmann's more inclusive cyclical method, where no restrictions as to the nature of the background obtain. Weitzmann's definition refers to any narrative cycle in which more than one scene is given in a unified context, which can include decorative as well as spatial arrangements.[6]

Peter von Blanckenhagen, in an essay on Hellenistic and Roman art, offers something of a compromise with respect to this third category (the continuous, or cyclical, method). For von Blanckenhagen a continuous narrative is one in which events separated in time are shown "at the same place in the same setting."[7] As in Weitzmann's cyclical method, von Blanckenhagen's definition requires that identical persons appear more than once; but like Wickhoff, he insists upon a unifying background of some kind, although he does not restrict the arrangement to a frieze.

Although broader, Weitzmann's approach is concerned with narration per se: His primary interest is in tracing the development of the narrative impulse and the development of pictorial cycles – their expansion and contraction – in relation to textual sources. For him there is nothing anomalous about what he terms the cyclical method; the more restrictive definitions, on the other hand, shift our attention to the potentially paradoxical relation between time and space in pictorial depiction, ultimately a question of visual perception and aesthetic theory as much as it is an iconographic issue. These discussions

focus on the apparently anomalous narrative images in which more than one event takes place in what appears to be a single, unified setting.[8]

Taking these limited approaches as a point of departure, narratives then can be broken down rather simply on a conceptual rather than a historical basis: We need not refer back to their origins, to the circumstances of their invention, in order to distinguish between various methods of narration. Instead, we can sort pictorial narratives into two basic categories on the basis of how many episodes are included within a given setting.

In the first group are those narrative pictures that can be called "monoscenic" (corresponding either to Weitzmann's monoscenic method or to Wickhoff's isolating method), in which only one action or episode is represented: Every element in the picture pertains to, and is conceived in terms of, a single or key moment. The second category includes those narratives in which more than one moment is included in a single, unified context. This sort of pictorial narrative (the potentially paradoxical variety just discussed) can be described as "polyscenic" or "continuous" (corresponding to the simultaneous and cyclical methods described by Weitzmann or the complementary and continuous categories in Wickhoff's account).[9]

The question of what constitutes a unified context remains a ticklish one. We are in immediate difficulty, for example, when it comes to frieze compositions (such as the Odyssey landscapes) in which the landscape continues behind a succession of frames, thereby spatially unifying a series of separately framed units. Are they to be considered a single extended scene or a series of individual scenes? A related problem arises regarding compositions, again often friezes, that are too extensive physically to be considered a single composition in all but the most general sense. Is a frieze that extends from one wall to another wall one composition or several? And what about Trajan's column? In such cases the space must be understood more as a means of continuity than as an indication of a single location; size and viewing distance are, of course, important considerations in evaluating such narratives.[10]

Even for the quattrocento – when new, more unified methods of

representing space emerged – a firm definition of a single setting is not possible: We cannot really define the setting or place in terms of the spatial construction alone, as we have already seen; subject and size must also be considered before a pictorial space can be defined as but one place and a multiple narrative deemed continuous or polyscenic in the strictest sense. Ambiguities of this sort notwithstanding, we are essentially talking about a single composition, in the generally understood sense, indicated by a frame or related device (even if the limit is only implied); when more than one moment is represented within such a limit, that image can be regarded as continuous.

The term "continuous narrative" as a general and broad category has been subdivided or refined in a number of ways, taking into account a variety of specific characteristics and needs. Warman Welliver, for example, in a thought-provoking but not entirely convincing discussion of Masaccio's *Tribute Money*, proposes a distinction based on the nature of the units comprising the narrative image, that is, on whether the activities in question can be described or characterized as entire scenes, or merely as moments. According to Welliver, those pictures that include a series of discrete scenes, somewhat separate from one another (but presumably still within the same setting), can be called "continuous scenes," whereas those images, ostensibly simultaneous, that show a relatively brief succession of closely related actions should instead be termed "continuous action."[11]

Masaccio's *Tribute Money*, as Welliver explains it, includes both forms of narration. The central episode, often read as a single moment, can also be interpreted as a series of exchanges, a sequence of actions leading from the tax collector to Christ to Peter and then back again to the tax collector: Payment is demanded, Christ and Peter respond, and the collector indicates where the payment should be made. Although everything appears to be happening simultaneously, each figure is shown at a slightly different moment (or combination of moments). Accordingly, this part of the fresco can be described as "continuous action."[12]

The main scene is then combined with two other individual events, the Miracle of the Stater on the left and Peter's final encounter with the pesky tax collector on the right, and therefore Masaccio's picture

also qualifies as an example of "continuous scenes." Each of the events is separate from the others, but these three scenes are clearly continuous as well.

Welliver's distinction between action and narrative, or action and scenes, is really one of degree rather than of kind or principle. Although "continuous scenes" (or whatever one chooses to call them) can be mistaken for simultaneous depictions, as representations of single moments in which all movement has been arrested – such has sometimes been the fate of Leonardo's *Last Supper* or Poussin's *Fall of Manna* – time passes all the same, and in this respect such images are certainly comparable to those in which the passage of time is more extended and obvious. "Continuous action" is really only a special case of "continuous scenes"; conversely, the latter is only an expanded, elaborate version of the former. Nevertheless, without being overly dogmatic or even adopting Welliver's proposed terminology (which he himself eschews), we can still make a useful distinction between successions of separate incidents or events, on the one hand, and individual actions that have been subtly, almost imperceptibly, broken down into their component parts or actions, on the other.[13]

In the former category, when speaking of a succession of incidents, we can also differentiate between closely related moments or scenes, all belonging to essentially the same episode or story, and more extended, disparate narratives. As we have seen, Masaccio's fresco, taken as a whole, shows a single miracle described in successive phases following closely on one another. In contrast, Botticelli's St. Zenobius panel in New York depicts three entirely separate miracles (one of them in two phases) in an expansive town square.[14] Once again, the difference is as much a matter of degree as it is a distinction in kind: We can easily imagine narratives that fall somewhere between these extremes, or that include aspects of both types, but such distinctions might well prove useful nonetheless, at least in certain cases.[15]

Continuous narratives can be further differentiated on the basis of whether or not the various moments represented are indicated by the repetition of one or more characters. Individual episodes or actions – either close in time or clearly separated – can be shown without re-

peating any of the figures or with the same character or characters appearing more than once. This distinction corresponds to several of Weitzmann's categories, to his "simultaneous method" and "cyclical method" (and to Wickhoff's "complementary" or "continuous narratives"). But no historical evolution is implied here. The question is simply one of clarity (as is essentially true for Welliver's proposed breakdown as well).

If the figures included within a given image are not repeated (whether we are dealing with scenes or with actions), the narrative may have to be read with extra care: A spectator, unfamiliar with such methods or with the subject matter, can easily be misled and fail to recognize the presence of more than one moment or event. The repetition of figures, however, eliminates such confusion. The repeated appearance of one or more figures makes distinctions between moments more obvious while establishing the repeated characters as a dramatic focus and unifying force.[16]

Many of the narratives of the quattrocento are of this latter, explicit, type, emphasizing the passage of time through the repetition of figures. Masaccio's *Tribute Money* is, of course, one well-known instance of this (if we speak only of the main groupings or episodes, at any rate), and the St. Zenobius panel in New York is another; there are numerous additional examples, some of which have been mentioned. And it is very specifically to visual narratives of this kind – to narratives that include more than one moment, and in which the same figures are freely repeated – that the terms "continuous narrative," "continuous method," or even "continuous style" are most frequently (although not always carefully) applied.

In an earlier version of this study, I insisted upon differentiating between those images in which such repetition occurs and those where it does not, designating the former in the standard way, as continuous narratives, and the latter as complementary narratives, following Wickhoff. I then used the term "polyscenic" to describe all narrative images in which more than one moment is represented, whether or not the same figures are repeated. In other words, the continuous method and the complementary approach were presented as two forms of poly-

scenic narration, which was the more general, inclusive designation.[17] But this scheme proved unwieldy, and I have chosen to abandon it, preferring a simpler course.

To avoid a plethora of labels and the proliferation of categories that are ultimately confusing and restrictive, I have used only the term "continuous narrative," which is meant to describe all of the apparently paradoxical images in which the passage of time is represented within a unified context – whether the temporal flow is immediately obvious, or somewhat disguised; whether the spaces of time involved are greatly extended, or of relatively brief duration; and whether or not the same actors appear over and over again. The issues are essentially the same in every case. A more detailed set of definitions may eventually become necessary, depending, of course, on where future investigations lead. But the present study is primarily concerned with general theoretical matters and not with the classification of individual images; a single all-embracing term would therefore seem to be sufficient.

NOTES

ANNOTATIONS NECESSARY FOR THE UNDERSTANDING OF THE BOOK

Wherein the verity of some of the precepts is proved, and some arguments, which to the contrary might be objected, are refuted.

TO THE READER

When I had ended my book and shown it (to be perused) to some of better skill in letters than myself, I was by them requested to give some contentment to the learned, both by setting down a reason why I had disagreed from the opinion of others, as also to explain something which in the book itself might seem obscure. I have therefore thought it best to set down in Annotations such things as in the text could not so commodiously be handled, for interrupting of the continual course of the matter, that both the young beginner should not be overloaded with those things which at the first would be too hard for him to conceive, and also that they who were more skilful might have a reason for my proceedings.

THOMAS MORLEY*
*T. Morley, *A Plain and Easy Introduction to Practical Music*,
ed. R. A. Harman (New York, 1973), 100.

INTRODUCTION

1. Leonardo da Vinci, *The Literary Works of Leonardo da Vinci*, ed. J. P. Richter (London, 1939), no. 916 (MS Br. M. 173b). For a discussion of this and related statements, see Chapter 4.
2. J. Joyce, *Ulysses* (New York, 1966), 37.
3. L. B. Alberti, *De pictura*, ed. C. Grayson (Rome and Bari, 1975), paras. 12, 19. See also E. Panofsky, *Renaissance and Renascences in Western Art* (New York, 1972), 137–9, 165–8.
4. The essential interpretation of Alberti's method remains E. Panofsky, "Das perspektivische Verfahren Leone Battista Albertis," *Kunstchronik*, n.s. 26

(1915): 504–16; idem, "Die Perspektive als symbolische Form," *Vorträge der Bibliothek Warburg*, 1924–5 (Leipzig and Berlin, 1927), 284; and idem, *Renaissance and Renascences*, 123–8. Cf. A. Parronchi, *Studi su la dolce prospettiva* (Milan, 1964), 296–312; R. Krautheimer and T. Krautheimer-Hess, *Lorenzo Ghiberti*, 3d ed. (Princeton, 1982), 244–8. See also S. Y. Edgerton, "Alberti's Optics" (Ph.D. diss., University of Pennsylvania, 1965), 44–172, and idem, "Alberti's Perspective: A New Discovery and a New Evaluation," *Art Bulletin* 48 (1966): 367–78; J. Gadol, *Leon Battista Alberti: Universal Man of the Early Renaissance* (Chicago and London, 1969), 37–54; F. Borsi, *Leon Battista Alberti* (New York, 1977), 294.

5. See Krautheimer and Krautheimer-Hess, *Lorenzo Ghiberti*, 229–53. Cf. Parronchi, *Studi su la dolce prospettiva*, 313–48. See also G. Degl'Innocenti, "Problematica per l'applicazione della metodologia di restituzione prospettica a tre formelle della Porta del Paradiso di Lorenzo Ghiberti: proposte e verifiche," in *Lorenzo Ghiberti nel suo tempo*, Atti del convegno internazionale di studi (Florence, 1980), 561–87; J. Beck, *The Baptistry Doors, Florence* (Florence, 1985), 41–4. The panels for the *Porta del Paradiso* were designed and modeled sometime between 1428 and 1437; the precise order in which they were conceived remains uncertain.

6. For a discussion of terminology and definitions, see the Appendix.

7. There has been considerable disagreement as to how some of the individual episodes are to be identified; see J. Pope-Hennessy, *The Study and Criticism of Italian Sculpture* (New York, 1980), 51–2. Cf. F. Hartt, "*Lucerna ardens et lucens*: il significato della Porta del Paradiso," in *Lorenzo Ghiberti nel suo tempo*, 40–3.

8. On Masaccio's fresco, which has recently been cleaned, see U. Baldini and O. Casazza, *La Cappella Brancacci* (Milan, 1990), 39–81. See also Chapter 5 in this study.

9. Lippi's *Banquet of Herod* is part of a fresco cycle in the main chapel of the Duomo in Prato that includes scenes from the lives of St. Stephen and St. John the Baptist (three frescoes for each saint). Although Lippi received the Prato commission in 1452, most scholars agree that the banquet scene was the last of the scenes to be painted, perhaps as late as 1464 or 1465. See E. Borsook, *The Mural Painters of Tuscany* (Oxford, 1980), 102, and idem, "Fra Filippo Lippi and the Murals for Prato Cathedral," *Mitteilungen des Kunsthistorischen Institutes in Florenz* 19 (1975): 66–8. See also G. Marchini, *Il Duomo di Prato* (n.p., 1957), 57, and idem, *Filippo Lippi* (Milan, 1975), 99–100, in which he revises his position in certain respects but still supports a late dating, after 1463. For a recent discussion of Lippi's frescoes in Prato, see J. Ruda, *Fra Filippo Lippi: Life and Work, with a Complete Catalogue* (London, 1993), 258–92, 455–64. See also Chapter 5.

10. D. Frey, *Gotik und Renaissance: Als Grundlagen der modernen Weltanschauung* (Augs-

burg, 1929), 38. Eng. trans. in *Art History: An Anthology of Modern Criticism*, ed. W. Sypher (New York, 1963), 156.

11. Ibid., 55 (Eng. trans., p. 165).

12. Gadol, *Leon Battista Alberti*, 58. For similar and related views, see F. Antal, *Florentine Painting and Its Social Background* (London, 1947), 148; A. Hauser, *The Social History of Art* (New York, 1951), 1: 272–4; E. H. Swift, *Roman Sources of Christian Art* (New York, 1951), 69; J. Spencer, introduction to his translation of L. B. Alberti, *On Painting* (London, 1956), 23–4; D. Kunzle, *The Early Comic Strip: Narrative Strips and Picture Stories in the European Broadsheet from c. 1450 to 1825* (Berkeley, Los Angeles, and London, 1973), 4; W. Steiner, *The Colors of Rhetoric: Problems in the Relation between Modern Literature and Painting* (Chicago and London, 1982), 58; and A. B. Barriault, *Spalliera Paintings of Renaissance Tuscany: Fables of Poets for Patrician Homes* (University Park, 1994), 61–2.

13. The only true exception is Giotto's *The Birth of the Virgin*, in which the infant Mary appears twice. For bibliography on Giotto's frescoes, see C. Brandi, *Giotto* (Milan, 1983), 173–5, 188–9. See also G. Basile, *Giotto: The Arena Chapel Frescoes* (London, 1993), 383–5. On the term "monoscenic" and related definitions, see Appendix.

14. In addition to the Baptism proper (in the center, foreground), the fresco includes the Baptist preaching and advancing toward the Jordan (both on the left), as well as Christ preaching (on the right). On the attribution of this fresco, see P. Scarpellini, *Perugino* (Milan, 1984), 78; and R. Salvini (with an appendix by E. Camesasca), *The Sistine Chapel* (New York, 1965) 1: 39–40, 175–6. See also L. D. Ettlinger, *The Sistine Chapel before Michelangelo* (Oxford, 1965), 76–7. Among recent studies of the Sistine cycle, see C. F. Lewine, *The Sistine Chapel Walls and the Roman Liturgy* (University Park, 1993), esp. 103–14; R. Goffen, "Friar Sixtus IV and the Sistine Chapel," *Renaissance Quarterly* 39 (1986): 218–63; and J. Shearman, "The Chapel of Sixtus IV," in *The Sistine Chapel: A New Light on Michelangelo; The Art, the History, and the Restoration*, ed. C. Pietrangeli et al. (New York, 1986), 22–87.

15. See J. Moorman, *A History of the Franciscan Order: From Its Origins to the Year 1517* (Oxford, 1968), 83–95. See also G. Kaftal, *The Iconography of the Saints in Tuscan Painting* (Florence, 1952), 354.

16. The date and authorship of the frescoes in Assisi are the subject of considerable controversy. See J. White, *Art and Architecture in Italy, 1250–1400*, 3d ed. (New Haven and London, 1993), 344–8; and A. Smart, *The Assisi Problem and the Art of Giotto* (Oxford, 1971), 3–45. See also R. Offner, "Giotto, Non-Giotto," *Burlington Magazine* 74 (1939): 259–68; M. Meiss, *Giotto and Assisi* (New York, 1960), 1–28; and J. H. Stubblebine, *Assisi and the Rise of Vernacular Art* (New York, 1985), 131–6.

17. There is no conclusive evidence concerning the date of the Bardi Chapel frescoes; they are generally dated to the second or third decade of the four-

teenth century. See White, *Art and Architecture in Italy*, 334–7. See also R. Goffen, *Spirituality in Conflict: St. Francis and Giotto's Bardi Chapel* (University Park and London, 1988), 51–77; and J. Long, "Bardi Patronage at Santa Croce in Florence, c. 1320–1343" (Ph.D. diss., Columbia University, 1988).

18. The Charity of St. Francis is combined with the Dream of the Heavenly Palace, and St. Francis Preaching to the Birds is included in the same lunette as St. Francis Driving the Demons from Arezzo. The other seven surviving frescoes are monoscenic. See A. Chiapelli, "Puccio Capanna e gli affreschi in San Francesco di Pistoia," *Dedalo* 10 (1929–30): 199–228. Chiapelli attributes the Pistoia frescoes to Puccio Capanna (and another unidentified hand). Kaftal (*The Iconography of the Saints in Tuscan Painting*, 388) ascribes them to the Master of the Gondi Chapel in S. Maria Novella. D. Blume (*Wandmalerie als Ordenpropaganda: Bildprogramme in Chorbereich franziskanischer Konvent Italiens bis zur Mitte des 14. Jahrhunderts* [Worms, 1983], 162), following G. L. Mellini ("Commento a 'Dalmasio,'" *Arte illustrata* 27–9 [1970]: 40–55), gives them to Dalmasio, a painter of Bolognese origins who was in Florence toward the middle of the trecento.

19. Sassetta's altarpiece was dismantled in the eighteenth century and the pieces are now dispersed among various collections: Seven narrative panels are now in the National Gallery, London (nos. 4757–63); another, the *Marriage of St. Francis to Poverty* is in Chantilly (Musée Condé). Like the master of the Pistoia frescoes, Sassetta combines the Charity of St. Francis and the Dream of the Heavenly Castle, two episodes that had been presented separately at Assisi, in one panel (National Gallery, London, no. 4757); in the Chantilly panel, Poverty and her companions appear twice. The rest of the paintings are monoscenic. On Sassetta's altarpiece, see M. Davies, *The Earlier Italian Schools*, London National Gallery Catalogue, 2d ed., rev. (London, 1961), 502–12; E. Carli, *Sassetta e il Maestro dell'Osservanza* (Milan, 1957), 50–76, and idem, "Sassetta's Borgo San Sepolcro Altarpiece," *Burlington Magazine* 93 (1951): 145–52; J. Pope-Hennessy, *Sassetta* (London, 1939), 96–111; B. Berenson, *A Sienese Painter of the Franciscan Legend* (London, 1903), 21–43. See also J. Pope-Hennessy, "Rethinking Sassetta," *Burlington Magazine* 98 (1956): 365–70.

20. On Gozzoli's frescoes in Montefalco, see A. Padoa Rizzo, *Benozzo Gozzoli: pittore fiorentino* (Florence, 1972), 39–44, 115–16. See also A. Boschetto, *Gli affreschi di Benozzo Gozzoli nella chiesa di S. Francesco a Montefalco* (Milan, 1960); S. Nessi, "La Vita di S. Francesco dipinta da Benozzo Gozzoli a Montefalco," *Miscellanea Francescana* 61 (1961): 467–92; H. W. van Os, "St. Francis of Assisi as a Second Christ in Early Italian Painting," *Simiolus* 7 (1974): 130–2; E. Giese, *Benozzo Gozzolis Franziskuszyklus in Montefalco: Bildcomposition als Erzahlung* (Frankfurt am Main and Bern, 1986); M. A. Lavin, *The Place of Narrative: Mural Decoration in Italian Churches, 431–1600* (Chicago and London, 1990), 149–52.

21. Like both Sassetta and the Pistoiese master, Gozzoli combines the Charity

of St. Francis and the Dream of the Heavenly Palace. He also joins St. Francis Preaching to the Birds and St. Francis Blessing the City of Montefalco. Neither scene is included in Sassetta's series, but in San Francesco in Pistoia, St. Francis Preaching to the Birds is linked to St. Francis Driving the Demons from Arezzo.

22. Gozzoli's version of the Approval of the Rule features Pope Honorius III rather than Innocent III; it is nevertheless patterned on the *Approval of the Rule by Innocent III* at Assisi (which, at Assisi, follows the fresco of the *Dream of Innocent III*). No representation of the Birth of St. Francis prior to Gozzoli's is known, and the Montefalco fresco includes three episodes (one of which, the Homage of a Simpleton, is represented at Assisi as a single scene). On the Birth of St. Francis, see Nessi, "La Vita di S. Francesco dipinta da Benozzo Gozzoli," 477–80, and van Os, "St. Francis of Assisi as a Second Christ," 130–2.

23. On Gaddi's panel, see A. Ladis, *Taddeo Gaddi: Critical Reappraisal and Catalogue Raisonné* (Columbia and London, 1982), 114–26. On later, sixteenth-century pictures of the life of St. Francis (in which continuous narrative is often employed), see S. P. V. Rodinò, "Francescanesimo e pittura riformata in Italia centrale," in *L'Immagine di San Francesco nella controriforma*, Comitato Nazionale per le Manifestazioni Culturali per l' VIII Centenario della Nascita di San Francesco di Assisi (Rome, 1982), 63–72.

24. J. Pope-Hennessy, *A Sienese Codex of the Divine Comedy* (London, 1947), 33–5. Later critics have failed to appreciate the implications of Pope-Hennessy's observations. Cf. C. Singleton, M. Meiss, and P. Brieger, *Illuminated Manuscripts of the Divine Comedy* (Princeton, 1969), 47, 101, 107–9.

25. B. Fazio, *De viris illustribus* (chapter entitled "De pictoribus"), quoted in M. Baxandall, *Giotto and the Orators: Humanist Observers of Painting in Italy and the Discovery of Pictorial Composition, 1350–1450* (Oxford, 1971), 104–5 (Latin text, p. 164). On Gentile's altarpiece, see K. Christiansen, *Gentile da Fabriano* (Oxford, 1971), 24–37, 96–9.

26. Fazio, quoted in Baxandall, *Giotto and the Orators*, 109 (Latin text, p. 167).

27. Fazio, quoted in Baxandall, 104–5 (Latin text, p. 163).

28. Alberti, *De pictura*, ed. Grayson, para. 49.

29. A. Averlino detto Il Filarete, *Trattato di Architettura*, ed. A. M. Finoli and L. Grassi (Milan, 1972), 2: 672 (Book 24). Eng. trans., *Filarete's Treatise on Architecture: Being the Treatise by Antonio di Piero Averlino, Known as Filarete*, trans. J. R. Spencer (New Haven and London, 1965), 1: 313. On Filarete's treatise, see J. Schlosser Magnino, *La letteratura artistica*, trans. F. Rossi, ed. O. Kurz (Vienna, 1924; reprint, Florence, 1977), 129–34.

30. Filarete, *Trattato*, 2: 674 (Book 24).

31. On Filarete's doors, see M. Lazzaroni and A. Muñoz, *Filarete: scultore e architetto del secolo XV* (Rome, 1908), 35–82. Filarete's reliefs of the martyrdoms of St.

Peter and St. Paul are more discursive and include more episodes than Giotto's versions of the same subjects, for example, in the Vatican Pinacoteca (the Stefaneschi Triptych, inv. 120). See also J. R. Spencer, "Filarete's Bronze Doors at St. Peter's: A Cooperative Project with Complications of Chronology and Technique," in *Collaboration in Italian Renaissance Art*, ed. W. Stedman Sheard and J. T. Paoletti (New Haven and London, 1978), 33–45; and C. Seymour, *Sculpture in Italy: 1400–1500* (Harmondsworth and Baltimore, 1966), 116–19.

32. L. Ghiberti, *Lorenzo Ghibertis Denkwürdigkeiten (I Commentarii)*, ed. J. von Schlosser (Berlin, 1912), 1: 48–50.

33. G. Vasari, *Le vite de' più eccellenti pittori scultori ed architettori*, ed. G. Milanesi (Florence, 1878–85), 2: 237–43 (on Ghiberti's doors; quote from p. 242), 297–8 (on Masaccio).

34. Vasari, *Vite*, 4: 343–4 (Raphael), 7: 181 (Michelangelo).

35. Leonardo da Vinci, *Literary Works*, no. 542. See Chapters 4 and 5.

36. L. Steinberg, "Leonardo's *Last Supper*," *Art Quarterly* 36 (1973): 297–410. Steinberg's basic point is reaffirmed by M. Kemp, *Leonardo da Vinci: The Marvellous Works of Nature and Man* (Cambridge, Mass., 1981), 191.

37. E. H. Gombrich, *Means and Ends: Reflections on the History of Fresco Painting* (London, 1976).

38. See Chapter 4; Luini's fresco is taken up at that point as well. See also Chapter 5.

39. Pope-Hennessy, *The Study and Criticism of Italian Sculpture*, 39–70.

40. Krautheimer and Krautheimer-Hess, *Lorenzo Ghiberti*, 189–202.

41. For the Krautheimers' response, see ibid., xxx–xxxiii (preface to the new edition).

42. S. Ringbom, "Some Pictorial Conventions for the Recounting of Thoughts and Experiences in Late Medieval Art," in *Medieval Iconography and Narrative: A Symposium*, ed. F. G. Andersen et al. (Odense, 1980), 38–69, and idem, "Action and Report: The Problem of Indirect Narration in the Academic Theory of Painting," *Journal of the Warburg and Courtauld Institutes* 52 (1989): 34–51. See also N. Goodman, "Twisted Tales; or Story, Study and Symphony," in *On Narrative*, ed. W. J. T. Mitchell (Chicago and London, 1981), 99–115.

43. U. Eco, O. Calabrese, and L. Corrain, *Le figure del tempo* (Milan, 1987).

44. Ibid., 61.

45. Lavin, *The Place of Narrative*.

46. Among other recent discussions of Renaissance narratives, see B. Lamblin, *Peinture et temps* (Paris, 1983), 161–74; C. Hope, "Religious Narrative in Renaissance Art," *Royal Society of Arts Journal* 134 (1985/6): 804–18; W. Steiner, *Pictures of Romance: Form against Context in Painting and Literature* (Chicago and London, 1988), 7–42; and L. Marin, *Opacité de la peinture: essais sur le représentation*

au Quattrocento (Florence, 1989), 165–90. See also J. M. Greenstein, *Mantegna and Paintings as Historical Narrative* (Chicago and London, 1992).

47. The conditions imposed on the viewer by one-point perspective are discussed in detail in Chapter 2.

48. J. Mesnil, *Masaccio et les débuts de la Renaissance* (The Hague, 1927), 118.

CHAPTER 1. "BY THE OCEAN OF TIME"

1. T. Mann, *The Magic Mountain*, trans. H. T. Lowe-Porter (New York, 1967), 541 (Chapter 7: "By the Ocean of Time").

2. P. Klee, "Creative Credo" (1920), trans. N. Guterman, in H. B. Chipp, *Theories of Modern Art: A Source Book By Artists* (Berkeley and Los Angeles, 1968), 184.

3. O. Pächt, *The Rise of Pictorial Narrative in Twelfth-Century England* (Oxford, 1962), 1.

4. On theories concerning the relation between the arts, see R. W. Lee, *Ut Pictura Poesis: The Humanistic Theory of Painting* (New York, 1967), esp. 8–9, 61–6; N. R. Schweizer, *The Ut Pictura Poesis Controversy in Eighteenth-Century England and Germany* (Bern and Frankfurt, 1972); F. H. Dowley, "The Moment in Eighteenth-Century Art Criticism," *Studies in Eighteenth-Century Culture* 5 (1976): 317–36; M. Fried, *Absorption and Theatricality: Painting and the Beholder in the Age of Diderot* (Berkeley and Los Angeles, 1980), 82–92 (esp. pp. 209 n. 54, 215–16 n. 90); T. Puttfarken, "David's *Brutus* and Theories of Pictorial Unity in France," *Art History* 4 (1981): 291–304, and idem, *Roger de Piles' Theory of Art* (New Haven and London, 1985), esp. 1–37; D. T. Mace, "Transformations in Classical Art Theory: From 'Poetic Composition' to 'Picturesque Composition,'" *Word and Image* 1 (1985): 59–86. See also W. Steiner, *The Colors of Rhetoric: Problems in the Relation between Modern Literature and Painting* (Chicago and London, 1982), 1–69; W. J. T. Mitchell, "Spatial Form in Literature: Toward a General Theory," in *The Language of Images*, ed. W. J. T. Mitchell (Chicago and London, 1980), 271–99; G. Kauffmann, *Zum Verhältnis von Bild und Text in der Renaissance* (Rheinisch-Westfälische Akademie der Wissenschaften, Vorträge, G249, Opladen, 1980); D. Rosand, "*Ut Pictor Poeta*: Meaning in Titian's *Poesie*," *New Literary History* 3 (1971–2): 527–46; M. Praz, *Mnemosyne: The Parallel between Literature and the Visual Arts* (Princeton and London, 1970), 3–27.

5. G. E. Lessing, *Laocoön: An Essay on the Limits of Painting and Poetry*, trans. E. A. McCormick (Baltimore and London, 1984), with a useful introduction by the translator. On Lessing, see also B. Croce, *Aesthetic: As Science of Expression and General Linguistic* (1901), trans. D. Ainslie (Boston, 1978), 449–58; E. Gombrich, "Lessing," *Proceedings of the British Academy* 43 (1957): 133–56; W. J. T. Mitchell, *Iconology: Image, Text, Ideology* (Chicago and London, 1986), 95–115.

6. Lessing, *Laocoön*, 77.

7. Ibid., 77.

8. Ibid., 91.

9. Anthony Ashley Cooper, third earl of Shaftesbury, *Second Characters or the Language of Forms*, ed. B. Rand (Cambridge, 1914), 35–6. On Shaftesbury, see D. Townsend, "Shaftesbury's Aesthetic Theory," *Journal of Aesthetics and Art Criticism* 41 (1982): 205–13. See also R. Voitle, *The Third Earl of Shaftesbury: 1671–1713* (Baton Rouge and London, 1984), esp. 349–66.

10. For one special case, see B. Newhall, "The Case of the Elliptical Wheel and Other Photographic Distortions," *Image* 28 (1985): 1–4. See also K. Varnedoe, "The Artifice of Candor: Impressionism and Photography Reconsidered," *Art in America* 68 (January 1980): 66–78; L. Nochlin, *Realism* (Harmondsworth, 1971), 23–33.

11. W. Sypher, *Four Stages of Renaissance Style: Transformations in Art and Literature, 1400–1700* (New York, 1955), 52.

12. Aristotle, *The Poetics*, trans. W. Hamilton Fyfe (London and New York, 1927), VII.1, 33.

13. Ibid., V, 21.

14. Ibid., VII, 31–3.

15. On Castelvetro, see H. B. Charlton, *Castelvetro's Theory of Poetry* (Manchester, 1913), esp. 83–94; B. Weinberg, *A History of Literary Criticism in the Italian Renaissance* (Chicago, 1961), 1: 502–13; idem, "Castelvetro's Theory of Poetics," in *Critics and Criticism: Ancient and Modern*, ed. R. S. Crane (Chicago, 1952), 349–71. See also R. C. Melzi, *Castelvetro's Annotations to the Inferno: A New Perspective in Sixteenth Century Criticism* (The Hague and Paris, 1966), 26–38.

16. L. Castelvetro, *Poetica d'Aristotele vulgarizzata e sposta*, ed. W. Romani (Rome and Bari, 1978–9), 1: 149: "Ma così come il luogo stretto è il palco, così il tempo stretto è quello che i veditori possono a suo agio dimorare sedendo in teatro; il quale io non veggo che possa passare il giro del sole, sì come dice Aristotele, cioè ore dodici, conciosia cosa che per le necessità del corpo, come è mangiare, bere, diporre i superflui pesi del ventre e della vesica, dormire e per altre necessità, non possa il popolo continuare oltre il predetto termine così fatta dimora in teatro." (Trans. mine.)

17. Ibid.: "... la quale [la tragedia] conviene avere per soggetto un'azzione avenuta in picciolo spazio di luogo e in picciolo spazio di tempo, cioè in quel luogo e in quel tempo dove e quando i rappresentatori dimorano occupati in operazione, e non altrove nè in altro tempo." (Trans. Charlton, *Castelvetro's Theory of Poetry*, 85.)

18. See C. Molinari, "Gli spettatori e lo spazio scenico nel teatro del cinquecento," *Bolletino del Centro Internazionale di Studi di Architettura Andrea Palladio* 16 (1974): 145–54.

19. Shaftesbury, *Second Characters*, 32.

20. C. Hope, "Religious Narrative in Renaissance Art," *Royal Society of Arts Journal* 134 (1985/6): 804–18, makes a similar point.

21. G. Vasari, *Le vite de' più eccellenti pittori scultori ed architettori*, ed. G. Milanesi (Florence, 1878–85), 2: 297.

22. On the importance of rhetorical models, see S. L. Alpers, "*Ekphrasis* and Aesthetic Attitudes in Vasari's *Lives*," *Journal of the Warburg and Courtauld Institutes* 23 (1960): 190–215, and M. Baxandall, *Giotto and the Orators: Humanist Observers of Painting in Italy and the Discovery of Pictorial Composition, 1350–1450* (Oxford, 1971), 51–120. Cf. E. Gombrich, "The Style all'antica: Imitation and Assimilation," in *Norm and Form* (Oxford, 1978), 128. See also E. Barnes Sanders, "Realism in Florentine Painting, 1400–1465: Practice and Theory" (Ph.D. diss., Columbia University, 1984), 143–69.

23. On the distinctions between the subjective experience of time and concepts of time in physics, see R. Morris, *Time's Arrows: Scientific Attitudes toward Time* (New York, 1984), 144–8.

24. R. Arnheim, "A Stricture on Space and Time," *Critical Inquiry* 4 (1977–8): 645–55.

25. On the perception of time, see K. Lynch, *What Time Is This Place?* (Cambridge, Mass., and London, 1972), 65–72, 117–34; and P. Fraisse, *The Psychology of Time*, trans. J. Leith (New York, 1963), 280–7. Both have extensive and useful bibliographies. See also R. Arnheim, "Space as an Image of Time," in *Images of Romanticism*, ed. K. Kroeber and W. Walling (New Haven, 1978), 1–12.

26. See R. P. Morgan, "Musical Space/Musical Time," in *The Language of Images*, ed. W. J. T. Mitchell (Chicago and London, 1980), 259–70.

27. Arnheim, "Space as an Image of Time," 1–3.

28. See J. J. Gibson, *The Perception of the Visual World* (Boston, 1950), 157–8. See also J. Snyder, "Picturing Vision," in *The Language of Images*, 219–46; and E. H. Gombrich, "Standards of Truth: The Arrested Image and the Moving Eye," in ibid., 181–217 (reprinted in Gombrich, *The Image and the Eye: Further Studies in the Psychology of Pictorial Representation* [Ithaca, 1982], 244–77).

29. Arnheim, "Space as an Image of Time," 3–7.

30. A. Paivio, "Imagery and Synchronic Thinking," *Canadian Psychological Review* 16 (1975): 152.

31. Recent interest in the role of images in cognition and memory has centered on Allan Paivio's *Imagery and Verbal Processes* (New York, 1971). Paivio proposes a dual-code theory according to which thought and memory rely on the interaction between visual and verbal processes. The function of memory that we have been discussing falls into the domain of what he calls visual or synchronous thinking; the processing of more abstract, sequentially constrained information is reserved for the verbal or sequential mode. This position is restated in idem, "Imagery and Synchronic Thinking," 147–63. See

also idem, "The Empirical Case for Dual Coding," in *Imagery, Memory and Cognition: Essays in Honor of Allan Paivio*, ed. J. C. Yulle (Hillsdale and London, 1983), 307–32; idem, *Mental Representations: A Dual Coding Approach* (New York, 1986); and F. S. Bellezza, "Mnemonic Devices and Memory Schemas," in *Imagery and Related Mnemonic Processes: Theories, Individual Differences and Applications*, ed. M. A. McDaniel and M. Pressley (New York, 1987), 34–55. Related views are presented in A. Koestler, "Abstract and Picture Strip," in *The Pathology of Memory*, ed. C. A. Talland and N. C. Waugh (New York, 1969), 261–70. For a critical view of dual-code theory and the role of visual imagery in cognition, see G. Cohen, "Visual Imagery in Thought," *New Literary History* 7 (1976): 513–23.

32. F. A. Yates, *The Art of Memory* (Harmondsworth, 1966), 1–26. See also Paivio, *Imagery and Verbal Processes*, 153–75.

33. Cicero, *De Oratore*, 2, lxxxvi, 351–4, quoted in Yates, *Art of Memory*, 2.

34. Ibid., 3.

35. M. Carruthers, *The Book of Memory: A Study of Memory in Medieval Culture* (Cambridge, 1990), 71.

36. Ibid., 122–55. See also idem, "Italy, *Ars Memorativa*, and Fame's House," in *Studies in the Age of Chaucer*, Proceedings Series 2 (1987): 179–88.

37. Yates, *Art of Memory*, 55–6, 105–14, 160–2. See also L. Bolzoni, "Teatralità e techniche della memoria in Bernardino da Siena," in *Il francescanesimo e il teatro medievale*, Miscellanea storica della Valdesa, 6 (Castelfiorentino, 1984), 180–4; P. Rossi, *Francis Bacon: From Magic to Science*, trans. S. Rabinovitch (Chicago, 1968), 270 n. 48; and J. D. Spence, *The Memory Palace of Matteo Ricci* (New York, 1984), 13–14.

38. Yates (pp. 91–104) makes tentative but suggestive connections between memory images and painting (concentrating on allegorical representations in the trecento). See also J.-P. Antoine, "*Ad perpetuam memoriam*. Les nouvelles fonctions de l'image peinte en Italie: 1250–1400," *Mélanges de l'école française de Rome: Moyen Age–Temps Modernes* 100 (1988): 541–615 Carruthers, *Book of Memory*, 221–60; and W. Kemp, "Visual Narratives, Memory and the Medieval *Esprit du Système*," in *Images of Memory: On Remembering and Representation*, ed. S. Küchler and W. Melion (Washington, D.C., and London, 1991), 87–108.

39. See Bolzoni, 190. See also M. Baxandall, *Painting and Experience in Fifteenth Century Italy: A Primer in the Social History of Pictorial Style*, 2d ed. (Oxford and New York, 1988), 46.

40. *Zardino de oration* (Venice, 1494), pp. x. ii v.–x. iii r. (Cap. XVI. Chome meditare la vita di christo . . .), quoted in Baxandall, *Painting and Experience*, 46.

41. Similar "spiritual exercises" can be found in many devotional writings of the period. In the *Meditations on the Life of Christ*, for example, the reader is repeatedly called upon to imagine herself present at the events described by the author. See *Meditations on the Life of Christ*, trans. Ragusa and Green, 1–5

and *passim*. See also E. H. Gombrich, *Means and Ends: Reflections on the History of Fresco Painting* (London, 1976), 34, and Barnes Sanders, "Realism in Florentine Painting," 110. For other examples, see Spence, *Memory Palace of Matteo Ricci*, 13–14, 259–80. See also M. Meiss, *Painting in Florence and Siena after the Black Death: The Arts, Religion, and Society in the Mid-Fourteenth Century* (Princeton, 1951), 121–31; S. Ringbom, "Devotional Images and Imaginative Devotions," *Gazette des Beaux-Arts*, ser. 6, 73 (1969): 159–70, and idem, "Maria in Sole and the Virgin of the Rosary," *Journal of the Warburg and Courtauld Institutes* 25 (1962): 326–30.

42. Hans Memling, *Scenes from the Passion*, Turin, Galleria Sabauda. The picture is generally dated to the early 1470s and was apparently commissioned by Tommaso Portinari; by Vasari's day it was in the collection of Cosimo I de' Medici. See D. De Vos, *Hans Memling: The Complete Works* (Ghent, 1994), 105–9; and M. Corti and G. T. Faggin, *L'opera completa di Memling* (Milan, 1969), 102 (no. 42). See also L. Castelfranchi Vegas, *Italia e fiandra: nella pittura del quattrocento* (Milan, 1983), 195. I am not suggesting any specific historical links between the handbook and Memling's painting, although such connections are certainly possible.

43. See N. Goodman, "Twisted Tales; or Story, Study, and Symphony," in *On Narrative*, ed. W. J. T. Mitchell (Chicago and London, 1981), 99–115.

44. *Zardino de oration*, pp. x. ii v.–x. iii r., quoted in Baxandall, *Painting and Experience*, 46.

45. On the relation between Renaissance realism and devotional practice, see Gombrich, *Means and Ends*, 32–9, and Barnes Sanders, 108–14. See also S. Sandström, *Levels of Unreality: Studies in Structure and Construction in Italian Mural Painting during the Renaissance* (Uppsala, 1963); S. Ringbom, *Icon to Narrative: The Rise of the Dramatic Close-up in Fifteenth-Century Devotional Painting* (Doornspijk, 1983), 11–71, 212–19. Cf. H. Belting, *Das Bild und sein Publikum im Mittelalter: Form und Funktion früher Bildtafeln der Passion* (Berlin, 1981), esp. 69–104.

46. On narrative in general, see R. Scholes and R. Kellog, *The Nature of Narrative* (London, 1966); *On Narrative*, ed. Mitchell. See also G. Genette, *Narrative Discourse: An Essay in Method*, trans. J. E. Lewin (Ithaca, 1983); S. Chatman, *Story and Discourse: Narrative Structure in Fiction and Film* (Ithaca and London, 1983); M. Bal, *Narratology: Introduction to the Theory of Narrative* (Toronto, 1985).

CHAPTER 2. THE VIEWER AND THE VANISHING POINT

1. J. Ruskin, *St. Mark's Rest, Lectures on Art, Opening of the Crystal Palace, Elements of Perspective* (New York, n.d.), 328 (*Elements of Perspective*, introduction).

2. A. Einstein, letter to M. H. Pirenne, 24 February 1955, quoted in Pirenne, *Optics, Painting and Photography* (Cambridge, 1970), 99 (trans. Pirenne).

3. D. Frey, *Gotik und Renaissance: als Grundlagen der modernen Weltanschauung* (Augsburg, 1929), 54. Eng. trans. in *Art History: An Anthology of Modern Criticism*, ed. W. Sypher (New York, 1963), 164.

4. Ibid., 54–5 (Eng. trans., pp. 164–5).

5. An argument similar to Frey's is the basis for Svetlana Alpers's distinction between Southern and Northern modes of seeing: As opposed to the synthetic approach to perspective that prevailed in the North, based on the distance-point method and presupposing, it seems, a moving eye, Southern perspective is tailored for a viewer in a fixed position and describes a single view of a homogeneous space. See S. Alpers, *The Art of Describing: Dutch Art in the Seventeenth Century* (Chicago, 1983), 41–70. A similar position is implicit in M. Scriabine, "La perspective temporelle dans les oeuvres de la Renaissance," in *Filippo Brunelleschi: la sua opera e il suo tempo*, Atti di convegno internazionale di studi (Florence, 1980), 1: 325–31. On Frey's position, see also Introduction.

6. G. C. Argan, "The Architecture of Brunelleschi and the Origins of Perspective Theory in the Fifteenth Century," *Journal of the Warburg and Courtauld Institutes* 9 (1946): 116.

7. On Brunelleschi's perspective experiments, see S. Lang, "Brunelleschi's Panels," in *La prospettiva rinascimentale: codificazioni e trasgressioni*, ed. M. Dalai Emiliani (Florence, 1980), 1: 63–72; L. Vagnetti, "La posizione di Filippo Brunelleschi nell'invenzione della prospettiva lineare: precisioni ed aggiornamenti," in *Filippo Brunelleschi: la sua opera e il suo tempo*, 1: 279–306; H. Damisch, "L' 'origine' de la perspective," *Macula* 5/6 (1979): 112–37, and idem, *L'Origine de la perspective* (n.p., 1987), 67–154; M. Kemp, "Science, Non-Science and Nonsense: The Interpretation of Brunelleschi's Perspective," *Art History* 1 (1978): 134–61, and idem, *The Science of Art: Optical Themes in Western Art from Brunelleschi to Seurat* (New Haven and London, 1990), 9–15, 344–5. Kemp suggests that Brunelleschi's invention of perspective occurred ca. 1413. A. Parronchi, *Studi su la dolce prospettiva* (Milan, 1964), 242–3, proposes a later date, 1424–5, after Paolo Toscanelli's arrival in Florence; D. Gioseffi, *Perspectiva artificialis: per la storia della prospettiva spigolature e appunti* (Trieste, 1957), 82, dates the perspective panels to the very first years of the quattrocento.

8. Antonio di Tuccio Manetti, *The Life of Brunelleschi*, ed. H. Saalman, trans. C. Engass (University Park and London, 1970), 44 (Italian text, p. 45), and see Saalman's introduction, pp. 10–20, for a discussion of the authorship and date of the *Vita*, matters of considerable controversy. See also, G. Tanturli, introduction to Antonio Manetti, *Vita de Filippo Brunelleschi preceduta de la novella del grasso*, ed. D. de Robertis and G. Tanturli (Milan, 1976), xiii–xlix.

9. Cf. Damisch, *L'Origine de la perspective*, 116–18.

10. Manetti, *Life of Brunelleschi*, 44, 46 (Italian text, pp. 45, 47).

11. Ibid., 46 (Italian text, p. 47).

12. Ibid., 44, 46 (Italian text, pp. 45, 47). Manetti specifies that two sides of the Palazzo della Signoria were shown, suggesting some sort of two-point construction (or "perspective cornue"). The adoption of such a method may well have motivated the more flexible viewing conditions Manetti describes, at least in part. But too many uncertainties remain about the appearance of the panels and the underlying perspective system to draw firm conclusions, and Manetti himself does not explain the matter in those terms. Cf. Damisch, *L'Origine*, 138-9.

13. Ibid., 46 (Italian text, p. 47). On the humor in Manetti's wording, see Damisch, *L'Origine*, 136-8.

14. Manetti describes how Brunelleschi cut away the upper portion of the panel, just above the buildings, and how he then took the panel to an unspecified outdoor location (not necessarily the Piazza della Signoria) for viewing, in order that the actual sky appear above the painted architecture. There is no mention, however, of any intention on Brunelleschi's part to have the viewer align the upper edge of the panel with the actual skyline and thereby establish a specific viewing position. Cf. Damisch, *L'Origine*, 136-43.

15. Piero della Francesca, *De prospectiva pingendi*, with additional material by E. Battisti et al., ed. G. Nicco-Fasola (1942; reprint, Florence, 1984), 96-7: ". . . per levare via l'erore ad alchuni, che non sono molto periti in questa scienza, quali dicono che molte volte nel devidere loro il piano degradato a bracci, li vene magiore lo scurto che non fa quello che non è scurto . . . e necessaria de fare una demostratione della vera distantia et quanto se può l'angolo ampliare nell'occhio" (trans. mine). The final phrase, "quanto si può l'angolo ampliare nell'occhio" (how much the angle is amplified in the eye) simply means the size of the visual angle. On Piero's treatise, probably written during the first half of the 1470s, see A. Janhsen, *Perspektivregeln und Bildgestaltung bei Piero della Francesca* (Munich, 1990), 9-48; M. Salmi, *La pittura di Piero della Francesca* (Novara, 1979), 199-204; L. Vagnetti, "Riflessioni sul 'De prospectiva pingendi,'" *Commentarii* 26 (1975): 14-55; and Nicco Fasola's introduction to *De prospectiva pingendi*, 3-59, as well as Battisti's remarks in the same volume, pp. vii-xxvii (with extensive bibliography, xliii-lxx). Piero's theorem has received a good deal of attention in recent years. See especially J. V. Feld, "Piero della Francesca's Treatment of Edge Distortion," *Journal of the Warburg and Courtauld Institutes* 49 (1986): 60-90, and Damisch, "La perspective au sens strict du terme," in *Piero: teorico dell'arte*, ed. O. Calabrese (Rome, n.d.), 20-7 (or idem, *L'Origine*, 315-23); see also J. Elkins, "Piero della Francesca and the Renaissance Proof of Linear Perspective," *Art Bulletin* 69 (1987): 220-3.

16. Damisch, "La perspective au sens strict du terme," 20-7.

17. Piero della Francesca, *De prospectiva pingendi*, 96-7.

18. Ibid., 98: "perchè entra nella parte de l'altro ochio col vedere."

19. Piero takes the matter one step further: Having established 90° (and the

corresponding distance) as a limit, as the maximum possible angle, he then suggests that smaller visual angles and rather longer distances are more satisfactory. For Piero, the ideal visual angle (in the construction) would be 60° rather than 90°, and the distance should be modified accordingly. Ibid., 99.

20. For Piero's frescoes, see M. Lavin, *The Place of Narrative: Mural Decoration in Italian Churches, 431–1600* (Chicago and London, 1990), 167–94. On Leonardo's *Last Supper*, see esp. L. Steinberg, "Leonardo's *Last Supper*," *Art Quarterly* 36 (1973): 346–60, 372–81. See also M. Kemp, *Leonardo da Vinci: The Marvellous Works of Nature and Man* (Cambridge, Mass., 1981), 189–99.

21. Leonardo da Vinci, *The Literary Works of Leonardo da Vinci*, ed. J. P. Richter (London, New York, and Toronto, 1939), no. 543 (MS A. 40b). For the dating of the various notebooks, I am following the indications in C. Pedretti, *The Literary Works of Leonardo da Vinci Compiled and Edited from the Original Manuscripts by Jean Paul Richter: Commentary* (Berkeley and Los Angeles, 1977), which follows Richter's numbering system.

22. Leonardo, *Literary Works*, no. 544 (MS A. 41a).

23. Ibid., no. 543.

24. Ibid., no. 544.

25. Ibid., no. 545 (MS A. 41b). In MS B.N. 2038.31b (Leonardo, no. 540), another manuscript from the early 1490s, Leonardo advises: "Quando ài a ritrarre di naturale sta lontano 3 volte la grandezza della cosa che tu ritrai." (When you draw from nature stand at a distance of 3 times the height of the object you wish to draw.)

26. Ibid., nos. 107, 108 (MS E. 16b, 16a).

27. Ibid., no. 108.

28. Ibid., no. 107. All forms are "automatically" presented *in propria forma* vertically, regardless of the distance used in the construction.

29. Cf. H. Damisch, "La perspective au sens strict du terme," 13–20.

30. For a different interpretation of Leonardo's basic terminology, see K. Veltman, *Linear Perspective and the Visual Dimensions of Science and Art*, Studies on Leonardo da Vinci, 1 (Munich, 1986), 165–9. See also J. White, *The Birth and Rebirth of Pictorial Space*, 3d ed. (Cambridge, Mass., 1987), 207–15; and J. Elkins, "Did Leonardo Develop a Theory of Curvilinear Perspective? Together with Some Remarks on the 'Angle' and 'Distance' Axioms," *Journal of the Warburg and Courtauld Institutes* 51 (1988): 192–3.

31. Leonardo, no. 108.

CHAPTER 3. A SINGLE GLANCE

1. Euclid, "The Optics of Euclid," trans. H. E. Burton, *Journal of the Optical Society of America* 35 (1945): 357.

2. Marsilio Ficino, *Opera Omnia* (Basel, 1576), 118 (from *Theologia Platonica*),

quoted in E. H. Gombrich, *Symbolic Images: Studies in the Art of the Renaissance* (Oxford, 1978), 77 (trans. Gombrich).

3. L. B. Alberti, *De pictura*, ed. C. Grayson (Rome and Bari, 1975), para. 7.

4. Ibid., para. 12.

5. See J. J. Gibson, "The Information Available in Pictures," *Leonardo* 4 (1971): 27–35, and idem, "The Ecological Approach to the Visual Perception of Pictures," *Leonardo* 11 (1978): 227–35. Cf. R. Arnheim, "Some Comments on J. J. Gibson's Approach to Picture Perception," *Leonardo* 12 (1979): 121–2. See also T. Frangenberg, "The Image and the Moving Eye: Jean Pélerin (Viator) to Guidobaldo del Monte," *Journal of the Warburg and Courtauld Insitutes* 49 (1986): 150–71.

6. Alberti, *De pictura*, para. 7. English translation Grayson, Alberti, *On Painting and Sculpture* (London, 1972), 43.

7. Leonardo da Vinci, *The Literary Works of Leonardo da Vinci*, ed. J. P. Richter (London, New York, and Toronto, 1939), no. 294.

8. D. C. Lindberg, "Medieval Latin Theories of the Speed of Light," in *Roemer et la vitesse de la lumière*, ed. R. Taton (Paris, 1978), 45–72.

9. See D. C. Lindberg, "The Science of Optics," in *Science in the Middle Ages*, ed. D. C. Lindberg (Chicago and London, 1978), 338–68.

10. On the *Third Commentary*, see R. Krautheimer and T. Krautheimer-Hess, *Lorenzo Ghiberti*, 3d ed. (Princeton, 1982), 306–14. A number of pertinent studies, by Gioseffi, Maltese, and others, appear in the Acts of the *Convegno Internazionale* devoted to Ghiberti held in Florence in 1978, *Lorenzo Ghiberti nel suo tempo* (Florence, 1980); I have relied here especially on G. Federici Vescovini, "Il problema delle fonti ottiche medievali del *Commentario Terzo* di Lorenzo Ghiberti," 349–87. A useful outline of the contents of Ghiberti's *Commentary* is provided by J. L. Hurd in the same volume, 312–15. Bergdolt, in his new edition of the *Third Commentary* (with a German translation), likewise provides a step-by-step explanation of its contents, which clarifies the underlying logic of Ghiberti's compilation; see L. Ghiberti, *Der dritte Kommentar Lorenzo Ghibertis: Naturwissenschaften und Medezin in der Kunsttheorie der Frührenaissance*, ed. and trans. K. Bergdolt (Weinheim, 1988) (hereafter "Bergdolt"), esp. lxxiv–lxxxiii. See also G. ten Doesschate, *De deerde Commentaar van Lorenzo Ghiberti in Verband met de middeleeuwsche Optik* (Utrecht, 1940); J. White, *The Birth and Rebirth of Pictorial Space*, 3d ed. (Cambridge, Mass., 1987), 126–30; A. Parronchi, *Studi su la dolce prospettiva* (Milan, 1964), 313–48; J. Schlosser Magnino, *La letteratura artistica*, ed. O. Kurz, trans. F. Rossi (Florence, 1977), 103–4.

11. J. Mesnil, *Masaccio et les débuts de la Renaissance* (The Hague, 1927), 122–7.

12. On Alhazen's optics, see D. C. Lindberg, *Theories of Vision from Al-Kindi to Kepler* (Chicago, 1976), 58–86; A. I. Sabra, "Sensation and Inference in Alhazen's Theory of Visual Perception," in *Studies in Perception: Interrelations in the History of Philosophy and Science*, ed. P. K. Machamer and R. G. Turnbull (Co-

lumbus, Ohio, 1978), 160–85. See also H. Bauer, *Die Psychologie Alhazens auf Grund von Alhazens Optik dargestellt (Beiträge zur Geschichte der Philosophie des Mittelalters*, vol. 10, no. 5), Münster, 1911; G. Federici Vescovini, *Studi sulla prospettiva medioevale* (Turin, 1965), 113–35; S. B. Omar, *Ibn al-Haytham's Optics: A Study of the Origins of Experimental Science* (Minneapolis and Chicago, 1977).

13. See Vescovini, "Le fonti ottiche medievali," 348–87. See also Lindberg, "Alhazen's Theory of Vision and Its Reception in the West," *Isis* 58 (1967): 321–41. For a recent critical edition, in English, of the first three books of *De aspectibus (Kitab al-Manazir)*, see *The Optics of Ibn Al-Haytham: Books I–III, On Direct Vision*, trans. and ed. A. I. Sabra (London, 1989).

14. Cf. T. Frangenberg, "The Image and the Moving Eye: Jean Pélerin (Viator) to Guidobaldo del Monte," *Journal of the Warburg and Courtauld Institutes* 49 (1986): 150–71, who stresses Alhazen's influence on cinquecento perspective theory, downplaying and underestimating the importance of Alhazen's views for Alberti, Ghiberti, and Leonardo.

15. L. Ghiberti, *Lorenzo Ghibertis Denkwürdigkeiten (I Commentarii)*, ed. J. von Schlosser (Berlin, 1912), 1: 85: "Addunque da' visibili dal viso saranno in due modi: la comprensione superficiale la quale il primo aspetto et la comprensione superficiale e.llo primo aspetto per la comprensione per lo risguardamento et la comprensione è comprensione non certificata, la comprensione per intuitione cioè è in comprensione per la quale s'è certificato la forma de' visibili." See also Bergdolt, p. 106. The corresponding passage in Alhazen's *De aspectibus* is given by Vescovini ("Le fonti," p. 383), from a fourteenth-century Italian translation (Biblioteca Vaticana, MS. Vat. 4595): ". . . la comprensione adonche di li visibili dal viso, serà sicondo dui modi: la comprensione superficiale la quale è in lo primo aspecto, e la comprensione per lo risguardamento. La comprensione per lo primo aspecto è comprensione non certificata; e la comprensione per intuitione, zioè per lo sguardaminto, è per comprensione, per la quale se certificano le forme di li visibili" (The perception, therefore, of visual objects by the sense of sight will be in two ways: superficial perception which is a first impression, and perception by repeated looking. Perception of the first impression is uncertified perception, and attentive perception, that is by repeated looking, is perception by which the forms of the visual objects are certified [trans. mine]).

16. Omar (*Ibn al-Haythan's Optics*, 50–1) correctly observes that the two stages or categories of perception are not strictly dichotomous. On eye movements, see J. E. Hochberg, *Perception* (Englewood Cliffs, 1978), 40–3. On certification, see Lindberg, *Theories of Vision*, 80–5, and S. Y. Edgerton, Jr., "Alberti's Optics" (Ph.D. diss., University of Pennsylvania, 1965), 69–70.

17. Ghiberti, *I Commentarii*, 1: 87: ". . . la vision non fusse se non per lo moto dell' asse radiale, et che nessuna cosa visa si vedrà tutta insieme, perchè esso intendeva dire la visione tutta certificata la quale non può essere se non per

intuitione et per lo moto del viso et per lo moto dell' asse radiale sopra tutti li diametri della cosa visa" (Bergdolt, pp. 110, 112).

18. Ibid., 85–6: "Quando addunque el viso arà compreso tutta la cosa visa trouerà che la forma della parte opposita al mezo d'esso e più manifesta di tutte l'altri parti. Et quando arà voluto certificare la forma della cosa visa, si mouerà sicchè il mezo sia opposita a ciascheduna parte delle cosa visa" (Bergdolt, p. 108).

19. Ibid., 85: ". . . non certificherà nel viso, la forma della cosa visa per lo sguardare di tutti le intentioni le quali possono apparere, et per lo sguardare di tutte le intentioni" (Bergdolt, p. 104). This passage makes more sense when compared with the corresponding passage in Alhazen: ". . . non certifica el viso la forma de la cosa visa, si no per consideratione de tute le parte de la cosa visa, e per lo sguardare de tute le intentione, le quale possono aparere in la cosa visa" (Vescovini, "Le fonti," 382).

20. Alhazen mentions twenty-two visible properties or intentions: light, color, distance, position, solidity, shape, magnitude, discreteness, continuity, number, motion, rest, roughness, smoothness, transparency, opacity, shadow, darkness, beauty, ugliness, similarity, and dissimilarity. Light and color are perceived as pure sensation; the rest require knowledge and judgment, that is, the operation of the *virtus distinctiva*, the distinguishing faculty, and are sometimes called common sensibles (following Aristotle) because they can be perceived through numerous senses – external senses, that is – either individually or together and are not specific to vision alone (unlike light and color). See Sabra, "Sensation and Inference in Alhazen's Theory of Visual Perception," 171–4, 177–9. Ghiberti lists these properties ("le 20 altre cose sensibili" in addition to color and light), p. 68, following Bacon. Cf. R. Bacon, *Opus Majus*, trans. R. B. Burke (New York, 1962), 2: 423.

21. For his description of the internal senses and their relationship to one another Ghiberti relies on Bacon, *Opus Majus*, 2: 421–9. According to Bacon, and as reported by Ghiberti (pp. 67–8), the imagination is located in the same part of the brain as the common sense, the first chamber ("la prima cellula"), and differs from it only in function. The number of internal senses, as well as the exact role of each one, was a matter of considerable confusion during the Middle Ages, because of the ambiguity of Aristotle's explanation of the matter in *De Anima*, a discussion on which the medieval conception rested. See H. A. Wolfson, "The Internal Senses in Latin, Arabic and Hebrew Philosophic Texts," *Harvard Theological Review* 28 (1935): 69–133; N. H. Steneck, "The Problem of the Internal Senses in the Fourteenth Century" (Ph.D. diss., University of Wisconsin, 1970), and idem, "Albert the Great on the Classification and Localization of the Internal Senses," *Isis* 65 (1974): 193–211; E. R. Harvey, *The Inward Wits: Psychological Theory in the Middle Ages and the Renaissance* (London, 1975).

22. Ghiberti, 1: 140: "... la comprensione della base et della piramide radiale continente la magnitudine et l'angulo della piramide: la quale apresso al centro del viso e.lla longitudine della piramide, la quale è remotione della magnitudine della cosa visa" (Bergdolt, p. 280). For a discussion of Euclid's "Angle Axiom" (Theorem VIII), see E. Panofsky, *Renaissance and Renascences in Western Art* (New York, 1972), 128–33. See also K. Veltman, "Panofsky's Perspective: A Half Century Later," in *La prospettiva rinascimentale, codificazioni e trasgressioni*, ed. M. Dalai Emiliani (Florence, 1980), 565–80.

23. Ghiberti, 1: 131: "Addunche comprende la quantità la remotione delle cose visibili delle quali la remotione risguarda i corpi continuati et ordinati per la comprensione delle misure delli corpi ordinati risguardanti la remotione di quelle" (Bergdolt, p. 250). The basic point emerges here despite missing words and repetitions. Ghiberti (or Alhazen) describes the perception and measurement of distance more fully on pp. 131–3, 136–40, and passim (Bergdolt, pp. 250–8, 266–80). These passages led Parronchi to argue that Ghiberti envisaged an anti-Albertian system of perspective (geared for two eyes instead of one). But that interpretation is based on a willful and arbitrary reading of Ghiberti's text. See Parronchi, *Studi su la dolce prospettiva*, esp. 325–7. Cf. R. Klein, "Studies on Perspective in the Renaissance," in *Form and Meaning* (New York, 1979), 134. See also J. White, *The Birth and Rebirth of Pictorial Space*, 129–30. White suggests, quite rightly I suspect, that Ghiberti's *Third Commentary* was intended to provide the optical and scientific underpinnings of Alberti's system of linear perspective.

24. Ghiberti, 1: 140: "... el viso non comprende tutta la cosa visa se non dal viso apresso a tutta la sua oppositione" (Bergdolt, p. 278). Ghiberti (Alhazen) is referring here to another of the *intentioni* or common sensibles, position (*situs*). Earlier in his *Commentary*, Ghiberti had included a specific discussion of the perception of position (1: 133), drawn from Pecham this time (but based ultimately on Alhazen), where it is explained that an object can be considered diametrically opposed to the eye when its form is perpendicular to the central axis of sight ("la sua forma nasce perpendicularemente sopra el vedere"); an object can be judged oblique, on the other hand, when the extrinsic rays of the visual pyramid are unequal in length ("per comprensione di diversitate di distantia delli istremi della cosa visibile"). For the corresponding sections of Pecham's Latin text (with English translation), see D. C. Lindberg, *John Pecham and the Science of Optics: Perspectiva Communis* (Madison, Milwaukee, and London, 1970), 142–5.

25. Ghiberti, 1: 103: "... Diremo addunque come il viso comprende el moto per comprensione della cosa visa mota secondo due siti diversi in due ore diversi tra la quale è tempo sensibile" (trans. mine) (Bergdolt, p. 164).

26. Ghiberti, 1: 103–4: "Ma la quiete si comprende, ma per comprensione della cosa visa in tempo sensibile in uno medesimo luogo secondo uno medesimo

sito tra lo quale è quando in due hore diverse tra.lle quale sia tempo sensibile" (trans. mine) (Bergdolt, p. 164).

27. Vescovini, "Le fonte ottiche medievale," 377: "E quando se considererà le intentione belle, le quale fanno le intentione particulare per la loro coniuntione insieme, si troverà che la pulchritudine, la quale apare per la coniutione di quelle, no apare, si no per la portionalità di quelle coniuctione coniunte tra se . . ." (trans. mine). Ghiberti's rendition (1: 105) is less clear due to repetitions and omissions: "Et quando si considerra la intentione e.lle intentioni belle le quale fanno il particulare per la loro congiuntione insieme et trovare che.lla pulchritudine la quale appare per la congiuntione di quelle, et non è per la proportionalità" (Bergdolt, pp. 170, 172).

28. Ghiberti, 1: 106: ". . . e.lla pulchritudine. Addunque non è per la intentione particulare e.lla perfectione d'esse et della proportionalità et consonantia la quale si fa tra.lla intentione particulare" (Bergdolt, p. 172). Cf. Vescovini's version of Ghiberti's wording ("Le fonti," 377): "E.lla pulchritudine addunque non è per la intentione particulare, e.lla perfectione d'esse, et della proportionalità et consonantia la quale si fa tra.lla intentione particulare." Vescovini's interpretation is apparently confirmed by Alhazen's text ("Le fonti," 377): "La pulchritudine, andoche, non è per le intentione particulare, e la perfectione de essa è da la proportionalità e consonantia, la quale si fa tra le intentione particulare."

29. In Alhazen's words (Vescovini, "Le fonti," 379): "Quando, adonche, el viso arà compreso alcuna cosa visa, e in quella cosa visa fosse pulchritudine composita de le intentione coniunte, e fosse risguardante quella cosa visa, e arà distinto le intentione che sono in quella, e arà compreso le intentione, le quale fanno pulchritudine e per la coniuntione de esse insieme, e serà pervénuta quella comprensione appresso lo sentiente, e arà fatto comperatione la virtù distintiva di quelle intentione insieme: comprenderà la pulchritudine di quella cosa visa composita de la coniuntione de le intentione, le quale sono in quella." (When the sense of sight has taken in the object in view, and if that object were beautiful, made up of conjoined properties, and that object were looked at again and its [individual] properties have been distinguished, and the properties which determine beauty (either by their conjunction or the proportional relationships between them) have been perceived and that perception has reached the sensor [the *ultimum sentiens*, the last sensor] and the distinguishing faculty has compared them with each other, [then] the beauty of the visual object arising from the conjunction of the properties of which it is composed will be understood" [trans. mine].) Ghiberti gives only part of this passage, breaking off in midstream for no apparent reason (1: 106): "Et quando el viso arà compreso alcuna cosa visa in quella visa fusse pulchritudine composta delle intentione coniunte della nostra intentione o fusse riguardante, a quella arà compreso la intentione che

sarà in quella. Et modo noi abbiamo distinto et dichiarato" (Bergdolt, p. 174).

30. Vescovini, "Le fonti," 367, and see Chapter 4 here. See also E. Panofsky, "The History of the Theory of Human Proportions as a Reflection of the History of Styles," in *Meaning in the Visual Arts* (New York, 1955), 89–90 n. 63.

31. J. Hochberg, "In the Mind's Eye," in *Contemporary Theory and Research in Visual Perception*, ed. R. N. Haber (New York, 1968), 309–31.

32. The duration of visual perception in the fullest sense, as opposed to the speed at which light is propagated, was also discussed by Blasius of Parma (Biagio Pelacani) in his *Questiones super perspectivam (Quaestiones perspectivae)* of ca. 1390; in Pelacani's treatise the temporality of vision is specifically explained in terms of the certification of sight. Similar or related formulations can also be found in the works of Bacon, Pecham, and Witelo. See G. Federici Vescovini, "Le questioni di 'perspectiva' di Biagio Pelacani da Parma," *Rinascimento* 12 (1961): esp. 210, and Lindberg, "Medieval Latin Theories of the Speed of Light," 45–72. The importance of Pelacani's writings for the development of Renaissance pictorial perspective has been stressed by Parronchi, according to whom *Questiones super perspectivam* was brought to Florence by Pelacani's student, the scientist Paolo Toscanelli (a friend of both Brunelleschi and Alberti, sometimes characterized as a kind of midwife to one-point perspective). See Parronchi, *Studi su la dolce prospettiva*, 227–95. See also E. Garin, "Ritratto di Paolo dal Pozzo Toscanelli," in *La cultura filosofica del Rinascimento italiano: ricerche e documenti* (Florence, 1979), 313–33; S. Y. Edgerton, Jr., *The Renaissance Rediscovery of Linear Perspective* (New York, 1976), 120–3; Vescovini, *Studi sulla prospettiva medievale*, 239–72, and idem, "La prospettiva del Brunelleschi, Alhazen e Biagio Pelacani a Firenze," in *Filippo Brunelleschi: la sua opera e il suo tempo*, Atti di convegno internazionale di studi (Florence, 1980), 1: 333–48.

33. Alberti, para. 30. Trans. Grayson, 67.

34. Alberti's understanding of the certification process is discussed in Edgerton, "Alberti's Optics," 69–76 (although the passage quoted here is not mentioned in that regard). As Edgerton suggests, Alberti's description of the centric ray (Alberti, para. 8) as extremely strong and lively and further as the prince of rays indicates his awareness of the important role of this ray in the optical science of his time (even if at this point Alberti is not specifically referring to the certification of sight as Alhazen and the rest had described it). Edgerton's study remains the fullest account, in general, of Alberti's treatise in relation to earlier optical theory. See also Parronchi, *Studi su la dolce prospettiva*, 296–312; Lindberg, *Theories of Vision*, 149–52.

35. On the sources of Leonardo's optical theories, see E. Garin, "Il problema delle fonti del pensiero di Leonardo," in *La cultura filosofica del Rinascimento*, 388–401, with further references and a good summary of the previous literature, and

idem, "La cultura fiorentina nell'età di Leonardo," in *Medioevo e Rinascimento: studi e ricerche* (Bari, 1954), 331–9. See also E. Solmi, *Scritti vinciani: le fonti dei manoscritti di Leonardo da Vinci e altri studi* (Florence, 1976), esp. 226–9; V. Ronchi, "Leonardo e l'ottica," in *Leonardo: saggi e ricerche*, ed. A. Marazza (Rome, 1954), 161–85; C. Maccagni, "Riconsiderando il problema delle fonti di Leonardo: l'elenco di libri ai fogli 2 verso–3 recto del codice 8936 della Biblioteca Nacional di Madrid," in *Leonardo letto e commento da Marinoni, Heidenreich, Brizio et al.*, Letture vinciane I–XII, 1960–72, ed. P. Galluzzi (Florence, 1974), 285–307; Lindberg, *Theories of Vision*, 154–68; M. Kemp, *Leonardo da Vinci: The Marvellous Works of Nature and Man* (Cambridge, Mass., 1981), esp. 125–36.

36. Leonardo da Vinci, *The Literary Works of Leonardo da Vinci*, ed. J. P. Richter (London, New York, and Toronto, 1939), no. 51 (C.A. fol. 232R, formerly numbered 85Va). On the dating of this sheet, see C. Pedretti, *The Literary Works of Leonardo da Vinci Compiled and Edited from the Original Manuscripts by Jean Paul Richter: Commentary* (Berkeley and Los Angeles, 1977), 1: 127 (no. 51).

37. Leonardo da Vinci, *Il Codice Atlantico della Biblioteca Ambrosiana di Milano*, ed. A. Marinoni (Florence, 1975–80), fol. 729R (formerly 270Rb): "Ora li obbietti che sono opposti a li occhi, fanno co' razzi delle loro spezie a simultudine di molti arcieri, i quali volessino trarre per uno buso d'uno scoppietto, che quello che si troverà infra li arcieri per linia retta alla dirittura del buso dello scoppietto, quello fia più atto a toccare colla saetta il fondo d'esso buso. Così li obbietti opposti a l'occhio saranno di più passata al senso, quanto più saranno per linia al nervo perforato.

"Quell'acqua ch'è nella luce intorno al centro nero dell' occhio, fa come i bracchi in nelle cacce, i quali sono cagione di levare la fiera e i leverieri poi la pigliano. Così questa, perché è uno omore che tiene della virtù imprensiva e vede molte cose, ma non le piglia, ma subito vi volge la ⟨po⟩pilla di mezzo, la quale va per linia al senso, e quella piglia le spezie, e quelle che piaciano, le incarcera nella prigione della memoria." Eng. trans., E. MacCurdy, *The Notebooks of Leonardo da Vinci* (New York, 1958), 237.

38. Leonardo's reference to memory here must be approached with caution; he does not mean memory in the sense I have used it earlier (in Chapter 1, for example), that is, for short-term retention, which was generally regarded as one of the functions of the common sense or imagination, and which must be distinguished from long-term storage, or memory proper (*memoria*), to which Leonardo refers in this passage. Short-term memory plays a role in the formation of images; long-term memory is where such images, once "completed," are stored for future reference. Leonardo's terminology regarding the internal senses is rather difficult to sort out and warrants further study, especially in relation to traditional systems of classification, but, on the whole, his discussion of postocular transmission conforms to the views of the per-

spectivists and the Aristotelian notions from which they are derived. For a discussion of Leonardo's views on the internal senses, see K. D. Keele, "Leonardo da Vinci's Physiology of the Senses," in *Leonardo's Legacy: An International Symposium*, ed. C. D. O'Malley (Berkeley and Los Angeles, 1969), 35–56.

39. See White, *Birth and Rebirth of Pictorial Space*, 126–30. Cf. Parronchi, *Studi su la dolce prospettiva*, 314–48.

40. J. J. Gibson, "The Problem of Temporal Order in Stimulation and Perception," *Journal of Psychology* 62 (1966): 143.

CHAPTER 4. SIMPLER COMPLETENESS

1. J. Keats, "Ode on a Grecian Urn," *The Poetical Works of John Keats*, ed. H. W. Garrod (Oxford, 1939), 260.

2. C. Dickens, *The Old Curiosity Shop*, orig. published 1841 (London, 1985), 237.

3. On the *Trattato* see A. M. Brizio, "Il Trattato della pittura di Leonardo," in *Scritti di storia dell'arte in onore di Lionello Venturi* (Rome, 1956), 1: 309–20; L. H. Heydenreich's introduction to Leonardo da Vinci, *Treatise on Painting [Codex Urbinas Latinus* 1270], trans. and ed. A. Philip McMahon (Princeton, 1956), xi–xliii (hereafter, McMahon). The *Codex Urbinas Latinus* 1270, in the Vatican Library, is the earliest known version of Leonardo's *Treatise*; the origins of the *Codex* and its exact date remain uncertain. See also K. T. Steinitz, *Leonardo da Vinci's Trattato della Pittura (Treatise on Painting): A Bibliography of the Printed Editions, 1651–1956* (Copenhagen, 1958); C. Pedretti, *Leonardo da Vinci on Painting: A Lost Book (Libro A)* (Berkeley and Los Angeles, 1964), 95–174; and idem, *The Literary Works of Leonardo da Vinci Compiled and Edited from the Original Manuscripts by Jean Paul Richter. Commentary* (Berkeley and Los Angeles, 1977), 1: 12–47 (hereafter, Pedretti, *Commentary*). In the discussion that follows I refer to a number of different editions of the *Trattato*, and so a bit of clarification is in order. All references will be (first of all) to the *Codex Vaticanus Urbinas Lat.* 1270, for which I have used the facsimile published by McMahon, with the appropriate page numbers as given in the manuscript, along with the numbers used in the accompanying English translation. I have also relied on the transcriptions and translations in Leonardo da Vinci, *Paragone: A Comparison of the Arts*, translated and annotated by J. A. Richter (London, New York, and Toronto, 1949), hereafter Richter, *Paragone*; the numbers used here, which differ from McMahon's, will also be given when applicable. Richter's explanatory remarks, however, will be cited in the standard way, with page numbers. The same material appears (as a separate unit and with the same numbers) in the second edition of J. P. Richter's collection of Leonardo's writings (which otherwise includes only selections from manuscripts in the artist's own

hand, governed by a still different set of numbers), Leonardo da Vinci, *The Literary Works of Leonardo da Vinci*, ed. J. P. Richter (London, 1939), 1: 13–101. I have also consulted the translations in E. Winternitz, *Leonardo da Vinci as a Musician* (New Haven and London, 1982), 204–23; he uses the numbering system in the first critical edition of the *Trattato*, Leonardo da Vinci, *Das Buch von der Malerei: nach dem Codex Vaticanus* 1270, ed. and trans. H. Ludwig (Vienna, 1882). References to Winternitz's translations will be given here as "Winternitz," with the appropriate paragraph number; his comments and arguments will be cited in the ordinary way. A useful concordance is provided in Pedretti, *Commentary*, 1: 77. Recently, a solid new edition of the *Paragone* has appeared, with thoughtful commentaries and extensive documentation, prepared by C. J. Farago, *Leonardo da Vinci's Paragone: A Critical Interpretation with a New Edition of the Text in the Codex Urbinas* (Leiden, 1992). Like Winternitz, Farago uses Ludwig's numbering. Where appropriate I will give those references in addition to the rest; for references to her introductory material and commentaries, however, I will use regular page numbers.

4. *Cod. Urb.* 11 (McMahon, no. 42; Richter, *Paragone*, no. 27; Farago/Winternitz, no. 23). Trans. mine. M. Kemp and M. Walker, *Leonardo on Painting* (New Haven and London, 1986), 313, define the puzzling term *imprensiva* as follows: "apparently Leonardo's own term for a 'receptor of impressions' which he saw as a staging house between the sensory nerves and the *senso comune*." For another explanation, see Farago, *Leonardo da Vinci's Paragone*, 301–2.

5. See Richter, *Paragone*, 47–9; D. Summers, *The Judgment of Sense: Renaissance Naturalism and the Rise of Aesthetics* (Cambridge, 1987), 74. See also Chapter 1.

6. Summers, *Judgment of Sense*, 74–5. See also Richter, *Paragone*, 72–3; Winternitz, *Leonardo da Vinci*, 206.

7. *Cod. Urb.* 16–16v (McMahon, no. 39; Richter, *Paragone*, no. 32; Farago/Winternitz, no. 29). Trans. mine.

8. Richter (*Paragone*, no. 32) translates "tempi armonici" as "harmonic rhythms"; the phrase "nel medesimo tempo" is given as "simultaneously," meaning "as a musical chord sounded all at one time" (p. 72). Winternitz also translates "nel medesimo tempo" as "simultaneously" but in this instance interprets that to mean "the voices or melodic strands that run at the same time, that is the juxtaposition within the polyphonic web"; "tempi armonici" is given as "harmonic sections." Winternitz thus advances the possibility that Leonardo is at times (and presumably only at times) speaking of musical harmony as it occurs between successive elements or sections of a composition, which is the starting point for much of the discussion that follows. Kemp and Walker, *Leonardo on Painting*, 34, translate "tempi armonici" as "harmonic intervals," which expresses the proportionality that is a part of Leonardo's meaning. Farago (no. 29) favors "harmonic tempos" because it implies a rate of movement, not a rhythmic pattern.

9. The division of a semibreve is given a different term, *prolatio*, which, like *tempus*, can be either perfect (three minims) or imperfect (two minims); minims can be subdivided into semiminims, semiminims into fusae, and so on. See W. Apel, *The Notation of Polyphonic Music, 900–1600* (Cambridge, Mass., 1961), 96–100. See also T. Morley, *A Plain and Easy Introduction to Practical Music*, ed. R. Alec Harman (New York, 1973), 9–99. Gaffurio, *Practica Musicae*, ed. and trans. C. A. Miller (n.p., 1968), 87, defined *tempus* as follows: "Musicians wish *tempus* to be understood as the measurement of breves. It is twofold, perfect and imperfect. *Tempus perfectum* ascribes three semibreves to one breve, and it is shown by a circle at the beginning of a song. Musicians believe that a circle indicates the ternary and perfect division of a breve, since its circumference contains equally a beginning, middle and end. . . . In *tempus imperfectum* one breve is divided into two semibreves, for a semibreve was formed from *semis* or a halved breve, as if it were half the size of a breve. A semicircle in songs indicates the binary value of breves. Do not consider a semicircle but as an imperfect circle, for *semi* means imperfect." Gaffurio's teacher, the noted musician and theorist Johannis Tinctoris (*Tractatus de regulari valore notarum*, in *Johannis Tinctoris, Opera Theoretica*, ed. A. Seay [n.p., 1975], 1: 127–8), defined a musical time in essentially the same way: "Tempus est quantitas ex certis semibrevis brevem respicientibus consituta, et hoc duplex est, videlicet perfectum et imperfectum. Tempus perfectum est quantitas qua tres semibreves pro una brevi numerantur. . . . Tempus imperfectum est quantitas qua duae semibreves pro una brevi numerantur." A later writer, Gioseffo Zarlino (*The Art of Counterpoint* [Part 3 of *Le Istitutioni Harmoniche*, 1558], trans. G. A. Marco and C. V. Palisca [New Haven and London, 1968], 246), described *tempus* as follows: "Let it be understood that in this context the term *tempus* does not refer to the good health or fortune of an individual, in the sense found in the expression: 'Francesco è houmo di buon tempo,' meaning Francesco leads a peaceful and happy life. Nor does it refer to the weather, as when we say, 'Hoggi è buon tempo,' meaning today is a fair, clear, and pleasant day. Nor does it signify here what the Philosopher [Aristotle] defines to be number, or measure of movement, or other successive elements [i.e., time in the general sense, defined by Aristotle as the number of movement]. Tempus here means a certain and determined quantity of small notes contained or considered in a breve." On Gaffurio and his links to Leonardo, see Winternitz, *Leonardo da Vinci*, 5–8. See also M. Kemp, *Leonardo da Vinci: The Marvellous Works of Nature and Man* (Cambridge, Mass., 1981), 169–70; A. Caretta et al., *Franchino Gaffurio* (Lodi, 1951); E. Praetorius, *Die mensural Theorie des Franchinus Gafurius und der folgenden Zeit bis zur Mitte des 16. Jahrhunderts* (Berlin, 1905); Farago, *Leonardo da Vinci's Paragone*, 43–4.

10. A. Marinoni, " 'Tempo armonico' o 'musicale' in Leonardo da Vinci," *Lingua Nostra*, 16 (1955): 45–8. It has also been argued that the *tempus* set the speed

in an absolute sense, that is, the duration of breves or their subdivisions was fixed by convention; changes in speed during a composition, from one section to another, were expressed as proportions of the initial or immediately preceding pace. See Apel, *Notation of Polyphonic Music*, 188–95; C. Sachs, *Rhythm and Tempo: A Study in Music History* (New York, 1953), 200–17. Cf. J. A. Bank, *Tactus, Tempo and Notation in Mensural Music from the 13th to the 17th Century* (Amsterdam, 1972).

11. Farago, *Leonardo da Vinci's Paragone*, 366–7, explains Leonardo's analogy between harmonic times and line (or outline) in terms of proportionality. The temporal dimension is not mentioned. In only one instance, *Cod. Urb.* 18–19 (McMahon, no. 41; Richter, *Paragone*, no. 35; Farago/Winternitz, no. 32), does Leonardo specifically discuss the "vertical" relations between different voices or parts: ". . . et al poeta accade il medesimo, come al musico, che canta sol' un canto composto di quattro cantori, e canta prima il canto, poi il tenore, e cose seguita il contr'alto e poi il basso; e di costui non risulta la gratia della proportionalita armonica, la quale si rinchiude in tempi armonici." (And for the poet it is the same as if a musician sings a composition made for four singers all by himself, singing first the canto then the tenor, and after that the contralto and then the bass; from which does not result the grace of the harmonic proportionality which is enclosed within harmonic times [trans. mine].) Although the blending of voices is clearly at issue, Leonardo's wording also suggests that even here the "gratia della proportionalita armonica" is only fully disclosed in the course of time; in all likelihood the proportional relationships to which Leonardo refers are "horizontal" as much as "vertical," including the contrapuntal interactions and exchanges between one voice and another, as they reveal themselves in one or more spans of time – enclosed ("rinchiude"), as Leonardo says, within "tempi armonici." See also T. Brachert, "A Musical Canon of Proportion in Leonardo da Vinci's *Last Supper*," *Art Bulletin* 53 (1971): 461–6. Brachert seeks proportional relationships corresponding to musical intervals in Leonardo's painting. He renders "tempi armonici" as "harmonious beats" (p. 461). On the polyphonic practice of Leonardo's day, especially in relation to the subsequent development of tonal, homophonic music, see E. E. Lowinsky, *Tonality and Atonality in Sixteenth-Century Music* (Berkeley and Los Angeles, 1961). See also Winternitz, *Leonardo da Vinci*, 211.

12. Leonardo da Vinci, *Il Codice Atlantico della Biblioteca Ambrosiana di Milano*, ed. A. Marinoni (Florence, 1975–80), fol. 1002 (formerly 360Ra): "O⟨g⟩ni impressione è per alquanto tempo riservata nel suo obbietto sensibile . . . e come la voce nell' orecchio, il quale se non riservassi impression delle voci, un sol canto mai li arebbe grazia, perché saltandosi dalla prima alla quinta voce, elli è come se sentissi 'n un tempo esse due voci, e sente la vera consonanza che fa la prima colla quinta; e se la impression della prima non restassi nell'

orecchio per alquanto spazio, la quinta che succede immediate dopo la prima, parrebbe sola, e una voce non fa alcuna consonanza" (trans. mine).

13. Leonardo, *Codice Atlantico*, fol. 1002 (formerly 360Ra): ". . . li graniculi delle acque pioventi paia⟨n⟩ continuate fila che discendin de lor nuvoli; e cosi per questo si mostra nell' occhio riservarsi le impression delle cose mosse da lu⟨i⟩ vedute." (The droplets of rain descending from the clouds appear as a continuous line, demonstrating how the eye holds the impression of the moving things it sees [trans. mine].)

14. Leonardo, no. 916 (Br. M. 173b). Pedretti (*Commentary*, 2: 135) dates this passage to ca. 1503–4. A related statement appears elsewhere in the same manuscript (Br. M. 190v); it is quoted in Kemp (*Leonardo da Vinci*, 250): "A line is made by the movement of a point; a surface is made by the movement of a line which travels in straight lines; the point in time is to be compared to an instant, and the line represents time with a length." On line and motion in Leonardo's drawings, see D. Rosand, *The Meaning of the Mark: Leonardo and Titian* (Lawrence, 1988), 11–48. See also M. Kemp, "In the Beholder's Eye: Leonardo and the 'Errors of Sight' in Theory and Practice," *Achademia Leonardi Vinci* 5 (1992): 156–7.

15. See 57–64. Farago, *Leonardo da Vinci's Paragone*, 321, 348–9, entertains this very possibility, but seems to regard it more as the exception than the rule. Leonardo also compares musical intervals to spatial ones (*Cod. Urb.* 17–18): "Although objects observed by the eye touch one another as they recede, I shall nevertheless found my rule on a series of intervals measuring 20 braccia each, just as the musician who, though his voices [i.e., tones] are united and strung together [i.e., continuous], has created intervals according to the distance from voice to voice [i.e., from tone to tone], calling them unison [i.e., a prime], second, third, fourth, and fifth, and so on, until names have been given to the various degrees of pitch proper to the human voice." Trans. I. Richter, *Paragone*, no. 34. Cf. McMahon, no. 44; Farago/Winternitz, no. 31. Leonardo is referring here to successive increments in distance of 20 braccia each, which he likens to the notes of a musical scale (or mode); in both cases continuous quantities are subdivided, arbitrarily as it were, into measured segments. Virtually the same statement appears in Ash. I 12b of 1492 (Leonardo, *Literary Works*, no. 102).

16. *Cod. Urb.* 10–10V (McMahon, no. 40; Richter, *Paragone*, no. 25; Farago/Winternitz, no. 21). Trans. mine.

17. In Aristotelian terms, poetry, like speech, can be considered a discontinuous quantity, although Leonardo does not say so explicitly. At one point (*Cod. Urb.* 17–18; McMahon, no. 44; Richter, *Paragone*, no. 34; Farago/Winternitz no. 31C), Leonardo characterizes painting, along with music and geometry, as a continuous quantity: "Se tu dirai le scientie non mecaniche sono le mentali, io ti dirè che la pittura è mentale, e ch'ella, sicome la musica e geometria

considera le proportioni delle quantità continue, e l'aritmetica delle discontinue, questa considera tutte le quantità continue, e le qualità delle proportioni d'ombre e lumi e distantie nella sua prospettiva." (If you call the nonmechanical sciences mental activities, then I would say to you that painting is a mental activity, and that, just as music and geometry deal with the proportions of continuous quantities, and arithmetic with discontinuous ones, it [painting] deals with all the continuous quantities and qualities of the proportions of shadows and lights and distances in perspective [trans. mine].) See Winternitz, *Leonardo da Vinci*, 216. See also A. Marinoni, "L'essere del nulla," in *Leonardo da Vinci letto e commento da Marinoni, Heidenreich, Brizio, et al.*, ed. P. Galluzzi (Florence, 1974), 9–28; Kemp, *Leonardo da Vinci*, 250. In modern terms, the Aristotelian distinction between, for example, continuous and discontinuous quantities becomes one between "analog" and "digital," between, for example, a traditional sort of watch in which each point in time is seen in relation to a spatial continuum that is the watch face, and a digital clock, in which each moment is shown in isolation from every other one.

18. Comparable views are stated in *Cod. Urb.* 18–19 (McMahon, no. 41; Richter, no. 35; Farago/Winternitz, no. 32): ". . . il poeta nel descrivere la bellezza o' brutezza di qualonche corpo te lo dimostra a membro a membro et in diversi tempi, et il pittore tel fa vedere tutto in un tempo . . . et fa esso poeta a similitudine d'un bel volto, il quale ti si mostra a membro a membro, che cosi facendo, non remarresti mai satisfatto dalla sua bellezza, la quale solo consiste nella divina proportionalità delle predette membra insieme composte, le quali solo in un tempo compongono essa divina armonia d'esso congionto di membre, che spesso tolgono la libertà posseduta a chi le vede." (. . . the poet in describing the beauty or ugliness of a particular body shows it to you piece by piece and in different times and the painter lets you see all of it in one [span of] time . . . and the poet when making a likeness of a beautiful face shows it to you piece by piece, and when done in this way it would never satisfy you with its beauty, which consists only in the divine proportionality of the aforementioned parts assembled together, which only in one [span of] time comprise that divine harmony of the conjunction of parts which often enthralls those who see it [trans. mine].)

19. *Cod. Urb.* 13–13V (McMahon, no. 33; Richter, *Paragone*, no. 28; Farago, no. 25).

20. Cf. Farago, *Leonardo da Vinci's Paragone*, 354.

21. *Cod. Urb.* 8–9 (McMahon, no. 30; Richter, *Paragone*, no. 23; Farago no. 25). Translation Richter.

22. Leonardo, *The Literary Works of Leonardo da Vinci*, no. 542 (MS Ash I. 19b). On the dating of the manuscript, see Pedretti, *Commentary*, 1: 336. Cf. *Cod. Urb.* 47 (McMahon, no. 265).

23. See E. H. Gombrich, *Means and Ends: Reflections on the History of Fresco Painting* (London, 1976), 10–11.
24. On Gaudenzio's fresco, see L. Mallé, *Incontri con Gaudenzio: raccolte di studi e note su problemi gaudenziani* (Turin, 1969), 37–41. See also V. Viale, *Gaudenzio Ferrari* (Turin, 1968), 19–28.
25. *Cod. Urb.* 108 (McMahon, no. 418; cited by Gombrich, *Means and Ends*, 11).
26. See Gombrich, *Means and Ends*, 11. Gombrich restates Leonardo's prescription as a simple, even simplistic, but perfectly accurate rule: one wall, one illusion of space or one spatial setting.
27. On Luini's fresco, see M. T. Binaghi, "L'immagine sacra in Luini e il circolo di Santa Marta," in *Sacro e profano nella pittura di Bernardino Luini*, ed. P. Chiara et al. (Milan, 1975), 69–70 (Catalogue of 1975 exhibition, Civico Istituto di Cultura Popolare, Luino); see also Gombrich, *Means and Ends*, 13.

CHAPTER 5. POSITION AND MEANING IN CONTINUOUS NARRATION

1. M. W. Roskill, *Dolce's "Aretino" and Venetian Art Theory of the Cinquecento* (New York, 1968), 120–1: "Quanto all'ordine, è mistiero, che'l Pittore vada di parte in parte rassembrando il successo della historia, che ha presa a dipingere, cosi propriamente, che i riguardanti stimino, che quel fatto non debba essere avenuto altrimenti di quello, che da lui è dipinto. Ne ponga quello, che ha ad essere inanzi, dapoi; ne quello, c'ha ad esser dapoi, inanzi, disponendo ordinatissimamente le cose, nel modo, che elle seguirono."
2. G. P. Bellori, *Dafne trasformata in lauro: pittura del Signor Carlo Maratti*, published with the *Vita di Carlo Maratti pittore* in *Ritratti di alcuni celebri pittori del sec. XVII, disegnati ed intagliati in rame del cavaliere Ottavio Lione, con le vite de'medesimi tratte da vari autori* (Rome, 1731), 265–6. Trans. mine.
3. This chapter is a modified version of my article "Ordering Space in Renaissance Times: Position and Meaning in Continuous Narration," *Word and Image* 10 (1994): 84–94.
4. The standard exposition of this distinction is G. Genette, *Narrative Discourse: An Essay on Method*, trans. J. E. Lewin (Ithaca, 1983), esp. 33–5. See also S. Chatman, *Story and Discourse: Narrative Structure in Fiction and Film* (Ithaca and London, 1978), 19–42. J. Elkins, "On the Impossibility of Stories: The Antinarrative Impulse in Modern Painting," *Word and Image* 7 (1991): 350, adds a third category, the "order of reading," making a distinction, therefore, between the order in which the narrative is presented and the order in which that presentation is experienced.
5. See B. Herrnstein Smith, "Narrative Versions, Narrative Theories," in *On Narrative*, ed. W. J. T. Mitchell (Chicago and London, 1981), 209–32.

6. Cf. W. Steiner, *Pictures of Romance: Form against Context in Painting and Literature* (Chicago and London, 1988), 14–15.

7. The classic study is H. Wölfflin, "Ueber das Rechts und Links im Bilde," *Gedanken zur Kunstgeschichte* (Basel, 1941), 82–90. The right–left problem is also taken up in M. Gaffron, "Right and Left in Pictures," *Art Quarterly* 13 (1950): 312–30; the matter is also discussed at some length, and much of the earlier literature reviewed, by B. Lamblin, *Peinture et temps* (Paris, 1983), 58–125. See also M. Schapiro, *Words and Pictures: On the Literal and the Symbolic in the Illustration of a Text* (The Hague, 1973), and idem, "On Some Problems in the Semiotics of Visual Art: Field and Vehicle in Image-Signs," *Semiotica* 1 (1969): 223–42; D. Rosand, *Painting in Cinquecento Venice: Titian, Veronese, Tintoretto* (New Haven and London, 1982), 39–43; and U. Eco, O. Calabrese, and L. Corrain, *Le figure del tempo* (Milan, 1987), 15, 22–3, 61. Experimental studies of eye movements and visual imagery offer little support for giving priority to the left-to-right direction: These experiments show only that the eye repeatedly seeks what seems to be the most important or informative sections of the image; such studies establish no order or direction independent of the specific image involved. See G. T. Buswell, *How People Look at Pictures* (Chicago, 1935), and A. L. Yarbus, *Eye Movements and Vision*, trans. B. Haigh (New York, 1967), 171–96. Additional references are given in H. B. J. Maginnis, "The Role of Perceptual Learning in Connoisseurship," *Art History* 13 (1990): 117 (n. 21).

8. See M. Lavin, *The Place of Narrative: Mural Decoration in Italian Churches, 431–1600* (Chicago and London, 1990), 1–12. In many cases, it is difficult to tell whether the overall pattern determines the ordering of scenes within each picture or whether it is the other way around.

9. For a similar view, see Eco, Calabrese, and Corrain, *Le figure del tempo*, 61.

10. On Masaccio's fresco, see U. Baldini and O. Casazza, *La Capella Brancacci* (Milan, 1990), 39–81.

11. See, for example, A. B. Barriault, *Spalliera Paintings of Renaissance Tuscany: Fables of Poets for Patrician Homes* (University Park, 1994), 82 (n. 52).

12. On the importance of the central position, see R. Arnheim, *The Power of the Center: A Study of Composition in the Visual Arts* (Berkeley and Los Angeles, 1982).

13. See M. Meiss, "Masaccio and the Early Renaissance: The Circular Plan," in *The Painter's Choice: Problems in Interpretation of Renaissance Art* (New York, 1976), 63–5. Cf. W. Welliver, "Narrative Method and Narrative Form in Masaccio's *Tribute Money*," *Art Quarterly* 1 (1977): 40–58. See also A. Molho, "The Brancacci Chapel: Studies in Its Iconography and History," *Journal of the Warburg and Courtauld Institutes* 40 (1977): 66–70; K. Christiansen, "Some Observations on the Brancacci Chapel Frescoes after Their Cleaning," *Burlington* 133 (Jan. 1991): 5–20.

14. National Gallery of Art, Washington, D.C., no. 1086. Gozzoli's panel was

part of a large altarpiece, dated 1461, painted for the company of the Purification of the Virgin in Florence, a confraternity under the patronage of the Medici and housed in San Marco. The altarpiece included a main panel of the Madonna and Child surrounded by six saints, among them the standing figures of St. Zenobius, the Baptist, St. Peter, and St. Dominic; scenes from the lives of these four saints – miracles or martyrdoms – were shown in the predella below. The predella also included a fifth scene, directly below the Madonna and Child in the main panel, representing the Purification of the Virgin. On the history of Gozzoli's altarpiece, see F. Rusk Shapley, "A Predella Panel by Benozzo Gozzoli," *Gazette des Beaux-Arts* 39 (1952): 78–88, and idem, *Catalogue of the Italian Paintings* (National Gallery of Art, Washington, D.C., 1979), 1: 229–30. This image has been admirably analyzed by Steiner, *Pictures of Romance*, 28–42. I would differ in one detail only: It seems to me unlikely that the figure with arms crossed at the corner of the room is another Herodias. Her appearance is too different; more likely she is simply an attendant or onlooker, rather than one of the principals. See also Chatman, *Story and Discourse*, 34.

15. To reinforce the distinction between the two parts of the setting, Gozzoli shifts the rhythm of the transversals and orthogonals at the back of the room, filling the interstices between them with a new decorative element. At the same time, the pilasters around the main hall are eliminated in favor of a plain wall broken only by doors and windows. In effect, Gozzoli inverts the decorative terms, adding embellishment to the ceiling and removing it from the walls.

16. For Lippi's fresco, see Introduction, note 9.

17. On the role of the barrier, see S. Sandström, *Levels of Unreality: Studies in Structure and Construction in Italian Mural Painting during the Renaissance* (Uppsala, 1963), pp. 75–76.

18. There has been considerable disagreement as to the identity of many of the figures in Lippi's fresco (and as to how often some of them are shown). The current consensus holds – and I would agree – that Herod and Herodias, unlike Salome, appear only once in Lippi's picture, at a separate table on the right. See J. Ruda, *Fra Filippo Lippi: Life and Work, with a Complete Catalogue* (London, 1993), 464, and Borsook, "Fra Filippo Lippi and the Murals for Prato Cathedral," figs. 61–2 (captions). See also Marchini, *Il Duomo di Prato*, 86 and pl. LXVIII, and H. Mendelsohn, *Fra Filippo Lippi* (Berlin, 1909), 121–2. For a contrasting view, see M. Pittaluga, *Filippo Lippi* (Florence, 1949), 114–15. Pittaluga presumes (as others too have done) that Herod and Herodias appear twice, once at the center and again on the right. None of the figures at the center, however, resemble those on the right closely enough to be considered the same character or characters. L. Marin, *Opacité de la peinture: essais sur le représentation au Quattrocento* (Florence, 1989), 168, suggests that the figure at

the extreme right of the fresco, in all likelihood a servant or attendant, might be a fourth Salome.

19. It is sometimes assumed that Gozzoli's version reflects the influence of Lippi's fresco in Prato. Cf. A. M. Frankfurter, "Washington: Celebration, Evaluation," *Art News* 50 (April, 1951): 26–35, 62–3; and Shapley, "A Predella Panel by Benozzo Gozzoli," 77–8. This is unlikely, however. Gozzoli's *Banquet of Herod* was completed by 1461, several years before Lippi's.

20. See H. G. Zagona, *The Legend of Salome and the Principle of Art for Art's Sake* (Geneva and Paris, 1960); H. Daffner, *Salome: Ihre Gestalt in Geschichte un Kunst* (Munich, 1912); F.-A. von Metzsch, *Johannes der Täufer: seine Geschichte und seine Darstellung in der Kunst* (Munich, 1989). See also Marin, *Opacité de la peinture*, 177–80.

21. F. Pezzarossa, *I poemetti sacri di Lucrezia Tornabuoni* (Florence, 1978), 192 (stanza CXXIII): "Questa allegrezza in dolor tornò presto, / vedi quel che n'ebbe poi a seguire / pel ballar de costei, che sol fu questo / la cagion che Giovanni fe' morire. / Sta, auditor, con lo intellecto desto / et vedra' il gioco in pianto convertire. / Quanto fu breve et la festa et la gioia! / Partissi ognuno con dispiacere et noia." According to Pezzarossa, 41–2, Lucrezia's religious poems, including the *Vita di Sancto Giovanni Baptista*, were composed in the mid-1470s (not long after Lippi's fresco). Borsook notes the similarity between the description of Salome in Lucrezia's poem and Lippi's representation of Salome. See Borsook, "Fra Filippo Lippi and the Murals for Prato Cathedral," 32.

22. On Rogier's panel, probably painted sometime after 1450, see M. Davies, *Rogier van der Weyden* (London, 1972), 200.

23. Rogier used the same device in a number of instances. See Davies, *Rogier van der Weyden*, 16–18. See also Eco, Calabrese, and Corrain, *Le figure del tempo*, 68.

24. For the aftermath of these events – the burying of the body of the Baptist on the orders of Julian the Apostate, as described in the Golden Legend – we must go back to the main panel. The very earliest parts of the story – those parts concerning the birth of the Baptist – are shown in the main panel also, as reliefs embellishing the capitals above the standing figure of the Baptist to the left of the Madonna. The latter scenes are thus removed from the immediate present, cast into the past tense, in much the same way as the architectural figures in Rogier's panel. On Memling, see D. De Vos, *Hans Memling: The Complete Works* (Ghent, 1994), 151–7. See also V. J. Hull, *Hans Memling's Paintings for the Hospital of Saint John in Bruges* (New York and London, 1981), 67–73. The *St. John Altarpiece* is dated 1479.

25. On Metsys's altarpiece, probably painted between 1508 and 1511, see L. Silver, *The Paintings of Quinten Massys: With Catalogue Raisonné* (Totowa and Montclair, 1984), 204–5 (cat. 11). See also A. de Bosque, *Quentin Metsys* (Brussels, 1975), 99–100.

26. See Eco, Calabrese, and Corrain, *Le figure del tempo*, 68.

27. For a recent discussion of Alberti's conception of pictorial narrative, see J. M. Greenstein, *Mantegna and Painting as Historical Narrative* (Chicago and London, 1992), 34–58.

28. Leonardo da Vinci, *The Literary Works of Leonardo da Vinci*, ed. J. P. Richter (London, New York and Toronto, 1939), no. 542 (MS Ash I. 19b): ". . . e isù detto piano figura la prima storia . grade e poi, diminvedo di mano i mano le figure e casameti isù diuersi colli e pianvre, farai tutto il fornimeto d'essa storia."

29. Barriault (*Spalliera Paintings of Renaissance Tuscany*, 88–92) discusses Leonardo's remarks in relation to *spalliera* painting; she cites examples by Andrea del Sarto and some of his Florentine contemporaries that seem to follow Leonardo's guidelines.

CHAPTER 6. SPACE AND NARRATIVE

1. G. E. Lessing, *Laocoön: An Essay on the Limits of Painting and Poetry*, trans. E. A. McCormick (Baltimore and London, 1984), 92.

2. A. Rodin, *Rodin on Art and Artists* (Conversations with Paul Gsell) (New York, 1983), 32–3.

3. On the treatment of space in the trecento, see J. White, *The Birth and Rebirth of Pictorial Space*, 3d ed. (Cambridge, Mass., 1987), 23–112. See also E. Panofsky, *Renaissance and Renascences in Western Art* (New York, 1972), 144–61; D. Gioseffi, *Perspectiva artificialis: per la storia della prospettiva spigolature e appunti* (Trieste, 1957); M. Meiss, *Painting in Florence and Siena after the Black Death: The Arts, Religion, and Society in the Mid-Fourteenth Century* (Princeton, 1978), 9–58; M. Schild Bunim, *Space in Medieval Painting and the Forerunners of Perspective* (New York, 1940), esp. 136–51; G. J. Kern, "Die Anfänge der zentralperspektivischen Konstruktion in der italienischen Malerei des 14. Jahrhunderts," *Mitteilungen des Kunsthistorischen Institutes in Florenz* 2 (1912–17): 39–65.

4. On Taddeo's work in the Baroncelli Chapel, see Andrew Ladis, *Taddeo Gaddi: Critical Reappraisal and Catalogue Raisonné* (Columbia and London, 1982), 88–112. On the Bardi di Vernio Chapel, see D. G. Wilkins, *Maso di Banco: A Florentine Artist of the Early Trecento* (New York, 1985), 1–59.

5. See Meiss, *Painting in Florence and Siena after the Black Death*, 9–58. Cf. L. Bellosi, *Buffalmacco e il trionfo della morte* (Turin, 1974). See also M. Boskovits, *Pittura fiorentina alla vigilia del Rinascimento, 1370–1400* (Florence, 1975).

6. For Agnolo Gaddi's True Cross cycle, see B. Cole, *Agnolo Gaddi* (Oxford, 1977), 79–81. See also M. A. Lavin, *The Place of Narrative: Mural Decoration in Italian Churches, 431–1600* (Chicago and London, 1990), 99–118. For the frescoes in Pisa, see M. Bucci and L. Bertolini, *Camposanto monumentale di Pisa: affreschi e sinopie* (Pisa, 1960), 69–110.

7. For a similar suggestion, see U. Eco, O. Calabrese, and L. Corrain, *Le figure del tempo* (Milan, 1987), 61.

8. On Gozzoli's Pisan frescoes, see A. Padoa Rizzo, *Benozzo Gozzoli: pittore fiorentino* (Florence, 1972), 76–82, 140–2. See also Bucci and Bertolini, *Camposanto monumentale di Pisa*, 111–44. For Gozzoli's frescoes in Montefalco, see S. Nessi, "La Vita di San Francesco dipinta di Benozzo Gozzoli a Montefalco," *Miscellanea Francescana* 61 (1961): 467–92, and H. W. van Os, "St. Francis of Assisi as a Second Christ in Early Italian Painting," *Simiolus* 7 (1974): 130–2. On the St. Augustine cycle in San Gimignano, see D. Cole Ahl, "Benozzo Gozzoli's Frescoes of the Life of St. Augustine in San Gimignano: Their Meaning in Context," *Artibus et historiae* 13 (1986): 35–53. For Angelico's frescoes, see A. Greco, *La Capella di Niccolò V del Beato Angelico* (Rome, 1980).

9. See Introduction.

10. See *Botticelli and Dante*, ed. C. Gizzi (Milan, 1991). See also R. Lightbown, *Sandro Botticelli* (Berkeley and Los Angeles, 1978), 1: 147–51, 2: 172–205. On the frescoes in Prato, see Chapter 5.

11. L. D. Ettlinger and H. S. Ettlinger, *Botticelli* (New York, 1977), 105–8. Cf. Lightbown, *Sandro Botticelli*, 1: 145–6, 2: 106–11. See also K. Christiansen, *Early Renaissance Narrative Painting in Italy* (Metropolitan Museum of Art Bulletin 41, no. 2, Fall 1983): 14–17.

12. See J. Pope-Hennessy and K. Chrstiansen, *Secular Painting in Fifteenth-Century Tuscany: Birth Trays, Cassone Panels, and Portraits* (New York, 1980), 12–53. See also P. Schubring, *Cassoni, Truhenbilder der Italienischen Frührenaissance* (Leipzig, 1915). For a recent and welcome study of *spalliera* paintings, an especially important category in this context, see A. B. Barriault, *Spalliera Paintings of Renaissance Tuscany: Fables of Poets for Patrician Homes* (University Park, 1994), which includes a useful checklist of primary cycles.

13. F. Wickhoff, *Roman Art: Some of Its Principles and Their Applications to Early Christian Painting*, trans. E. Strong (London and New York, 1900), 154–6, 111–14.

14. Ibid., 114.

15. J. J. Pollitt, *Art in the Hellenistic Age* (Cambridge, 1986), 185–209. On the controversies surrounding the origin of the continuous method, see E. H. Swift, *Roman Sources of Christian Art* (New York, 1951), 50–69. See also H. Froning, "Anfänge der kontinvierenden Bilderzählung in der grieschen Kunst," *Jahrbuch des Deutschen Archäologischen Instituts* 103 (1988): 169–99.

16. On space and perspective in classical art, see G. M. A. Richter, *Perspective in Greek and Roman Art* (London and New York, n.d.), 21–61, and White, *Birth and Rebirth of Pictorial Space*, 236–73. See also P. H. von Blanckenhagen and C. Alexander, *The Paintings from Boscotrecase* (Heidelberg, 1962), 40–1.

17. See Introduction. See also C. Seymour, Jr., "Some Reflections on Filarete's Use of Antique Visual Sources," in *Arte Lombarda* 38–9 (1973): 36–47. On the influence of Trajan's column on Renaissance art, see G. Agosti and V. Fari-

nella, "Calore del marmo," in *Memoria dell'antico nell'arte italiana*, ed. S. Settis (Turin, 1984), 1: 390–427, and idem, "Nuove ricerche sulla Colonna Traiana nel rinascimento," in *La Colonna Traiana*, ed. S. Settis (Turin, 1988), 549–89. For the Roman sarcophagi available to Renaissance artists, see P. P. Bober and R. O. Rubenstein, *Renaissance Artists and Antique Sculpture: A Handbook of Sources* (London, 1987), 135–88.

18. See Introduction.

19. Specific examples include Pontormo, *Joseph in Egypt*, National Gallery, London (no. 1131). Illus. in K. W. Forster, *Pontormo* (Munich, 1966), fig. 15 (cata. 10). See also C. Gould, *The Sixteenth-Century Italian Schools* (London National Gallery Catalogues, London, 1975), 199–201. Rosso Fiorentino, *The Education of Achilles*, Gallery of Francis I, Fontainebleau Palace. Illus. in P. Barocchi, *Il Rosso Fiorentino* (Rome, n.d.), fig. 95. See also S. Béguin et al., *La Galerie François Ier au Chateau de Fontainebleau* (n.p., 1972), 53–6. Salviati, *Bathsheba Betaking Herself to David*, Sacchetti Palace, Rome. Illus. in C. Dumont, *Francesco Salviati au Palais Sacchetti de Rome et la décoration murale italienne, 1520–1560* (Rome, 1973), pl. XXXVI (fig. 189). For Luini, see Chapter 4.

20. See J. Brown, *Velásquez: Painter and Courtier* (New Haven and London, 1986), 96–7.

21. J. Szarkowski, *Photography until Now* (New York, 1989), 19.

22. On Caravaggio's pictures in the Cerasi Chapel, see H. Hibbard, *Caravaggio* (New York, 1983), 118–37.

23. On Michelangelo's Pauline Chapel frescoes, see W. E. Wallace, "Narrative and Religious Expression in Michelangelo's Pauline Chapel," *Artibus et historiae* 19 (1989): 107–21, and L. Steinberg, *Michelangelo's Last Paintings: The Conversion of St. Paul and the Crucifixion of St. Peter in the Cappella Paolina, Vatican Palace* (New York, 1975). Steinberg likens the circular motion of the executioners in the *Crucifixion of St. Peter* to the turning of a mill wheel (p. 50), which nicely expresses the sense of slowness and weight. See also H. Hibbard, *Michelangelo* (New York, 1974), 273–80.

24. U. Baldini and O. Casazza, *La Cappella Brancacci* (Milan, 1990), 245–9. See also L. Berti and U. Baldini, *Filippino Lippi* (Florence, 1991), 174–5 (catalogue entry by Baldini).

25. A. Félibien, *Conférences de L'Académie Royale de Peinture et des Sculpture Pendant L'Année 1667* (Genève, 1973; orig. publ. Paris, 1668), 103. In the course of these discussions there is some question as to the historical accuracy of Poussin's image, but his treatment of time is generally praised. See also R. W. Lee, *Ut Pictura Poesis: The Humanistic Theory of Painting* (New York, 1967), 61–6, and T. Puttfarken, *Roger de Piles' Theory of Art* (New Haven and London, 1985), 1–37.

26. G. P. Bellori, *Dafne trasformata in lauro: pittura del Signor Carlo Maratti*, published with the *Vita di Carlo Maratti pittore* in *Ritratti di alcuni celebri pittori del Sec. XVII,*

disegnati ed intagliati in rame dal cavaliere Ottavio Lioni, con le Vite de' medesimi tratte da vari autori (Rome, 1731), 257–71. Discussed in F. H. Dowley, "The Moment in Eighteenth-Century Art Criticism," *Studies in Eighteenth-Century Culture* 5 (1976): 320–1.

27. See Chapter 1.

28. Anthony Ashley Cooper, third earl of Shaftesbury, *Second Characters or the Language of Forms*, ed. B. Rand (Cambridge, 1914), 34–8. See also E. H. Gombrich, "Moment and Movement in Art," in *The Image and the Eye: Further Studies in the Psychology of Pictorial Representation* (Ithaca, 1982), 40–2 (orig. publ. in *Journal of the Warburg and Courtauld Institutes* 27 [1964]: 293–5). Cf. Dowley, "The Moment in Eighteenth-Century Art Criticism," 321–4.

29. Lessing, *Laocoön*, 78 (Ch. 16). Lessing also recognizes that in history painting it is sometimes necessary to depict figures at slightly different moments in the same scene, depending on their distance from the main action; as the first epigraph to this chapter indicates, he speaks too of Raphael's tendency to combine two moments into one in the poses of certain figures, an approach that he regards as but a minor error (pp. 91–2). Essentially the same procedure is described by Rodin, in the second epigraph, and is also embodied in his sculpture. See note 2.

AFTERWORD

1. L. B. Alberti, *L'architettura (De re aedificatoria)*, ed. and trans. G. Orlandi (Milan, 1966), 608–11 (Book 7, Ch. 10). Eng. trans. G. Leoni, Alberti, *The Ten Books of Architecture: The 1755 Leoni Edition* (New York, 1986), 150. Alberti began his treatise on architecture around 1443 and presumably finished it by 1452, when it was presented to Pope Nicholas V; the work was first published in 1485. See C. Grayson, "The Composition of L. B. Alberti's 'Decem Libri De re aedificatoria,'" *Müchner Jahrbuch der bildenden Kunst* 2 (1960): 152–61.

2. Shakespeare, *The Life of Henry V*, ed. J. R. Brown (The Signet Classic Shakespeare, New York, 1988), 42 (Prologue, 23–31).

3. E. Panofsky, "Die Perspektive als symbolische Form," *Vorträge der Bibliothek Warburg*, 1924–5 (Leipzig and Berlin, 1927), 258–330, and idem, *Renaissance and Renascences in Western Art* (New York, 1972), 118–45. Among the many discussions of Panofsky's position, see H. Damisch, *L'Origine de la perspective* (n.p., 1987), and M. A. Holly, *Panofsky and the Foundations of Art History* (Ithaca and London, 1984), esp. 130–8. See also E. Cassirer, *The Individual and the Cosmos in Renaissance Philosophy* (1927), trans. M. Domandi (Philadelphia, 1972); A. Koyré, *From the Closed World to the Infinite Universe* (Baltimore and London, 1968); M. Jammer, *Concepts of Space: The History of Theories of Space in Physics* (Cambridge, Mass., 1969).

4. On the representation of time and movement in the visual arts, see, for

example, E. Souriau, "Time in the Plastic Arts," *Journal of Aesthetics and Art Criticism* 7 (1949): 294–307; P. Francastel, *La figure et le lieu: l'ordre visuel du Quattrocento* (Paris, 1967), esp. 154–77; E. H. Gombrich, "Moment and Movement in Art," in *The Image and the Eye: Further Studies in the Psychology of Pictorial Representation* (Ithaca, 1982), 40–62 (orig. publ. as *Journal of the Warburg and Courtauld Institutes* 27 [1964]: 293–306); B. Lamblin, *Peinture et temps* (Paris, 1983); R. Pierantoni, *Forma fluens: il movimento e la sua rappresentazione nella scienza, nell'arte e nella tecnica* (Turin, 1986); U. Eco, O. Calabrese, and L. Corrain, *Le figure del tempo* (Milan, 1987). See also R. Brilliant, "Temporal Aspects in Late Roman Art," *L'Arte* 3 (1970): 65–87; Y. Bonnefoy, "Time and the Timeless in Quattrocento Painting," in *Calligram: Essays in New Art History from France*, ed. N. Bryson (Cambridge, 1988), 8–26; K. Varnedoe, "The Ideology of Time: Degas and Photography," *Art in America* 68 (Summer 1980): 96–110.

5. Souriau, "Time in the Plastic Arts," 295.

6. Ibid., 301.

7. Ibid.

8. For a useful discussion of Souriau's position, see Pierantoni, *Forma fluens*, 87–8.

9. Gombrich, "Moment and Movement in Art," 49–52.

10. Ibid., 52–5.

11. See R. Pierantoni, *L'occhio e l'idea: fisiologia e storia della visione* (Turin, 1981), 182–7; J. E. Hochberg, *Perception* (Englewood Cliffs, 1978), 158–211; J. J. Gibson, *The Perception of the Visual World* (Boston, 1950), 145–62; G. T. Buswell, *How People Look at Pictures* (Chicago, 1935). See also S. Alpers, "Describe or Narrate? A Problem in Realistic Representation," *New Literary History* 8 (1976–7): 15–41; D. Rosand, "Ut Pictor Poeta: Meaning in Titian's *Poesie*," *New Literary History* 3 (1971–2): 527–8, and idem, *Painting in Cinquecento Venice: Titian, Veronese, Tintoretto* (New Haven and London, 1982), 39–43.

12. See note 1.

13. L. B. Alberti, *De pictura*, ed. C. Grayson (Rome and Bari, 1975), para. 40. Trans. Grayson, Alberti, *On Painting and On Sculpture* (London, 1972), 79.

14. See R. Brilliant, "Temporal Aspects in Late Roman Art," *L'Arte* 10 (1970): 65–87, and idem, *Visual Narratives: Storytelling in Etruscan and Roman Art* (Ithaca and London, 1984), 18–19, 104–6. Cf. F. Wickhoff, *Roman oArt: Some of Its Principles and Their Applications to Early Christian Painting* (London and New York, 1900), 111–13.

15. See, for example, R. N. Haber, "Perceiving Space from Pictures: A Theoretical Analysis," in *The Perception of Pictures*, ed. M. A. Hagen (New York, London, and Toronto, 1980), 1: 3–31, and in the same collection, J. Hochberg, "Pictorial Functions and Perceptual Structures," 2: 47–93 (both with further relevant bibliography). See also J. White, *The Birth and Rebirth of Pictorial Space*, 3d ed. (Cambridge, Mass., 1987), 189–201.

APPENDIX. DEFINITIONS

1. K. Weitzmann, *Illustrations in Roll and Codex: A Study of the Origin and Method of Text-Illustration* (Princeton, 1947), 12–46. See also C. Robert, *Bild und Lied: Archäeologische Beiträge zur Geschichte der griechischen Heldensage* (Philologische Untersuchungen heräsugegeben von A. Kiessling und U. v. Wilamowitz–Moellendorf, V, Berlin, 1881), 3–51 and passim.

2. Weitzmann, *Roll and Codex*, 13–14. The classic example is the representation of the killing of Troilus on the François Vase in Florence (Weitzmann, fig. 2), which includes, in addition to the main event, a prior moment of a Trojan boy and girl drawing water, as well as the announcement of and reaction to Troilus's death, all within the same frame (or band). A. M. Snodgrass, *Narration and Allusion in Archaic Greek Art* (London, 1982), 5–10, uses the term "synoptic" for this type of narrative. See also idem, *An Archaeology of Greece,* (Berkeley, 1987), 136–47, and H. A. Shapiro, *Myth into Art* (London and New York, 1994), 7–10.

3. Shapiro, *Myth into Art*, 14–17 and Fig. 3. Weitzmann gives the example of a mid-fifth century B.C. skyphos depicting Odysseus slaying the suitors: All the action refers to one precise moment in the fight. On Greek narrative painting, see G. M. A. Hanfmann, "Narration in Greek Art," *American Journal of Archaeology* 61 (1957): 71–8.

4. Weitzmann, *Roll and Codex*, 17. Following Robert, Weitzmann cites a group of terracotta cups (generally known as the Megarian bowls) as early examples of this method: One such cup in Berlin (Weitzmann, fig. 6) includes three scenes from the *Odyssey* on its outer surface with no division between them; Odysseus appears in each of the episodes. On the relation of continuous or cyclical narrative to the evolution of book illustration, see ibid., 47–129, and idem, "Narration in Early Christendom," *American Journal of Archaeology* 61 (1957): 83–91. This connection has been reaffirmed by J. J. Pollit, *Art in the Hellenistic Age* (Cambridge, 1986), 204–5. For views critical of Weitzmann's position, see H. Bober, review of *Illustrations in Roll and Codex*, in *Art Bulletin* 30 (1948): 284–8; K. Schefold, *Vergessenes Pompeji: Veröffentliche Bilder römischer Wanddekorationen in geschichtlichte Folge herausgegeben* (Bern and Munich, 1962), 78–88, and idem, "Buch und Bild im Alterum," in *Wort und Bild: Studien zur Gegenwart der Antike* (Basel, 1975), 125–8. See also M. Schapiro, "The Place of the Joshua Roll in Byzantine History," in his *Late Antique, Early Christian and Medieval Art* (New York, 1979), 58–9.

5. F. Wickhoff, *Roman Art: Some of Its Principles and Their Applications to Early Christian Painting* (London and New York, 1900), 8–16.

6. See Weitzmann, *Roll and Codex*, 29–30. J. B. Connelly, "Narrative and Image in Attic Vase Painting," in *Narrative and Event in Ancient Art*, ed. P. J. Holliday (Cambridge, 1993), 119, speaks of an additional category, "episodic" narra-

tive, which refers to the "placement of independent yet related events side by side in a single picture field." It is similar to the cyclical method, but the same characters are not necessarily repeated.

7. P. H. von Blanckenhagen, "Narration in Hellenistic and Roman Art," *American Journal of Archaeology* 61 (1957): 78.

8. Cf. K. Lehmann-Hartleben, *Die Trajanssaüle: ein romische Kunstwerk zu Beginn der Spätantike* (Berlin and Leipzig, 1926), 120–3; see also S. Jones, "The Historical Interpretation of the Reliefs of Trajan's Column," *Papers of the British School in Rome* 5 (1910): 437; R. Brilliant, *Roman Art: From the Republic to Constantine* (London, 1974), 190–2; J. M. C. Toynbee, "The Ara Pacis Reconsidered and Historical Art in Roman Italy," *Proceedings of the British Academy* 39 (1953): 93–4 n. 11; and S. Ringbom, "Some Pictorial Conventions for the Recounting of Thoughts and Experiences in Late Medieval Art," in *Medieval Iconography and Narrative: A Symposium*, ed. F. G. Andersen et al. (Odense, 1980), 38–41.

9. The term "polyscenic" is initially proposed by Weitzmann: He discards it, however, because it does not adequately describe narrative cycles – successions of individually framed scenes linked by subject – which he includes in this category. See Weitzmann, *Roll and Codex*, 21. Our concern, however, is primarily with individual pictures rather than complete cycles. For a breakdown similar to the one described here, see D. Kunzle, *The Early Comic Strip: Narrative Strips and Picture Stories in the European Broadsheet from c. 1450 to 1825* (Berkeley, Los Angeles, and London, 1973), 4.

10. On the function of the frame, see M. Schapiro, "On Some Problems in the Semiotics of Visual Art: Field and Vehicle in Image-Signs," *Semiotica* 1 (1969): 223–42. C. M. Dawson adopts the word "locality," without, however, resolving the question of what constitutes a single locality. See C. M. Dawson, *Roman-Campanian Landscape Painting* (New Haven, 1944), 190 and passim. See also R. Brilliant, *Visual Narratives: Storytelling in Etruscan and Roman Art* (Ithaca and London, 1984), 29–30, 105–6.

11. W. Welliver, "Narrative Method and Narrative Form in Masaccio's *Tribute Money*," *Art Quarterly* 1 (1977): 40–58. Welliver perhaps assumes that continuous actions involve the repetition of figures in each of the separate episodes, but he does not say so.

12. Welliver, "Narrative Method," 51–2. This scene can also be read in a simpler way: The tax collector demands payment and indicates where that payment should be made, Christ responds, telling Peter what to do, and Peter, echoing Christ's gesture, indicates his willingness to do as he has been instructed.

13. D. Frey, *Gotik und Renaissance: Als Grundlagen der modernen Weltanschauung* (Augsburg, 1929), 140–54, regards what Welliver has called "continuous action" as an intermediate phase between the continuous narrative of Gothic art and the simultaneity of Renaissance pictures. For a discussion of Leonardo's *Last Supper* as an example of this sort of narration, see L. Steinberg, "Leonardo's

Last Supper," *Art Quarterly* 36 (1973): 303–5. On Poussin's *Fall of Manna,* see Chapter 6.

14. For Botticelli's Zenobius panels, see, for example, K. Christiansen, *Early Renaissance Narrative Painting in Italy* (Metropolitan Museum of Art Bulletin 41, no. 2, Fall 1983), 14–17.

15. In her study of *spalliera* paintings, Barriault makes a distinction between linear narratives, which can be read in sequence from left to right, and nonlinear narratives, which cannot be read in order because the distribution of episodes is not chronological. Botticelli's St. Zenobius panel is an example of the former; the Lucretia panel in the Gardner Museum in Boston is an example of the latter. See A. B. Barriault, *Spalliera Paintings of Renaissance Tuscany: Fables of Poets for Patrician Homes* (University Park, 1994), 82–6.

16. The repetition of characters within a given narrative image does not necessarily guarantee the unity of time and place, as Weitzmann had suggested. With or without the reappearance of special figures, the relation between time and space remains the same: In either case more than one moment is presented in what we provisionally accept as a single space. Neither variation violates the presumed unity of time and place any more than the other, or conversely, both violate it to the same degree; the violation is only more apparent in one case than the other. But both instances must be distinguished from the monoscenic method and for the same reason: More than one moment is represented in a unified picture.

17. L. Andrews, "A Space of Time: Continuous Narrative and Linear Perspective in Quattrocento Tuscan Art" (Ph.D. diss., Columbia University, 1988), 44.

SELECT BIBLIOGRAPHY

Ackerman, J. S. "Leonardo's Eye." *Journal of the Warburg and Courtauld Institutes* 41 (1978): 108–46.

Ahl, D. Cole. "Benozzo Gozzoli's Frescoes of the Life of St. Augustine in San Gimignano: Their Meaning in Context." *Artibus et historiae* 13 (1986): 35–53.

Alberti, L. B. *Leone Battista Alberti's Kleinere Kunsttheoretische Schriften.* Translated by H. Janitschek. Vienna, 1877.

On Painting. Translated by J. R. Spencer. New Haven and London, 1966.

On Painting and Sculpture. Translated by C. Grayson. London, 1972.

De pictura. Edited by C. Grayson. Rome and Bari, 1975.

Alpers, S. L. "*Ekphrasis* and Aesthetic Attitudes in Vasari's *Lives.*" *Journal of the Warburg and Courtauld Institutes* 23 (1960): 190–215.

"Describe or Narrate?: A Problem in Realistic Representation." *New Literary History* 8 (1976–7): 15–41.

The Art of Describing: Dutch Art in the Seventeenth Century. Chicago, 1983.

Antal, F. *Florentine Painting and Its Social Background.* London, 1947.

Antoine, J.-P. "*Ad perpetuam memoriam.* Les nouvelles fonctions de l'image peinte en Italie: 1250–1400." *Mélanges de l'école francaise de Rome: Moyen Age–Temps Modernes* 100 (1988): 541–615.

Apel, W. *The Notation of Polyphonic Music, 900–1600.* Cambridge, Mass., 1961.

Apollonio, M. *Storia del teatro italiano.* Florence, 1943.

Temi danteschi ad Orvieto. Milan, 1968.

Arasse, D. "Espace pictural et image religieuse: le point de vue de Masolino sur la Perspective." In *La prospettiva rinascimentale: codificazioni e trasgressioni,* edited by M. Dalai Emiliani, 137–50. Florence, 1980.

Arese, M., A. Bonomi, C. Cavalieri, and C. Fronza. "L'impostazione prospettica della 'Cena' di Leonardo da Vinci: un' ipostesi interpretativa." In *La prospettiva rinascimentale: codificazioni e trasgressioni,* edited by M. Dalai Emiliani, 249–59. Florence, 1980.

Argan, G. C. "The Architecture of Brunelleschi and the Origins of Perspective Theory in the Fifteenth Century." *Journal of the Warburg and Courtauld Institutes* 9 (1946): 96–121.

Aristotle. *The Poetics.* Translated by W. Hamilton Fyfe. London and New York, 1927.

Arnheim, R. *Art and Visual Perception: A Psychology of the Creative Eye; The New Version.* Berkeley and Los Angeles, 1974.

"Perception of Pictorial Space from Different Viewing Points." *Leonardo* 10 (1977): 283–8.

"A Stricture on Space and Time." *Critical Inquiry* 4 (1977–8): 645–55.

"Brunelleschi's Peepshow." *Zeitschrift für Kunstgeschichte* 41 (1978): 57–60.

"Space as an Image of Time." In *Images of Romanticism*, edited by K. Kroeber and W. Walling, 1–12. New Haven, 1978.

"Some Comments on J. J. Gibson's Approach to Picture Perception." *Leonardo* 12 (1979): 121–2.

The Power of the Center: A Study of Composition in the Visual Arts. Berkeley and Los Angeles, 1982.

Bacon, R. *Opus Majus*. Translated by R. B. Burke. 2 vols. New York, 1962.

Badt, K. "Raphael's 'Incendio del Borgo.' " *Journal of the Warburg and Courtauld Institutes* 22 (1959): 35–59.

Bal, M. *Narratology: Introduction to the Theory of Narrative*. Toronto, 1985.

Baldini, U., and O. Casazza. *La Cappella Brancacci*. Milan, 1990.

Baltrusaitis, J. *Anamorphic Art*. Translated by W. J. Strachan. Cambridge, 1977.

Bank, J. A. *Tactus, Tempo and Notation in Mensural Music from the 13th to the 17th Century*. Amsterdam, 1972.

Barbaro, D. *La practica della perspectiva*. Venice, 1569; reprint, Sala Bolognese, 1980.

Barriault, A. B. *Spalliera Paintings of Renaissance Tuscany: Fables of Poets for Patrician Homes*. University Park, 1994.

Battisti, E. *Piero della Francesca*. Milan, 1971.

Brunelleschi: The Complete Work. Translated by R. E. Wolf. New York, 1981.

Bauer, H. *Die Psychologie Alhazens auf Grund von Alhazens Optik dargestellt*. Vol. 10, no. 5, of *Beiträge zur Geschichte der Philosophie des Mittelalters*. Münster, 1911.

Baxandall, M. *Giotto and the Orators: Humanist Observers of Painting in Italy and the Discovery of Pictorial Composition, 1350–1450*. Oxford, 1971.

Painting and Experience in Fifteenth Century Italy: A Primer in the Social History of Pictorial Style. 2d ed. Oxford and New York, 1988.

Bellezza, F. S. "Mnemonic Devices and Memory Schemas." In *Imagery and Related Mnemonic Processes: Theories, Individual Differences and Applications*, edited by M. A. McDaniel and M. Pressley, 34–55. New York, 1987.

Belting, H. *Das Bild und sein Publikum im Mittelalter: Form und Funktion früher Bildtafeln der Passion*. Berlin, 1981.

Berenson, B. *A Sienese Painter of the Franciscan Legend*. London, 1903.

Berti, L. *Masaccio*. University Park and London, 1967.

Berti, L., and U. Baldini. *Filippino Lippi*. Florence, 1991.

Beyen, H. G. *Die pompejanische Wanddekoration: Vom zweiten bis zum vierten Stil*. The Hague, 1960.

Bielefeld, E. "Zum Probleme der kintinuierenden Darstellungweise." *Archaologischer Anzeiger* (Beiblatt zum *Jahrbuch des Deutschen Archäologischen Instituts*) 71 (1956): 29–34.

Binaghi, M. T. "L'immagine sacra in Luini e il circolo di Santa Marta." In *Sacro e*

profano nella pittura di Bernardino Luini, edited by P. Chiara et al., 49–76. Milan, 1975.

Bjurström, P. "Espace scénique et durée de l'action dans le théâtre italien du XVIe siècle." In *Le Lieu théâtral à la Renaissance*, edited by J. Jacquot with E. Königson and M. Oddon, 73–84. Paris, 1984.

Bober, H. Review of *Illustrations in Roll and Codex*, by K. Weitzmann. *Art Bulletin* 30 (1948): 284–8.

Bolzoni, L. "Teatralità e tecniche della memoria in Bernardino da Siena." *Il francoscanesimo e il teatro medievale*, 177–94. Miscellanea storica della Valdesa, 6, Castelfiorentino, 1984.

Bonnefoy, Y. "Time and the Timeless in Quattrocento Painting." In *Calligram: Essays in New Art History from France*, edited by N. Bryson, 8–26. Cambridge, 1988.

Borsook, E. "Fra Filippo Lippi and the Murals for Prato Cathedral." *Mitteilungen des Kunsthistorischen Institutes in Florenz* 19 (1975): 1–148.

The Mural Painters of Tuscany. Oxford, 1980.

Boschetto, A. *Gli affreschi di Benozzo Gozzoli nella chiesa di S. Francesco a Montefalco*. Milan, 1960.

Brandi, C. *Giotto*. Milan, 1983.

Brendel, O. J. *Prolegomena to the Study of Roman Art*. New Haven and London, 1979.

Brilliant, R. "Temporal Aspects in Late Roman Art." *L'Arte* 10 (1970): 65–87.

Roman Art: From the Republic to Constantine. London, 1974.

Visual Narratives: Storytelling in Etruscan and Roman Art. Ithaca and London, 1984.

Brizio, A. M. "Il Trattato della pittura di Leonardo." In *Scritti di storia dell'arte in onore di Lionello Venturi*, 1: 309–20. Rome, 1956.

Bryson, N. *Vision and Painting: The Logic of the Gaze*. New Haven and London, 1983.

Bucci, M., and L. Bertolini. *Camposanto monumentale di Pisa: affreschi e sinopie*. Pisa, 1960.

Bunim, M. Schild. *Space in Medieval Painting and the Forerunners of Perspective*. New York, 1940.

Buswell, G. T. *How People Look at Pictures*. Chicago, 1935.

Caretta, A., L. Cremascoli, and L. Salamina. *Franchino Gaffurio*. Lodi, 1951.

Carruthers, M. *The Book of Memory: A Study of Memory in Medieval Culture*. Cambridge, 1990.

Casazza, O. "Il ciclo delle storie di San Pietro e la 'Historia Salutis.' Nuova lettura della Cappella Brancacci." *Critica d'Arte* 51, no. 9 (1986): 69–84.

Cassirer, E. *The Individual and the Cosmos in Renaissance Philosophy*. Translated by M. Domandi. Philadelphia, 1972.

Castelvetro, L. *Poetica d'Aristotele vulgarizzata e sposta*. Edited by W. Romani. 2 vols. Rome and Bari, 1978–9.

Charlton, H. B. *Castelvetro's Theory of Poetry*. Manchester, 1917.

Chatman, S. *Story and Discourse: Narrative Structure in Fiction and Film.* Ithaca and London, 1978.

Chiapelli, A. "Puccio Capanna e gli affreschi in San Francesco di Pistoia." *Dedalo* 10 (1929–30): 199–228.

Christiansen, K. "Some Observations on the Brancacci Chapel Frescoes after Their Cleaning." *Burlington* 133 (January 1991): 5–20.

Clark, K. *Leonardo da Vinci: An Account of His Development as an Artist.* Harmondsworth, 1976.

Cohen, G. "Visual Imagery in Thought." *New Literary History* 7 (1976): 513–23.

Croce, B. *Aesthetic: As Science of Expression and General Linguistic.* Translated by D. Ainslie. Boston, 1978.

Damisch, H. *Théorie du nuage: pour une historie de la peinture.* Paris, 1972.

———. "L' 'origine' de la perspective." *Macula* 5/6 (1979): 112–37.

———. "Le dit du peintre: En marge du livre I du *Della Pittura* de Leon Battista Alberti." In *La prospettiva rinascimentale: codificazioni e trasgressioni,* edited by M. Dalai Emiliani, 409–15. Florence, 1980.

———. *L'Origine de la perspective.* N.p., 1987.

———. "La perspective au sens strict du terme." In *Piero: teorico dell'arte,* edited by O. Calabrese, 13–20. Rome, n.d.

D'Ancona, A. *Origini del teatro italiano.* Turin, 1891.

Dawson, C. M. *Roman-Campanian Landscape Painting.* New Haven, 1944.

de Campos, D. Redig. "I 'tituli' degli affreschi del quattrocento nella Cappella Sistina." In *Studi di storia dell'arte in onore di Valerio Mariani,* 113–21. Naples, 1971.

Degl'Innocenti, G. "Problematica per l'applicazione della metodologia di restituzione prospettica a tre formelle della Porta del Paradiso di Lorenzo Ghiberti: proposte e verifiche." In *Lorenzo Ghiberti nel suo tempo,* Atti del Convegno Internazionale di Studi, 561–87. Florence, 1980.

De Vos, D. *Hans Memling: The Complete Work.* Ghent, 1994.

Dowley, F. H. "The Moment in Eighteenth-Century Art Criticism." *Studies in Eighteenth-Century Culture* 5 (1976): 317–36.

Dürer, A. *The Painter's Manual.* Translated by W. L. Strauss. New York, 1977.

Eco, U., O. Calabrese, and L. Corrain. *Le figure del tempo.* Milan, 1987.

Edgerton, S. Y., Jr. "Alberti's Optics." Ph.D. diss., University of Pennsylvania, 1965.

———. "Alberti's Perspective: A New Discovery and a New Evaluation." *Art Bulletin* 48 (1966): 367–78.

———. "Brunelleschi's First Perspective Picture." *Arte Lombarda* 38/39 (1973): 172–95.

———. *The Renaissance Rediscovery of Linear Perspective.* New York, 1976.

———. "*Mensurare temporalia facit Geometria spiritualis*: Some Fifteenth-Century Italian Notions about When and Where the Annunciation Happened." In *Studies in Late*

Medieval and Renaissance Painting in Honor of Millard Meiss, edited by I. Lavin and J. Plummer, 1: 115–30. New York, 1977.

"The Renaissance Artist as Quantifier." In *The Perception of Pictures*, edited by M. A. Hagen, 1: 179–212. New York, London, and Toronto, 1980.

Elkins, J. "On the Impossibility of Stories: The Anti-narrative Impulse in Modern Painting." *Word and Image* 7 (1991): 350.

Emiliani, M. Dalai. "La questione della prospettiva." In E. Panofsky, *La prospettiva come "forma simbolica" e altri scritti*, edited by G. D. Neri, 118–41. Milan, 1961.

"La questione della prospettiva, 1960–1968." *L'arte* 2 (1968): 96–105.

ed. *La prospettiva rinascimentale: codificazioni e trasgressioni*. Florence, 1980.

Ettlinger, L. D. *The Sistine Chapel before Michelangelo*. Oxford, 1965.

Ettlinger, L. D., and H. S. Ettlinger. *Botticelli*. New York, 1977.

Euclid. "The Optics of Euclid." Translated by H. E. Burton. *Journal of the Optical Society of America* 35 (1945): 357–72.

Fabbri, M., E. Garbero Zorzi, and A. Petriola Tofani. *Il luogo teatrale a Firenze*. Milan, 1975.

Farago, C. *Leonardo da Vinci's Paragone: A Critical Interpretation with a New Edition of the Text in the Codex Urbinas*. Leiden, 1992.

Field, J. V. "Piero della Francesca's Treatment of Edge Distortion." *Journal of the Warburg and Courtauld Institutes* 49 (1986): 66–90.

Filarete. *Filarete's Treatise on Architecture: Being the Treatise by Antonio di Piero Averlino, Known as Filarete*. Translated by J. R. Spencer. 2 vols. New Haven and London, 1965.

Trattato di Architettura. Edited by A. M. Finoli and L. Grassi. 2 vols. Milan, 1972.

Filippo Brunelleschi: la sua opera e il suo tempo, Atti di Convegno Internazionale di Studi. Florence, 1980.

Flocon A., and R. Taton. *La prospettiva*. Milan, 1985.

Fraisse, P. *The Psychology of Time*. Translated by J. Leith. New York, 1963.

Francastel, P. "Espace génétique et éspace plastique." *Revue d'Esthétique* 1 (1948): 349–80.

Peinture et Société: naissance et destruction d'un espace plastique de la Renaissance au Cubisme. Lyon, 1951.

La Figure et le Lieu: l'ordre visuel du Quattrocento. Paris, 1967.

Frangenberg, T. "The Image and the Moving Eye: Jean Pélerin (Viator) to Guidobaldo del Monte." *Journal of the Warburg and Courtauld Institutes* 49 (1986): 150–71.

Frey, D. *Gotik und Renaissance: als Grundlagen der modernen Weltanschauung*. Augsburg, 1929. Partial English translation in *Art History: An Anthology of Modern Criticism*, edited by W. Sypher, 154–72. New York, 1963.

Fried, M. *Absorption and Theatricality: Painting and the Beholder in the Age of Diderot*. Berkeley and Los Angeles, 1980.

Friedman, S. L., and M. B. Stevenson. "Perception of Movement in Pictures."

In *The Perception of Pictures*, edited by M. A. Hagen, 1: 225–55. New York, 1980.

Froning, H. "Anfänge der kontinvierenden Bilderzählung in der griechen Kunst." *Jahrbuch des Deutschen Archäologischen Instituts* 103 (1988): 169–99.

Gadol, J. *Leon Battista Alberti: Universal Man of the Early Renaissance.* Chicago and London, 1969.

Gaffron, M. "Right and Left in Pictures." *Art Quarterly* 13 (1950): 312–30.

Gaffurio. *Practica Musicae.* Edited and translated by C. A. Miller. N.p., 1968.

Gardner, J. "The Decoration of the Baroncelli Chapel in Santa Croce." *Zeitschrift für Kunstgeschichte* 34 (1971): 89–114.

Gardner, P. "Professor Wickhoff on Roman Art." *Journal of Roman Studies* 7 (1917): 1–26.

Garin, E. "La cultura fiorentina nell'età di Leonardo." In *Medioevo e rinascimento: studi e ricerche*, 311–40. Bari, 1954.

"Il problema delle fonti del pensiero di Leonardo." In *La cultura filosofica del rinascimento italiano: ricerche e documenti*, 388–401. Florence, 1979.

Garrison, E. B. "A New History of Bonaventura di Berlinghiero's St. Francis Dossal in Pescia." *Studies in the History of Medieval Italian Painting* 1 (1953): 69–78.

Genette, G. *Narrative Discourse: An Essay on Method.* Translated by J. E. Lewin. Ithaca, 1980.

Ghiberti, L. *Lorenzo Ghibertis Denkwürdigkeiten (I Commentarii).* Edited by J. von Schlosser. 2 vols. Berlin, 1912.

Gibson, J. J. *The Perception of the Visual World.* Boston, 1950.

"The Problem of Temporal Order in Stimulation and Perception." *The Journal of Psychology* 62 (1966): 141–9.

"The Information Available in Pictures." *Leonardo* 4 (1971): 27–35.

"The Ecological Approach to the Visual Perception of Pictures." *Leonardo* 11 (1978): 227–35.

Gioseffi, D. *Perspectiva artificialis: per la storia della prospettiva spigolature e appunti.* Trieste, 1957.

"Complementi di prospettiva, 2." *Critica d'arte* 5 (1958): 102–49.

Gizzi, C., ed. *Botticelli and Dante.* Milan, 1991.

Goffen, R. "Friar Sixtus IV and the Sistine Chapel." *Renaissance Quarterly* 39 (1986): 218–63.

Gombrich, E. H. "Lessing." *Proceedings of the British Academy* 43 (1957): 133–56.

"Moment and Movement in Art." In *The Image and the Eye: Further Studies in the Psychology of Pictorial Representation*, 40–62. Ithaca, 1982. Originally published in *Journal of the Warburg and Courtauld Institutes* 27 (1964): 293–306.

"Light, Form and Texture in Fifteenth-Century Painting North and South of the Alps." In *The Heritage of Apelles: Studies in the Art of the Renaissance*, 19–35. Oxford, 1976.

Means and Ends: Reflections on the History of Fresco Painting. London, 1976.

Symbolic Images: Studies in the Art of the Renaissance. Oxford, 1978.

"Standards of Truth: The Arrested Image and the Moving Eye." In *The Language of Images,* edited by W. J. T. Mitchell, 181–217. Chicago and London, 1980. Reprinted in *The Image and the Eye: Further Studies in the Psychology of Pictorial Representation,* 244–7. Ithaca, 1982.

"Mirror and Map: Theories of Pictorial Representation." In *The Image and the Eye: Further Studies in the Psychology of Pictorial Representation,* 172–214. Ithaca, 1982.

Goodman, N. "Twisted Tales; or Story, Study, and Symphony." In *On Narrative,* edited by W. J. T. Mitchell, 99–115. Chicago and London, 1981.

Grayson, C. "Studi su Leon Battista Alberti." *Rinascimento* 4 (1953): 45–62.

Greco, A. *La Cappella di Niccolo V del Beato Angelico.* Rome, 1980.

Greenstein, J. M. *Mantegna and Painting as Historical Narrative.* Chicago and London, 1992.

Groenewegen-Frankfort, H. A. *Arrest and Movement: An Essay on Space and Time in the Representational Art of the Ancient Near East.* London, 1951.

Haber, R. N. "Perceiving Space from Pictures: A Theoretical Analysis." In *The Perception of Pictures,* edited by M. A. Hagen, 1: 3–31. New York, London, and Toronto, 1980.

Hanfmann, G. M. A. "Narration in Greek Art." *American Journal of Archaeology* 61 (1957): 71–8.

Hardison, O. B. *Christian Rite and Christian Drama in the Middle Ages: Essays in the Origin and Early History of Modern Drama.* Baltimore, 1965.

Hartt, F. "*Lucerna ardens et lucens:* il significato della Porta del Paradiso." In *Lorenzo Ghiberti nel suo tempo,* Atti del Convegno Internazionale di Studi, 27–57. Florence, 1980.

Harvey, E. R. *The Inward Wits: Psychological Theory in the Middle Ages and the Renaissance.* London, 1975.

Held, J. S. "Das gesprochene Wort bei Rembrandt." In *Neue Beiträge zur Rembrandt-Forschung,* edited by O. von Simson and J. Kelch, 111–25. Berlin, 1973.

Henderson, C. Dalrymple. *The Fourth Dimension and Non-Euclidean Geometry in Modern Art.* Princeton, 1983.

Hills, P. *The Light of Early Italian Painting.* New Haven and London, 1987.

Hirn, Y. *The Sacred Shrine: A Study of the Poetry and Art of the Catholic Church.* London, 1958.

Hochberg, J. "In the Mind's Eye." In *Contemporary Theory and Research in Visual Perception,* edited by R. N. Haber, 309–31. New York, 1968.

Perception. Englewood Cliffs, 1978.

"Pictorial Functions and Perceptual Structures." In *The Perception of Pictures,* edited by M. A. Hagen, 2: 47–93. New York, London, and Toronto, 1980.

Holly, M. A. *Panofsky and the Foundations of Art History.* Ithaca and London, 1984.

Hope, C. "Religious Narrative in Renaissance Art." *Royal Society of Arts Journal* 134 (1985/6): 804–18.

Jammer, M. *Concepts of Space: The History of Theories of Space in Physics.* Cambridge, Mass., 1969.

Janhsen, A. *Perspektivregelen und Bildgestaltung bei Piero della Francesca.* Munich, 1990.

Kauffmann, G. *Zum Verhältnis von Bild und Text in der Renaissance,* Rheinisch-Westfälische Akademie der Wissenschaften, Vorträge, G249. Opladen, 1980.

Keele, K. D. "Leonardo da Vinci's Physiology of the Senses." In *Leonardo's Legacy: An International Symposium,* edited by C. D. O'Malley, 35–56. Berkeley and Los Angeles, 1969.

Kemp, M. "Leonardo and the Visual Pyramid." *Journal of the Warburg and Courtauld Institutes* 40 (1977): 128–49.

——— "Science, Non-Science and Nonsense: The Interpretation of Brunelleschi's Perspective." *Art History* 1 (1978): 134–61.

——— *Leonardo da Vinci: The Marvellous Works of Nature and Man.* Cambridge, Mass., 1981.

——— *The Science of Art: Optical Themes in Western Art from Brunelleschi to Seurat.* New Haven and London, 1990.

——— "Visual Narratives, Memory and the Medieval *Esprit du Système.*" In *Images of Memory: On Remembering and Representation,* edited by S. Küchler and W. Melion, 87–108. Washington, D.C., and London, 1991.

——— "In the Beholder's Eye: Leonardo and the 'Errors of Sight' in Theory and Practice." *Achademia Leonardi Vinci* 5 (1992): 153–62.

Kern, G. J. "Die Anfänge der zentralperspektivischen Konstruktion in der italienischen Malerei des 14. Jahrhunderts." *Mitteilungen des Kunsthistorischen Institutes in Florenz* 2 (1912–17): 39–65.

Kernodle, G. *From Art to Theatre: Form and Convention in the Renaissance.* Chicago and London, 1970.

Kessler, H. L., and M. Shreve Simpson, eds. *Pictorial Narrative in Antiquity and the Middle Ages,* National Gallery of Art Studies in the History of Art 16. Washington, D.C., 1985.

Kitao, T. Kaori. "Prejudice in Perspective: A Study of Vignola's Perspective Treatise." *Art Bulletin* 44 (1962): 173–94.

——— "*Imago* and *Pictura:* Perspective, Camera Obscura and Kepler's Optics." In *La prospettiva rinascimentale: codificazioni e trasgressioni,* edited by M. Dalai Emiliani, 499–510. Florence, 1980.

Klein, R. *Form and Meaning.* New York, 1979.

Koestler, A. "Abstract and Picture Strip." In *The Pathology of Memory,* edited by C. A. Talland and N. C. Waugh, 261–70. New York, 1969.

Königson, E. *L'Espace théâtral médiéval.* Paris, 1975.

Koyré, A. *From the Closed World to the Infinite Universe.* Baltimore and London, 1968.

Krautheimer, R., and T. Krautheimer-Hess. *Lorenzo Ghiberti.* 3d ed. Princeton, 1982.

Kunzle, D. *The Early Comic Strip: Narrative Strips and Picture Stories in the European Broadsheet from c. 1450 to 1825.* Berkeley, Los Angeles, and London, 1973.

Ladis, A. *Taddeo Gaddi: Critical Reappraisal and Catalogue Raisonné.* Columbia and London, 1982.

Lamblin, B. *Peinture et temps.* Paris, 1983.

Lang, S. "Brunelleschi's Panels." In *La prospettiva rinascimentale: codificazioni e trasgressioni,* edited by M. Dalai Emiliani, 63–72. Florence, 1980.

Lavin, M. A. *The Place of Narrative: Mural Decoration in Italian Churches, 431–1600.* Chicago and London, 1990.

Lee, R. *Ut Pictura Poesis: The Humanistic Theory of Painting.* New York, 1967.

Lehmann-Hartleben, K. *Die Trajanssaüle: ein Romische Kunstwerk zu beginn der Spätantike.* Berlin and Leipzig, 1926.

Leonardo da Vinci. *Das Buch von der Malerei: nach dem Codex Vaticanus 1270.* Edited and translated by H. Ludwig. Vienna, 1882.

 Il Codice Atlantico di Leonardo da Vinci nella Biblioteca Ambrosiana di Milano. Edited by G. Piumati. Milan, 1894–1904.

 The Literary Works of Leonardo da Vinci. Edited by J. P. Richter. 2 vols. London, New York, and Toronto, 1939.

 Paragone: A Comparison of the Arts. Translated and annotated by I. A. Richter. London, New York, and Toronto, 1949.

 Treatise on Painting [*Codex Urbinus Latinus* 1270]. Translated and edited by A. P. McMahon. Princeton, 1956.

 The Notebooks of Leonardo da Vinci. Edited by E. MacCurdy. New York, 1958.

 Il Codice Atlantico della Biblioteca Ambrosiana di Milano: transcrizione diplomatica e critica di Augusto Marinoni. Florence, 1975–80.

Lessing, G. E. *Laocoön: An Essay on the Limits of Painting and Poetry.* Translated by E. A. McCormick. Baltimore and London, 1984.

Lewine, C. F. *The Sistine Chapel Walls and the Roman Liturgy.* University Park, 1993.

Lightbown, R. *Sandro Botticelli.* 2 vols. Los Angeles, 1978.

Lindberg, D. C. "Alhazen's Theory of Vision and Its Reception in the West." *Isis* 58 (1967): 321–41.

 John Pecham and the Science of Optics: Perspectiva Communis. Madison, Milwaukee, and London, 1970.

 Theories of Vision from Al-Kindi to Kepler. Chicago and London, 1976.

 "Medieval Latin Theories of the Speed of Light." In *Roemer et la vitesse de la lumière,* edited by R. Taton, 45–72. Paris, 1978.

 "The Science of Optics." In *Science in the Middle Ages,* edited by D. C. Lindberg, 338–68. Chicago and London, 1978.

Lomazzo, G. P. *Trattato dell' arte, della pittura, scoltura et architettura.* In *Scritti sulle arte,* edited by R. P. Ciardi, 2: 9–589. Florence, 1974.

Longhi, R. "Fatti di Masolino e di Masaccio." *Critica d'arte* 5 (1940): 145–91.

Lorenzo Ghiberti nel suo tempo, Atti del Convegno Internazionale di Studi. Florence, 1980.

Lowinsky, E. E. *Tonality and Atonality in Sixteenth-Century Music.* Berkeley and Los Angeles, 1961.

Lynch, K. *What Time Is This Place?* Cambridge, Mass., and London, 1972.

Maccagni, C. "Riconsiderando il problema delle fonti di Leonardo: l'elenco di libri ai fogli 2 verso–3 recto del codice 8936 della biblioteca nacional di Madrid." In *Leonardo da Vinci letto e commentto da Marinoni, Heidenreich, Brizio et al.,* Letture vinciane I-XII (1960–72), edited by P. Galluzzi, 285–307. Florence, 1974.

Mace, D. T. "Transformations in Classical Art Theory: From 'Poetic Composition' to 'Picturesque Composition.'" *Word and Image* 1 (1985): 59–86.

Manetti, Antonio di Tuccio. *The Life of Brunelleschi.* Edited by H. Saalman and translated by C. Engass. University Park and London, 1970.

Marchini, G. *Filippo Lippi.* Milan, 1979.

Marin, L. *Opacité de la peinture: essais sur la représentation au Quattrocento.* Florence, 1989.

Marinoni, A. "'Tempo armonico' o 'musicale' in Leonardo da Vinci." *Lingua Nostra* 16 (1955): 45–8.

"L'essere del nulla." In *Leonardo da Vinci letto e commento da Marinoni, Heidenreich, Brizio, et al.,* Letture vinciane I–XII (1960–72), edited by P. Galluzzi, 9–28. Florence, 1974.

Meditations on the Life of Christ. Translated by I. Ragusa and R. Green. Princeton, 1961.

Meiss, M. *The Painter's Choice: Problems in the Interpretation of Renaissance Art.* New York, 1976.

Painting in Florence and Siena after the Black Death: The Arts, Religion, and Society in the Mid-Fourteenth Century. Princeton, 1978.

Mesnil, J. *Masaccio et les débuts de la Renaissance.* The Hague, 1927.

Michel, P.-H. *La pensée de L. B. Alberti.* Paris, 1930.

Mitchell, W. J. T. "Spatial Form in Literature: Toward a General Theory." In *The Language of Images,* edited by W. J. T. Mitchell, 271–99. Chicago and London, 1980.

Iconology: Image, Text, Ideology. Chicago and London, 1986.

ed. *The Language of Images.* Chicago and London, 1980.

ed. *On Narrative.* Chicago and London, 1981.

Molho, A. "The Brancacci Chapel: Studies in Its Iconography and History." *Journal of the Warburg and Courtauld Institutes* 40 (1977): 66–70.

Molinari, C. *Spettacoli fiorentini del Quattrocento: contributi allo studio delle sacre rappresentazioni.* Venice, 1961.

"Gli spettatori e lo spazio scenico nel teatro del cinquecento." *Bolletino del Centro Internazionale di Studi di Architettura Andrea Palladio* 16 (1974): 145–54.

Moorman, J. *A History of the Franciscan Order: From Its Origins to the Year 1517.* Oxford, 1968.

Morgan, R. P. "Musical Space/Musical Time." In *The Language of Images*, edited by W. J. T. Mitchell, 259–70. Chicago and London, 1980.

Morley, T. *A Plain and Easy Introduction to Practical Music.* Edited by R. Alec Harman. New York, 1973.

Morris, R. *Time's Arrows: Scientific Attitudes Toward Time.* New York, 1984.

Neri, G. D. "Il problema dello spazio figurativo e la teoria artistica di E. Panofsky." In E. Panofsky, *La prospettiva come "forma simbolica" e altri scritti*, edited by G. D. Neri, 7–33. Milan, 1961.

Nessi, S. "La Vita di S. Francesco dipinta da Benozzo Gozzoli a Montefalco." *Miscellanea Francescana* 61 (1961): 467–92.

Newhall, B. "The Case of the Elliptical Wheel and Other Photographic Distortions." *Image* 28 (1985): 1–4.

Oertel, R. "Perspective and Imagination." In *The Renaissance and Mannerism, Studies in Western Art: Acts of the Twentieth International Congress of the History of Art* 2. Edited by M. Meiss et al., 146–59. Princeton, 1963.

Omar, S. B. *Ibn al-Haytham's Optics: A Study of the Origins of Experimental Science.* Minneapolis and Chicago, 1977.

Pächt, O. *The Rise of Pictorial Narrative in Twelfth-Century England.* Oxford, 1962.

Padoa Rizzo, A. *Benozzo Gozzoli: pittore fiorentino.* Florence, 1972.

Paivio, A. *Imagery and Verbal Processes.* New York, 1971.

——— "Imagery and Synchronic Thinking." *Canadian Psychological Review* 16 (1975): 147–63.

——— "The Empirical Case for Dual Coding." In *Imagery, Memory and Cognition: Essays in Honor of Allan Paivio*, edited J. C. Yulle, 307–32. Hillsdale and London, 1983.

——— *Mental Representations: A Dual Coding Approach.* New York, 1986.

Panofsky, E. "Das perspektivische Verfahren Leone Battista Albertis." *Kunstchronik*, n.s. 26 (1915): 504–16.

——— "Die Perspektive als symbolische Form." *Vorträge der Bibliothek Warburg*, 1924–5, 258–330. Leipzig and Berlin, 1927.

——— "The History of the Theory of Human Proportions as a Reflection of the History of Styles." In *Meaning in the Visual Arts*, 55–107. New York, 1955.

——— *Early Netherlandish Painting: Its Origins and Character.* New York, 1971.

——— *Renaissance and Renascences in Western Art.* New York, 1972.

Parronchi, A. "La 'costruzione legittima' è uguale alla 'costruzione con punti di distanza.' " *Rinascimento*, n.s. 4 (1964): 35–40.

——— *Studi su la dolce prospettiva.* Milan, 1964.

Pedretti, C. "Leonardo on Curvilinear Perspective." *Bibliothèque d'Humanisme et Renaissance* 25 (1963): 69–87.

——— *Leonardo da Vinci on Painting: A Lost Book (Libro A).* Berkeley and Los Angeles, 1964.

The Literary Works of Leonardo da Vinci Compiled and Edited from the Original Manuscripts by Jean Paul Richter: Commentary. 2 vols. Berkeley and Los Angeles, 1977.

Leonardo: A Study in Chronology and Style. New York and London, 1982.

Leonardo: Architect. New York, 1985.

Pierantoni, R. *L'occhio e l'idea: fisiologia e storia della visione.* Turin, 1981.

Forma fluens: il movimento e la sua rappresentazione nella scienza, nell'arte e nella tecnica. Turin, 1986.

Piero della Francesca. *Petrus pictor burgensis de prospectiva pingendi.* Translated by C. Winterberg. Strassburg, 1899.

De prospectiva pingendi, with additional material by E. Battisti et al., edited by G. Nicco-Fasola. Florence, 1942; reprint, 1984.

Pirenne, M. H. *Optics, Painting and Photography.* Cambridge, 1970.

Pollitt, J. J. *Art in the Hellenistic Age.* Cambridge, 1986.

Polzer, J. "The Perspective of Leonardo Considered as a Painter." In *La prospettiva rinascimentale: codificazioni e trasgressioni,* edited by M. Dalai Emiliani, 233–47. Florence, 1980.

Pope-Hennessy, J. *Sassetta.* London, 1939.

A Sienese Codex of the Divine Comedy. London, 1947.

"The Sixth Centenary of Ghiberti." In *The Study and Criticism of Italian Sculpture,* 39–70. New York, 1980.

Pope-Hennessy, J., and K. Christiansen. *Secular Painting in 15th-Century Tuscany: Birth Trays, Cassone Panels, and Portraits.* New York, 1980. Originally *Metropolitan Museum of Art Bulletin,* Summer, 1980.

Praetorius, E. *Die Mensural Theorie des Franchinus Gafurius und der Folgenden Zeit bis zur Mitte des 16. Jahrhunderts.* Berlin, 1905.

Praz, M. *Mnemosyne: The Parallel between Literature and the Visual Arts.* Princeton and London, 1970.

Preiser, A. *Das Entstehen und die Entwicklung der Predella in der italienischen Malerei.* Hildesheim and New York, 1973.

Previtali, G. *Giotto e la sua bottega.* Milan, 1974.

Puttfarken, T. "David's *Brutus* and Theories of Pictorial Unity in France." *Art History* 4 (1981): 291–304.

Roger de Piles' Theory of Art. New Haven and London, 1985.

Riegl, A. *Die spätrömische Kunstindustrie.* Vienna, 1927.

Ringbom, S. "Maria in Sole and the Virgin of the Rosary." *Journal of the Warburg and Courtauld Institutes* 25 (1962): 326–30.

"Devotional Images and Imaginative Devotions." *Gazette des Beaux Arts* 6:73 (1969): 159–70.

"Some Pictorial Conventions for the Recounting of Thoughts and Experiences in Late Medieval Art." In *Medieval Iconography and Narrative: A Symposium,* edited by F. G. Andersen et al., 38–69. Odense, 1980.

Icon to Narrative: The Rise of the Dramatic Close-up in Fifteenth-Century Devotional Painting. Doornspijk, 1983.

"Action and Report: The Problem of Indirect Narration in the Academic Theory of Painting." *Journal of the Warburg and Courtauld Institutes* 52 (1989): 34–51.

Robert, C. *Bild und Lied: Archäeologische Beiträge zur Geschichte der Griechischen Heldensage,* Philologische Untersuchungen heräsugegeben von A. Kiessling und U. v. Wilamowitz-Moellendorf, V. Berlin, 1881.

Rodin, A. *L'Art.* Edited by P. Gsell. Paris, 1911.

Rodinò, S. P. V. "Francescanesimo e pittura riformata in Italia centrale." In *L'Immagine di San Francesco nella controriforma,* Comitato Nazionale per le Manifestazioni Culturali per l' VIII Centenario della Nascita di San Francesco di Assisi, 63–72. Rome, 1982.

Ronchi, V. "Leonardo e l'ottica." In *Leonardo: saggi e ricerche,* edited by A. Marazza, 161–85. Rome, 1954.

Rosand, D. "*Ut Pictor Poeta:* Meaning in Titian's *Poesie.*" *New Literary History* 3 (1971–2): 527–46.

Painting in Cinquecento Venice: Titian, Veronese, Tintoretto. New Haven and London, 1982.

The Meaning of the Mark: Leonardo and Titian. Lawrence, 1988.

Rossi, P. *Francis Bacon: From Magic to Science.* Translated by S. Rabinovitch. Chicago, 1968.

Rossi, P. A. "Soluzioni Brunelleschiane; prospettiva: invenzione ed uso." *Critica d'arte* 175–7 (1981): 48–74.

"Il problema della tre colonne." *Critica d'arte* 175–7 (1981): 175–9.

Ruda, J. *Fra Filippo Lippi: Life and Work, with a Complete Catalogue.* London, 1993.

Rudrauf, L. *L'Annonciation: Etude d'un thème plastique et de ses variations en peinture et en sculpture.* Paris, 1943. Partial English translation by T. Munro in "The Annunciation: Study of a Plastic Theme and Its Variations in Painting and Sculpture." *Journal of Aesthetics and Art Criticism* 7 (1949): 325–48.

Sabra, A. I. "Sensation and Inference in Alhazen's Theory of Visual Perception." In *Studies in Perception: Interrelations in the History of Philosophy and Science,* edited by P. K. Machamer and R. G. Turnbull, 160–85. Columbus, Ohio, 1978.

ed. and trans. *The Optics of Ibn-Al-Haytham: Books I–III, On Direct Vision.* London, 1989.

Sachs, C. *Rhythm and Tempo: A Study in Music History.* New York, 1953.

Salmi, M. *La pittura di Piero della Francesca.* Novara, 1979.

Salvini, R. "The Sistine Chapel: Ideology and Architecture." *Art History* 3 (1980): 144–57.

Salvini, R., and E. Camesasca. *The Sistine Chapel.* New York, 1965.

Salvini, R., and L. Traverso. *The Predella from the XIIIth to the XVIth Centuries.* London, 1960.

Sanders, E. Barnes. "Realism in Florentine Painting, 1400–1465: Practice and Theory." Ph.D. diss., Columbia University, 1984.

Sandström, S. *Levels of Unreality: Studies in Structure and Construction in Italian Mural Painting During the Renaissance*. Uppsala, 1963.

Scarpellini, P. "Iconografia francescana nei secoli XIII e XIV." In *Francesco d'Assisi: storia e arte*, Comitato Regionale Umbro per le Celebrazioni dell'VIII Centenario della nascita di San Francesco di Assisi, 91–106. Milan, 1982.

Perugino. Milan, 1984.

Schapiro, M. "On Some Problems in the Semiotics of Visual Art: Field and Vehicle in Image-Signs." *Semiotica* 1 (1969): 223–42.

Words and Pictures: On the Literal and the Symbolic in the Illustration of a Text. The Hague, 1973.

"The Place of the Joshua Roll in Byzantine History." In *Late Antique, Early Christian and Medieval Art*, 49–66. New York, 1979.

Schefold, K. *Pompeianische Malerei*. Basel, 1952.

"Origins of Roman Landscape Painting." *Art Bulletin* 42 (1960): 87–96.

Vergessenes Pompeji: Veröfflentliche Bilder Römischer Wanddekorationen in Geschichtlichte Folge Herausgegeben. Bern and Munich, 1962.

"Buch und Bild im Alterum." In *Wort und Bild: Studien zur Gegenwart der Antike*, 125–8. Basel, 1975.

Schlosser Magnino, J. *La letteratura artistica*. Edited by O. Kurz and translated by F. Rossi. Florence, 1977.

Schnitzler, L. "Die Trajanssaüle und die mesopotamischen Bildannalen." *Jahrbuch des Deutschen Archäologischen Instituts* 67 (1952): 43–77.

Scholes, R., and R. Kellog. *The Nature of Narrative*. London, 1966.

Schubring, P. *Cassoni: Truhen und Truhenbilder der italienischen Frührenaissance*. Leipzig, 1915.

Schweizer, N. R. *The Ut Pictura Poesis Controversy in Eighteenth-Century England and Germany*. Bern and Frankfurt, 1972.

Scriabine, M. "La perspective temporelle dans les oeuvres de la Renaissance." In *Filippo Brunelleschi: la sua opera e il suo tempo*, Atti di Convegno Internazionale di Studi, 1: 325–31. Florence, 1980.

Shaftesbury, Anthony Ashley Cooper, third earl of. *Second Characters or the Language of Forms*. Edited by B. Rand. Cambridge, 1914.

Shearman, J. "The Chapel of Sixtus IV." In *The Sistine Chapel: A New Light on Michelangelo; The Art, the History, and the Restoration*. Edited by C. Pietrangeli et al. New York, 1986.

Sindona, E. "Introduzione alla poetica di Paolo Uccello: relazioni tra prospettiva e pensiero teoretico." *L'arte* 17 (1972): 7–39.

"Prospettiva e crisi nell'umanesimo." In *La prospettiva rinascimentale: codificazioni e trasgressioni*, edited by M. Dalai Emiliani, 95–124. Florence, 1980.

Singleton, C., M. Meiss, and P. Brieger. *Illuminated Manuscripts of the Divine Comedy.* Princeton, 1969.

Snyder, J. "Picturing Vision." In *The Language of Images,* edited by W. J. T. Mitchell, 219–46. Chicago and London, 1980.

Solmi, E. *Scritti vinciani: le fonti dei manoscritti di Leonardo da Vinci e altri studi.* Florence, 1976.

Souriau, E. "Time in the Plastic Arts." *Journal of Aesthetics and Art Criticism,* 7 (1949): 294–307.

Spence, J. D. *The Memory Palace of Matteo Ricci.* New York, 1984.

Spencer, J. R. "Spatial Imagery of the Annunciation in Fifteenth-Century Florence." *Art Bulletin* 37 (1955): 273–80.

"Filarete's Cooperative Project with Complications of Chronology and Technique." In *Collaboration in Italian Renaissance Art,* edited by W. Stedman Sheard and J. T. Paoletti, 33–45. New Haven and London, 1978.

Steinberg, L. "Leonardo's *Last Supper.*" *Art Quarterly* 36 (1973): 297–410.

Steiner, W. *The Colors of Rhetoric: Problems in the Relation between Modern Literature and Painting.* Chicago and London, 1982.

Pictures of Romance: Form against Context in Painting and Literature. Chicago and London, 1988.

Steinitz, K. T. *Leonardo da Vinci's Trattato della Pittura (Treatise on Painting): A Bibliography of the Printed Editions, 1651–1956.* Copenhagen, 1958.

Steneck, N. H. "The Problem of the Internal Senses in the Fourteenth Century." Ph.D. diss., University of Wisconsin, 1970.

"Albert the Great on the Classification and Localization of the Internal Senses." *Isis* 65 (1974): 193–211.

Summers, D. *The Judgment of Sense: Renaissance Naturalism and the Rise of Aesthetics.* Cambridge, 1987.

Swift, E. H. *Roman Sources of Christian Art.* New York, 1951.

Sypher, W. *Four Stages of Renaissance Style: Transformations in Art Literature, 1400–1700.* New York, 1955.

ten Doesschate, G. *De deerde Commentaar van Lorenzo Ghiberti in Verband met de Middeleeuwsche Optik.* Utrecht, 1940.

Perspective: Fundamentals, Controversials, History. Nieuwkoop, 1964.

Tinctoris, Johannis. *Tractatus de regulari valore notarum.* In *Opera Theoretica,* edited by A. Seay, 1: 121–79. N.p., 1975.

Tornabuoni, L. *I poemetti sacre di Lucrezia Tornabuoni.* Edited by F. Pezzarossa. Florence, 1978.

Townsend, D. "Shaftesbury's Aesthetic Theory." *Journal of Aesthetics and Art Criticism* 41 (1982): 205–13.

Toynbee, J. M. C. "The Ara Pacis Reconsidered and Historical Art in Roman Italy." *Proceedings of the British Academy* 39 (1953): 67–95.

Trexler, R. C. *Public Life in Renaissance Florence.* New York, 1980.

Vagnetti, L. "Riflessioni sul 'De prospectiva pingendi.'" *Commentari* 26 (1975): 14–55.

"La posizione di Filippo Brunelleschi nell'invenzione della prospettiva lineare: precisioni ed aggiornamenti." In *Filippo Brunelleschi: la sua opera e il suo tempo*, Atti di Convegno Internazionale di Studi, 1: 279–306. Florence, 1980.

van Os, H. W. "St. Francis of Assisi as a Second Christ in Early Italian Painting." *Simiolus* 7 (1974): 115–32.

Sienese Altarpieces, 1215–1460: Form, Content, Function. Groningen, 1984.

Varnedoe, K. "The Artifice of Candor: Impressionism and Photography Reconsidered." *Art in America* (January 1980): 66–78.

"The Ideology of Time: Degas and Photography." *Art in America* (Summer 1980): 96–110.

Vasari, G. *Le vite de' più eccellenti pittori scultori ed architettori*. Edited by G. Milanesi. 9 vols. Florence, 1878–85.

Veltman, K. "Panofsky's Perspective: A Half Century Later." In *La prospettiva rinascimentale: codificazioni e trasgressioni*, edited by M. Dalai Emiliani, 565–84. Florence, 1980.

Veltman, K., and K. D. Keele. *Linear Perspective and the Visual Dimensions of Science and Art, Studies on Leonardo da Vinci 1*. Munich, 1986.

Venturi, A. *Luca Signorelli: interprete di Dante*. Florence, 1922.

Vescovini, G. Federici. "Le questioni di 'perspectiva' di Biagio Pelacani da Parma." *Rinascimento* 12 (1961): 163–243.

Studi sulla prospettiva medioevale. Turin, 1965.

"Il problema delle fonti ottiche medievali del *Commentario Terzo* di Lorenzo Ghiberti." In *Lorenzo Ghiberti nel suo tempo*, Atti del Convegno Internazionale, 349–87. Florence, 1980.

"La prospettiva del Brunelleschi, Alhazen e Biagio Pelacani a Firenze." In *Filippo Brunelleschi: la sua opera e il suo tempo*, Atti di Convegno Internazionale di Studi, 1: 333–48. Florence, 1980.

Voitle, R. *The Third Earl of Shaftesbury: 1671–1713*. Baton Rouge and London, 1984.

von Blanckenhagen, P. H. "Narration in Hellenistic and Roman Art." *American Journal of Archaeology* 61 (1957): 78–83.

"The Odyssey Frieze." *Mitteilungen des Deutschen Archäologischen Instituts, Römische Abteilung* 70 (1963): 100–46.

Wakayama, E. M. L. "Filarete e il compasso: nota aggiunta alla teoria prospettica albertiana." *Arte Lombarda* 38/39 (1973): 161–71.

"La prospettiva come strumento di visualizzazione dell' 'istoria': il caso di Masolino." In *La prospettiva rinascimentale: codificazione e trasgressioni*, edited by M. Dalai Emiliani, 151–63. Florence, 1980.

Wallace, W. E. "Narrative and Religious Expression in Michelangelo's Pauline Chapel." *Artibus et historiae* 19 (1989): 107–21.

Ward, J. L. "A Piece of the Action: Moving Figures in Still Pictures." In *Perception and Pictorial Representation*, edited by C. F. Nodine and D. F. Fisher, 246–71. New York, 1979.

Weinberg, B. "Castelvetro's Theory of Poetics." In *Critics and Criticism: Ancient and Modern*, edited by R. S. Crane, 349–71. Chicago, 1952.

A History of Literary Criticism in the Italian Renaissance. 2 vols. Chicago, 1961.

Weissman, R. F. E. *Ritual Brotherhood in Renaissance Florence*. New York, 1982.

Weitzmann, K. *Illustrations in Roll and Codex: A Study of the Origin and Method of Text-Illustration*, Studies in Manuscript Illumination, no. 2. Princeton, 1947.

"Narration in Early Christendom." *American Journal of Archaeology* 61 (1957): 83–91.

Welliver, W. "Narrative Method and Narrative Form in Masaccio's *Tribute Money*." *Art Quarterly* 1 (1977): 40–58.

Wheelock, A. K., Jr. *Perspective, Optics, and Delft Artists around 1650*. New York and London, 1977.

White, J. *The Birth and Rebirth of Pictorial Space*. 3d ed. Cambridge, Mass., 1987.

Wickhoff, F., and W. Ritter von Hartel. *Die Wiener Genesis*. Vienna, 1901. English edition by F. Wickhoff, *Roman Art: Some of Its Principles and Their Applications to Early Christian Painting*. London and New York, 1900.

Winternitz, E. *Leonardo da Vinci as a Musician*. New Haven and London, 1982.

Wittkower, R. "Brunelleschi and 'Proportion in Perspective.'" *Journal of the Warburg and Courtauld Institutes* 16 (1953): 275–91.

Wittkower, R., and B. A. R. Carter. "The Perspective of Piero della Francesca's *Flagellation*." *Journal of the Warburg and Courtauld Institutes* 16 (1953): 292–302.

Wölfflin, H. "Ueber das Rechts und Links im Bilde." *Gedanken zur Kunstgeschichte*. Basel, 1941.

Wolfson, H. A. "The Internal Senses in Latin, Arabic and Hebrew Philosopic Texts." *Harvard Theological Review* 28 (1935): 69–133.

Yarbus, A. L. *Eye Movements and Vision*. Translated by B. Haigh. New York, 1967.

Yates, F. A. *The Art of Memory*. Harmondsworth, 1966.

Zarlino, Gioseffo. *The Art of Counterpoint*. Part 3 of *Le Istitutioni Harmoniche*, 1558, translated by G. A. Marco and C. V. Palisca. New Haven and London, 1968.

Zorzi, L. *Il teatro e la città*. Turin, 1977.

"Figurazione pittorica e figurazione teatrale." In *Storia dell'arte italiana*, 1: 421–62. Turin, 1979.

Carpaccio e la rappresentazione di Sant'Orsola: ricerche sulla visualitá dello spettacolo nel Quattrocento. Turin, 1988.

INDEX